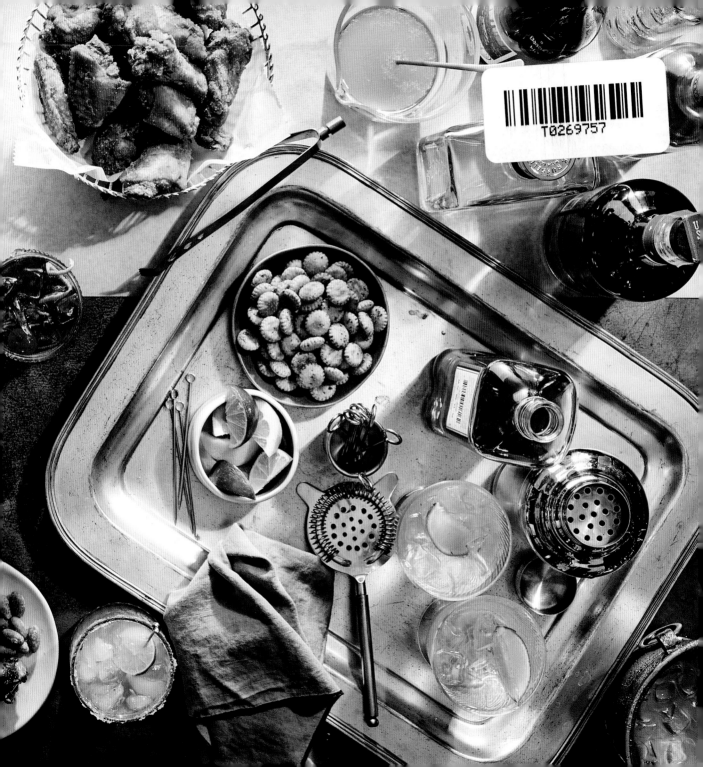

SOUTHERN COCKTAILS

STORIED SIPS, SNACKS & BARKEEP TIPS

SOUTHERN
Cocktails

iPg

For syndication or international licensing requests, email syndication.generic@dotdashmdp.com
For reprint and reuse permission, email mmc.permissions@dotdashmdp.com

Published by IPG
814 North Franklin Street
Chicago, Illinois 60610

ISBN 978-1-9573-1721-2

Produced by Blueline Creative Group, LLC
Visit: bluelinecreativegroup.com
Writer/Producer: Katherine Cobbs
Designer/Illustrator: Matt Ryan
Copyeditor: Donna Ingram
Indexer: Carol Roberts

Food Photography and Recipes by Dotdash Meredith Food Studios
Studio Photo Direction: Paden Reich
Photographers: Antonis Achilleos and Caitlin Bensel
Food Stylists: Torie Cox, Margaret Monroe Dickey, Emily Nabors Hall, Karen Rankin, and Tina Bell Stamos,
Prop Stylists: Kay E. Clarke, Thom Driver, Mary Clayton Carl Jones, Christine Keely and Lindsey Lower
Recipe Developers: Robin Bashinsky, Katherine Cobbs, Paige Grandjean, Julia Levy, Liz Mervosh and Anna Theoktisto

Scenic Photography Credits
Southern Living Staff and Freelance: 6-7: Lissa Gotwals, 42: Cedric Angeles, 46-47: Hector M. Sanchez, 64: Greg Dupree, 68-69: Robbie Caponetto, 161: Hector M. Sanchez, 176-177: Robbie Caponetto, 223: Kindra Clineff, 235: Laurey Glenn, 278: Gabriela Herman; **Getty:** 30-31: Sanny11, 52: Saul Loeb/AF, 54-55: EJ-J, 57: ghornephoto, 60-61: espiegle, 73: Education Images/Universal Images Group, 78: jtyler, 86: SeanPavonePhoto, 90-91: PhilipCacka, 105: Marilyn Nieves, 110-111: ©thierrydehove.com, 118-119: Image Source, 138-139: Sky Noir Photography by Bill Dickinson, 186: Brian Mitchell, 190-191: Hal Bergman, 199: Elizabeth Fernandez, 203: Edwin Remsberg, 224-225: MiguelMalo, 231: Carol M. Highsmith/Buyenlarge, 249: Robert Holmes

First Edition 2023
Printed in China
10 9 8 7 6 5 4 3 2 1

CONTENTS

FOREWORD BY GARY CRUNKLETON

IN THE 1950S, Ted and Marge Crunkleton met in Atlanta, married, and settled in North Carolina to start their family–a daughter and three boys. Marge was from Milwaukee, Wisconsin, and Ted was from a small mill town in rural North Carolina. Ted enlisted in the US Air Force and served in the Korean War, and Marge was a flight attendant for Eastern Airlines.

Marge was Armenian and grew up highly influenced by her parents' value system formed in the old country. This meant marrying someone who wasn't Armenian was not embraced, but ultimately moving together to the south was also a move towards self-preservation and happiness. Marge and Ted were my parents.

As bartender and owner of The Crunkleton bars in North Carolina, I have found plenty of enjoyment and satisfaction in serving cocktails to guests for the past thirty years. I'm fortunate enough to find a passion in life that I was able to parlay into a profession. I mention the story of my mom and dad to put my experience as a southerner in context. Hailing from the north, my mom looked at the south differently. She appreciated southern ways and sought the resources and experiences to make that happen. This led her to *Southern Living* magazine. She called it a "staple of the South." It helped her achieve her ambitions to master southern cooking, host neighbors, dress with style, decorate our home, and make the perfect pitcher of sweet tea. I credit her for teaching me how to cook and for my lifelong interest in cocktails. Mom introduced me to *Southern Living,* and

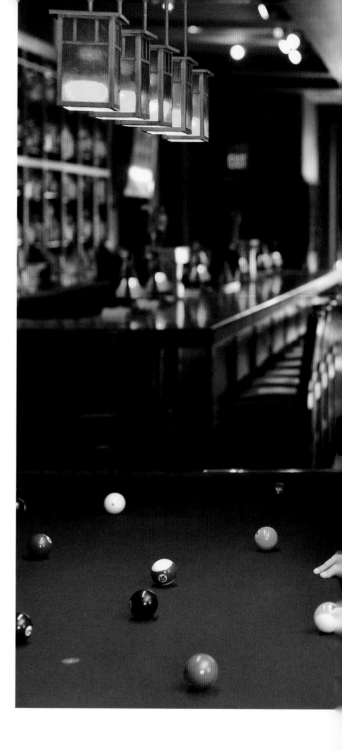

Photo by Lissa Gotwals

I took it from there. She kept every issue in the bathroom cabinet, which was more like a magazine rack. While I know reading in the bathroom doesn't paint the prettiest picture of grace and southern charm, the information I gained from reading those issues of *Southern Living* was priceless.

To be able to write the foreword to Southern Cocktails, the first book devoted to drinks from *Southern Living* brings me full circle. I met Katherine Cobbs, the writer and editor of this book when she visited my Chapel Hill bar years ago. Our shared love of cocktails sparked an instant appreciation for each other. This was during the height of the cocktail renaissance sparked by New York bartender Dale DeGroff. He inspired a renewed appreciation for classic cocktail culture's tools, skills, spirits, and techniques, ushering in the modern craft cocktail craze. This spurred the development of new recipes, many of which have become modern classics in their own right. This movement was happening in New York, San Francisco, Chicago, Portland, and Los Angeles, but not in the South. Around 2006 this spirited wave washed through the region. I was one of a handful of bartenders in the South working on the classics from the golden age of cocktails, spanning the 1870s through 1930s in the country. A collective passion for the provenance of food and drink had taken hold, as seen in the popularity of the Slow Food movement, the booming craft beer industry, and growth of small-batch distilleries. By 2006, we could see the flavorful future. That future is firmly here, and Southern Cocktails is an entertaining and informative guide to navigating the South through inventive cocktails that both celebrate and shake up traditions. I hope you will enjoy this beautifully curated book that will make any southerner (especially my mom) proud.

All-Purpose Wine Glass

Beer Mug

Coupe Glass

Footed Cocktail Glass

Martini Glass

Old-Fashioned Glass

THE ESSENTIALS
The Glass Guide

Most of us understand the importance of being able to put nose in glass to enjoy wine, but are less sure of the rationale behind the varied shapes of cocktail glasses.

A stemmed glass provides a place to grasp a drink without impacting its temperature. One that tapers towards the rim guides a drink's aromas or bubbles to the nose for a more complex sensory experience. Glass shapes are often more about history or form than function. But, not to be discounted, the drinker's perception of the glass matters too. A curvaceous coupe and angular martini glass do little to improve the flavor or aroma of cocktails. Yet, like a stylish accessory, they may make the imbiber feel more elegant or worldly. Whether brimming or empty, the power of the glass is heady stuff. Here is a roundup of glassware to enlist in your cocktail making.

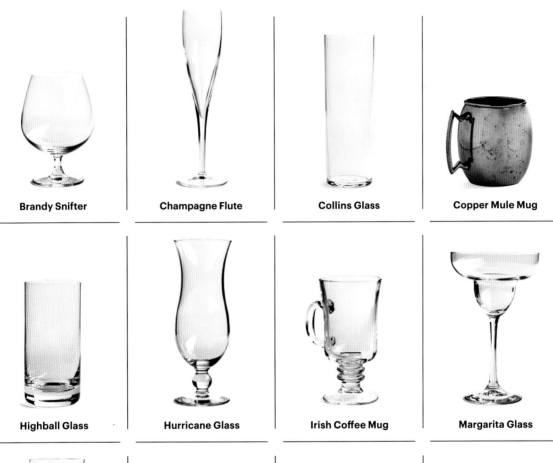

Brandy Snifter

Champagne Flute

Collins Glass

Copper Mule Mug

Highball Glass

Hurricane Glass

Irish Coffee Mug

Margarita Glass

Pilsner Glass

Shot Glass

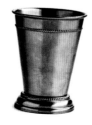

Silver Julep Glass

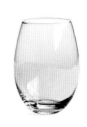

Stemless Wine Glass

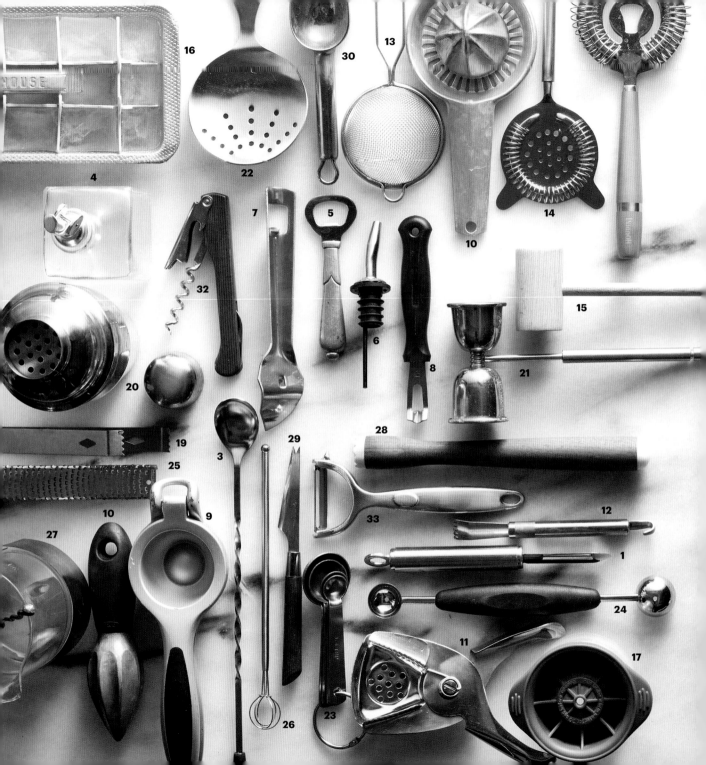

THE ESSENTIALS

Bar Tools

Must-haves for the home bartender that cover all beverage bases include a jigger, cocktail shaker, bar spoon, muddler, blender, and bottle opener. If mixology is your passion, however, outfit your bar with any number of the tools below to take your cocktail craft to the next level.

1. Apple Corer
2. Assorted Picks, Straws, Stirs, Umbrellas
3. Bar Spoon
4. Bitters Dasher
5. Bottle Opener
6. Bottle Pourer
7. Can Punch
8. Channel Knife
9. Citrus Press
10. Citrus Reamers
11. Citrus Squeezer
12. Citrus Zester
13. Fine Strainer
14. Hawthorne Strainer
15. Ice Mallet
16. Ice Cube Tray
17. Ice Mold
18. Ice Pick
19. Ice Tongs
20. Cocktail Shaker
21. Jigger
22. Julep Strainer
23. Measuring Spoons
24. Melon Baller
25. Microplane
26. Mini Cocktail Whisk
27. Mixing Glass
28. Muddler
29. Prong-Tipped Bar Knife
30. Small Scoop
31. Swizzle Sticks
32. Waiter's Corkscrew
33. Y-Peeler

THE ESSENTIALS
Garnish Basics

Do not let the ubiquitousness of the citrus garnish detract from the bright flavor and perfume both rind and fruit can bestow upon cocktails. Think beyond the wedge and get inventive with this favorite garnish.

Briny, tart, sweet, juicy, tropical, and herbaceous are flavor accents that can take a cocktail from average to artisan. Master these garnish basics to create drinks that hit all the right notes.

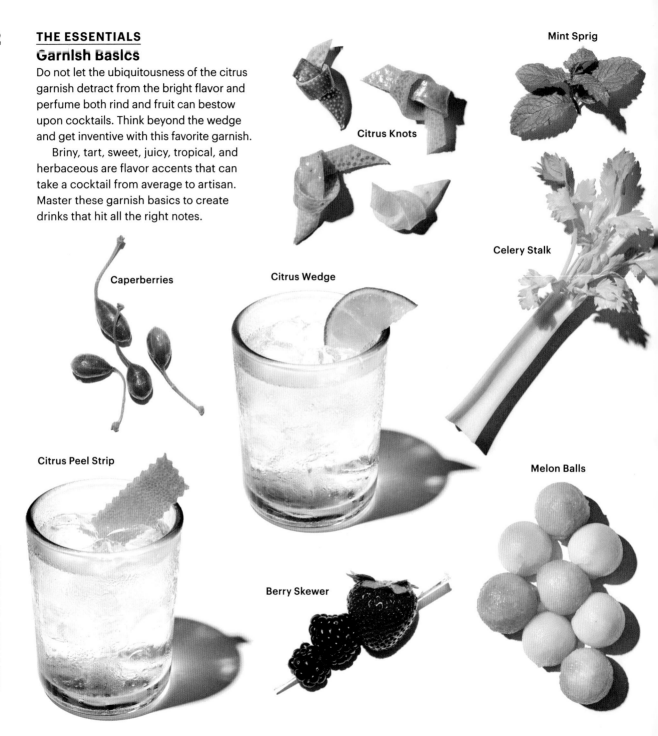

Mint Sprig

Citrus Knots

Celery Stalk

Caperberries

Citrus Wedge

Citrus Peel Strip

Melon Balls

Berry Skewer

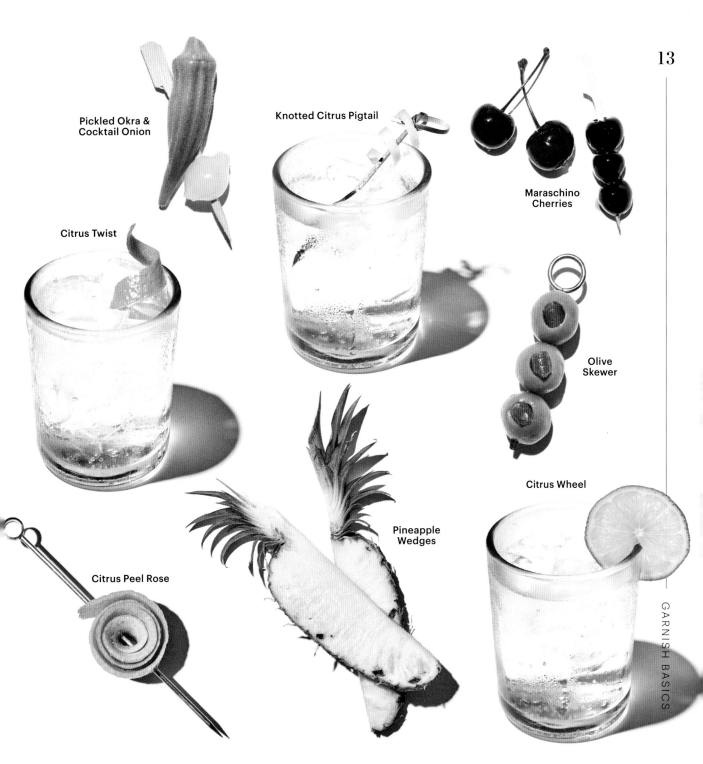

Pickled Okra &
Cocktail Onion

Knotted Citrus Pigtail

Maraschino
Cherries

Citrus Twist

Olive
Skewer

Citrus Wheel

Pineapple
Wedges

Citrus Peel Rose

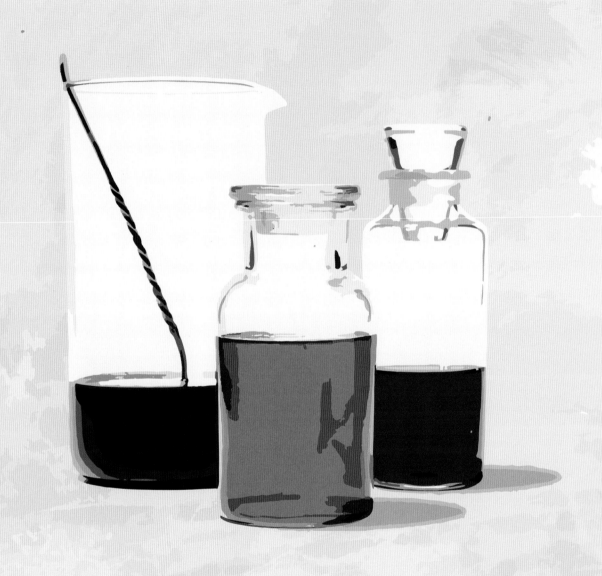

GARNISHES & MIXERS

WARM SPICED
RIM SUGAR (PG 19)

KEY LIME-MINT
RIM SALT (PG 17)

Bourbon

originated as bourbon
eastern Kentucky bourbon County in
1800s bourbon County. While in the early
whiskey production was a center of
industry was

I ♥ bourbon!

BLACK
PEPPER-BACON
RIM SALT
(PG 19)

HERB RIM
SALT (PG 18)

Mint Jul

KEY LIME-MINT RIM SALT

MAKES ½ CUP

Sanding the rim of a glass with salt, sugar, zests, or spices not only adds an element of complementary flavor to a drink, it also serves as a pretty accent—a crown of sparkles topping off the glass. Like jewels, rim salts and sugars can take on a colorful glow depending on the additions to the mix—green herbs, citrus zest, or chili powder. The options are limited only by your imagination. The key is to make sure the combinations enhance the flavor of the cocktail without overpowering it.

1 tablespoon finely chopped fresh mint

2 tablespoons Key lime zest (from 10 Key limes)

½ cup kosher salt

1. Process the mint, zest, and ¼ cup of the salt in a mini food processor until the salt is finely ground, about 10 seconds. Place the mint mixture in a small bowl; stir in remaining ¼ cup salt.

2. Evenly spread the salt mixture on a rimmed baking sheet, and let stand at room temperature until dry, about 2 hours. Store in an airtight container in the refrigerator up to 1 year.

VARIATIONS

Key Lime-Mint Rim Sugar: Substitute ½ cup granulated sugar for the kosher salt. Proceed with recipe as directed. After the sugar mixture stands for 2 hours in Step 2, return sugar mixture to mini food processor, and pulse until finely ground, about 4 times. Store in an airtight container in the refrigerator up to 3 months.

Citrus Rim Salt: Substitute lemon or orange zest (from 2 large lemons or oranges) for the Key lime zest. Omit the mint, if desired. Proceed with the recipe as directed.

Citrus Rim Sugar: Substitute lemon or orange zest (from 2 large lemons or oranges) for the Key lime zest and granulated sugar for the kosher salt. Omit the mint, if desired. Proceed with the recipe as directed. After the sugar mixture stands for 2 hours in Step 2, return the sugar mixture to the mini food processor, and pulse until finely ground, about 4 times. Store in an airtight container in the refrigerator up to 3 months.

HERB RIM SALT

MAKES 1 CUP

Margaritas and mojitos welcome the herbaceous boost of this rim mixture. Try the Herb Rim Sugar variation using mint with your next glass of iced tea or lemonade. *Photograph on pg 16*

½ cup fresh, tender herbs (such as basil, mint, or cilantro)

1 cup coarse kosher salt

Process the herbs and the salt in a food processor until the herbs are finely chopped and the mixture is combined, 4 or 5 times. Store in an airtight container in the refrigerator for up to 5 days.

VARIATIONS

Herb Rim Sugar: Substitute 1 cup granulated sugar for the kosher salt, and proceed with the recipe as directed.

Dried Herb Rim Salt or Sugar: Process 1 tablespoon dried woodsy herbs (such as rosemary, thyme, or sage) in a food processor until finely chopped, 4 or 5 times. Add 1 cup coarse kosher salt or coarse granulated sugar, and pulse until blended, 4 or 5 times. Store in an airtight container at room temperature for up to 6 weeks.

BAR TALK
Salt or No Salt?
Asking for a rim of salt while simultaneously aiming to slake thirst might seem counterintuitive, but the rationale behind its appeal takes a cue from cooking. Salt is thought to stimulate taste receptor cells in the tastebuds and creates a salivary response for a moutwatering effect. In the right dose, salt both balances and enhances flavors. Use it to temper bitter notes while providing balance in sweet and sour combos.

BLACK PEPPER-BACON RIM SALT

MAKES ⅔ CUP

Your Sunday brunch Bloody Mary begs for this rim mixture, but it's equally delicious gracing the rim of a smoky mezcal cocktail or Michelada (page 200). *Photograph on pg 16*

6 bacon slices (8 ounces)

½ cup coarse kosher salt

1 tablespoon black pepper

½ teaspoon celery salt

½ teaspoon lemon zest (from 1 lemon)

¼ teaspoon smoked paprika

1. Cook the bacon in a large nonstick skillet over medium, turning occasionally, until crispy, 12 to 15 minutes. Drain on paper towels. Let cool completely, about 15 minutes.

2. Process the cooled bacon in a food processor until bacon is crumbled and begins to form a paste, about 8 seconds. Add the kosher salt, pepper, celery salt, lemon zest, and paprika, and pulse until just combined, about 10 times. Store in an airtight container in the refrigerator up to 2 weeks.

WARM SPICED RIM SUGAR

MAKES ½ CUP

A perfect blend for garnishing hot buttered rum, a mug of piping spiced cider, or a soothing hot toddy on a blustery day. Think beyond the rim when it comes to these sugar and spice or herb mixes. Many may be used in other ways. This blend, in particular, adds the perfect dose of holiday spice mixed into the Classic Eggnog (page 207). *Photograph on pg 16*

½ cup coarse sugar (such as sanding sugar)

½ teaspoon ground cinnamon

¼ teaspoon kosher salt

¼ teaspoon ground ginger

⅛ teaspoon ground nutmeg

⅛ teaspoon ground cardamom

Stir together all the ingredients in a medium bowl until blended. Store in an airtight container at room temperature up to 1 year.

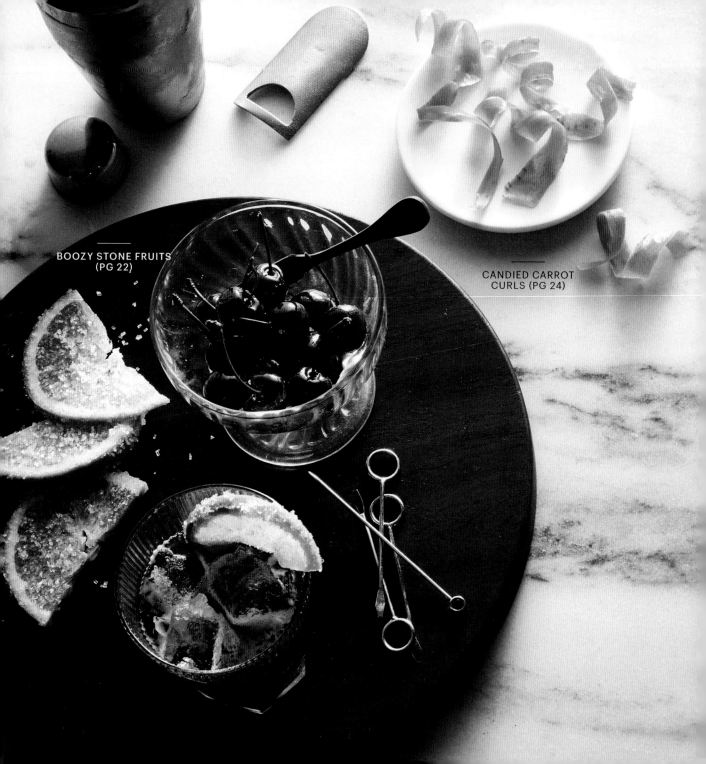

BOOZY STONE FRUITS
(PG 22)

CANDIED CARROT
CURLS (PG 24)

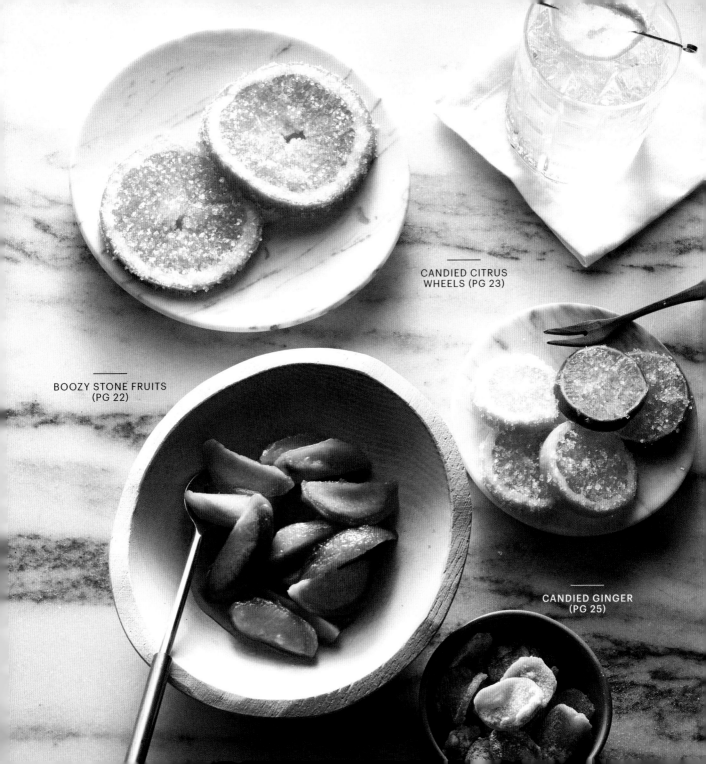

CANDIED CITRUS
WHEELS (PG 23)

BOOZY STONE FRUITS
(PG 22)

CANDIED GINGER
(PG 25)

BOOZY STONE FRUITS

SERVES 30

Allowing fruit to macerate in alcohol changes the texture and enhances the fruit's flavor. A welcome by-product is the fruit-infused spirit that results from the monthlong process, which may also be used in cocktails. *Photograph on pg 21*

1 pound fresh cherries or peaches

1¼ cups granulated sugar

20 to 22 ounces (2½ to 2¾ cups) vodka or bourbon

1. Remove the pits and stems from the cherries, or peel and slice the peaches.

2. In a 1-quart jar with a tight-fitting lid, combine the sugar and 2 cups of the vodka. Cover with the lid, and shake until most of the sugar dissolves, about 1 minute. Remove the jar lid, add the fruit, and top with enough of remaining vodka to cover the fruit and fill the jar. Cover with the jar lid.

3. Store in a cool, dark place for 4 weeks, shaking the jar every other day. Transfer the jar to the refrigerator, and use the fruit within 3 months.

CANDIED CITRUS WHEELS

MAKES 24

Wholly edible, this sweet-tart garnish is pretty and tasty from skin to fruit. A candied orange wheel garnishes the Whiskey Sour (page 142); candied lemon wheels accent Chatham Artillery Punch (page 184) and John Collins (page 141); while the Faux-jito (page 228) gets topped off with a candied lime peel. *Photograph on pg 21*

1 lemon, lime, or orange

1 ounce (2 tablespoons) light corn syrup

Sparkling sugar

Cut the citrus into ¼-inch-thick rounds; discard the seeds. Microwave the corn syrup in a small microwavable bowl on HIGH until warm, 5 to 10 seconds. Using a small brush, coat both sides and edges of the rounds with the warm corn syrup, and sprinkle lightly with the sparkling sugar. Place on a wire rack, and use within 2 hours.

SOUTHERN TWIST

Satsuma Wheels

Look for Southern satsumas, a variety of mandarin orange, to make these candied citrus garnishes.

CANDIED CARROT CURLS

MAKES 15 TO 20 CURLS

This novel cocktail garnish is as tasty as it is beautiful, adding sweetness, texture, and whimsy. Make the curls up to five days ahead, and layer between sheets of wax paper in an airtight container. Store at room temperature. *Photograph on pg 20*

Parchment paper

Vegetable cooking spray

1 or 2 large peeled carrots

8 ounces (1 cup) water

1 cup granulated sugar

Sugar (optional)

1. Preheat the oven to 225°F. Line a baking sheet with the parchment paper, and lightly grease with cooking spray. Remove 15 to 20 long strips from the carrots, using a vegetable peeler. (Strips will get wider as you get close to the core of the carrot.)

2. Bring 1 cup water and 1 cup sugar to a boil in a large, heavy saucepan over medium-high. Add the carrot strips, and reduce the heat to medium-low. Simmer the carrot strips 15 minutes. Drain in a mesh strainer, and cool 5 minutes.

3. Spread the cooked carrot strips 1 inch apart in a single layer on the prepared baking sheet. Bake at 225°F for 30 minutes. As the carrot strips bake, they will begin to look translucent. Remove from the oven. (The strips will be warm but cool enough to handle.)

4. Working quickly, wrap each carrot strip around the handle of a wooden spoon, forming curls. Gently slide off the spoon. Sprinkle with the sugar, if desired. Let the curls stand at room temperature until completely dry, about 30 minutes. Store in an airtight container for up to 3 days.

CANDIED GINGER

MAKES ABOUT 1¼ CUPS

As delicious in a steaming cup of tea as in a bracing Moscow Mule (page 123) or hot toddy, candied ginger may be used in baking too. *Photograph on pg 21*

1 (8-inch) piece fresh ginger, peeled (8 ounces)

20 ounces (2½ cups) water

2 cups superfine sugar

1. Cut the ginger into ⅛-inch-thick slices. Place in a medium saucepan, and add the 2½ cups water. Bring to a boil over medium-high. Cover, reduce the heat to medium-low, and simmer until tender, about 35 minutes.

2. Drain the ginger mixture, reserving the ginger slices and ¼ cup of the cooking liquid. Return the reserved ginger and the cooking liquid to the pan; add 1 cup of the sugar. Bring to a boil over medium-high, stirring often. Reduce the heat to medium-low, and cook, stirring occasionally, until the liquid has almost evaporated and begins to recrystallize, 18 to 20 minutes. Transfer the ginger to a wire rack, and spread to separate individual slices; let cool 2 hours. Toss the ginger slices in the emaining 1 cup sugar. Shake off the excess sugar, and transfer to a wire rack to dry completely, about 1 hour. Store in an airtight container at room temperature up to 2 weeks.

BAR TALK
Candy, Candy, Candy...
Candied and preserved garnishes are to the glass what a pocket square is to a tailored suit. It's a final flourish that makes a cocktail something extra-special. Doubtful you would put a pocket square in your knit polo shirt, likewise you can leave off the fancy garnishes on casual refreshments like a longneck beer or red solo cup brimming with trash can punch.

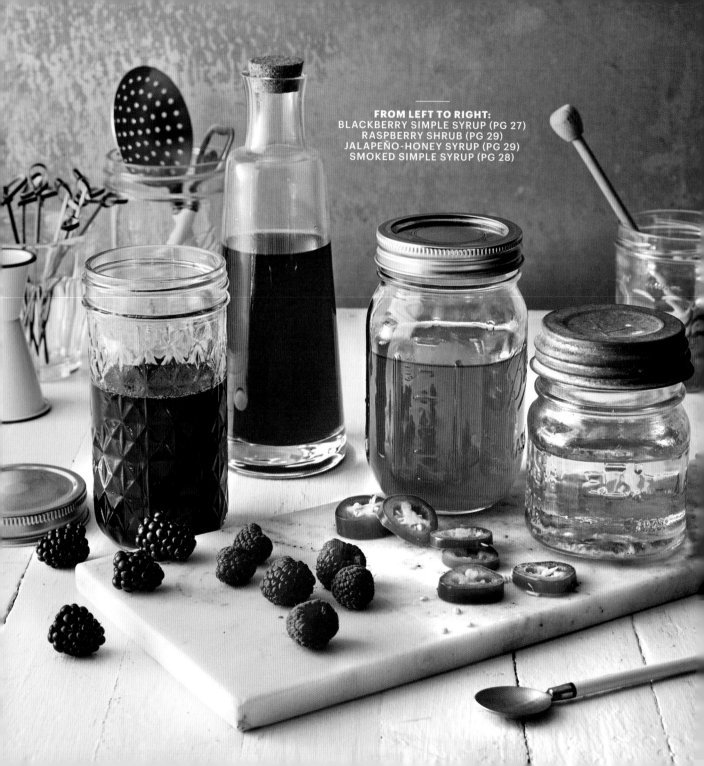

SIMPLE SYRUP

MAKES 8 OUNCES (1 CUP)

It feels like a futile effort trying to dissolve granulated sugar in a cold beverage. Simple syrup to the rescue! It's the ideal sweetener for Southern sweet tea and an array of cocktails that beg for a sweet note. Use the Spicy Simple Syrup variation to add a kick to margaritas or when making the Spiced Stout Cocktail, page 161. Turn to the Herb Simple Syrup with mint for a sublime mojito or sparkling flavored seltzer.

1 cup sugar

8 ounces (1 cup) water

Combine the sugar and the water in a small saucepan. Cook over medium, stirring constantly, until the sugar dissolves. Bring to a boil; reduce to low, and stir until the sugar is dissolved.

VARIATION

Spicy Simple Syrup: Stir ½ teaspoon ground red pepper and ½ teaspoon ground cinnamon into the reduced hot simple syrup. **MAKES 8 OUNCES (1 CUP)**

Herb Simple Syrup: Stir 10 to 12 fresh herb leaves, such as mint, basil, verbena, borage, a 4-inch fennel frond, or 4-inch sprig of wood herbs such as rosemary or thyme into the reduced hot simple syrup. **MAKES 8 OUNCES (1 CUP)**

BLACKBERRY SIMPLE SYRUP

MAKES 12 OUNCES (1½ CUPS)

This delicious syrup is a wonderful way to use summertime's bumper crop of blackberries. Use it to sweeten iced tea, lemonade, or seltzer too.

4 cups (1 pound, 2 ounces) fresh blackberries

1 cup granulated sugar

4 ounces (½ cup) water

Bring all the ingredients to a boil in a medium saucepan over medium-high, stirring often, until the sugar dissolves. Reduce the heat to medium-low, and simmer, stirring occasionally, until the berries are soft and liquid is syrupy, about 10 minutes. Press the mixture through a fine mesh strainer into a jar with a tight-fitting lid, discarding the solids. Cover with the lid, and store in the refrigerator up to 1 week.

SOUTHERN TWIST
Sweet Tea Simple Syrup
Add 2 orange pekoe tea bags to the sugar and water for the Simple Syrup to infuse the syrup with sweet tea flavor.

GARNISHES & MIXERS

SMOKED SIMPLE SYRUP

MAKES 24 OUNCES (3 CUPS)

This adds surprising smoked hickory flavor to cocktails like the Rhum Agricole Daiquiri (page 109) or to bourbon and tequila drinks. It's worth the effort and lasts a month in the fridge. *Photograph on pg 26*

2 cups granulated sugar

16 ounces (2 cups) water

1 cup hickory chips

1. Combine the sugar and water in a large skillet. Simmer over medium, whisking often, until the sugar dissolves. Remove from the heat, and cool completely, about 30 minutes.

2. Pour the syrup into a small metal bowl, and place inside a 9-quart metal steamer insert, leaving ½ inch of space between the rim of the bowl and sides of the steamer insert.

3. Place a single layer of aluminum foil on the bottom of a 9-quart metal steamer. Spread hickory chips evenly over the foil. Heat the steamer over high until the hickory chips begin to smoke, about 6 minutes. Let the chips smoke for 1 minute.

4. Remove the steamer from the heat, and set the steamer insert with the bowl of syrup into the smoking steamer. Double-wrap the top of insert with plastic wrap to cover, and let stand 10 minutes to become infused with the smoke.

5. Carefully uncover the steamer insert, and remove the bowl of syrup, and set aside. Allow the syrup to cool completely, about 40 minutes. Store in an airtight container in the refrigerator up to 1 month.

JALAPEÑO-HONEY SYRUP

MAKES 16 OUNCES (2 CUPS)

This natural sweetener lends honey's unique flavor and a chile pepper kick to cocktails. Try it in place of the simple syrup in a margarita, or stir it into a tequila and soda. *Photograph on pg 26*

8 ounces (1 cup) honey

8 ounces (1 cup) water

1 fresh jalapeño, halved lengthwise

Bring the honey and water to a boil in a medium saucepan over medium-high. Remove from the heat, and add the jalapeño; steep 15 minutes. Remove and discard the jalapeño, and cool the syrup completely, about 30 minutes. Store in an airtight container in the refrigerator for up to 2 weeks.

RASPBERRY SHRUB

MAKES ABOUT 8 OUNCES (ABOUT 1 CUP)

Avoiding high tariffs on imported spirits in England in the middle of the 1600s, smugglers sunk barrels of liquor offshore to recover later when the coast was clear. Seawater often penetrated the barrels. To mask the tainted spirits, bartenders added sweet juices and the shrub was born. Aside from blending in cocktails, shrubs are delicious on their own or mixed with soda water for a sparkling refresher. *Photograph on pg 26*

1 cup fresh raspberries

1 cup granulated sugar

8 ounces (1 cup) apple cider vinegar

1. Place the berries and the sugar in medium bowl; mash with a spoon, and stir to combine. Cover with plastic wrap, and refrigerate until the juice releases from the fruit and a syrup forms. (This may take 5 to 6 hours, or a day.)

2. Pour the syrup through a fine mesh strainer into a glass measuring cup, pressing on the berries to release any juices; discard the berries.

3. Whisk in the vinegar. Transfer to a jar with a tight-fitting lid. Refrigerate, shaking once or twice a day, until the sugar is dissolved, at least 1 week. Store in the refrigerator up to 2 weeks.

GARNISHES & MIXERS

Bitters & Rinses

Intensely flavored concentrates like cocktail bitters, as well as liqueurs and aromatized wines are added to cockails to build flavorful complexity or to develop more nuanced notes. A bitters decanter topped with a dasher delivers the ideal dose of intense aromatic bitters. Droppers do the job too. A small spray bottle or atomizer works wonders for liquids like absinthe or vermouth often used to rinse a glass before a cocktail is poured into it. The fine mist that an atomizer releases coats the glass ever so lightly, so that there is much less waste than you would get from adding the liquid, swirling it to coat the glass, and tossing out the excess.

HOMEMADE DIGESTIVE BITTERS

MAKES 12 OUNCES (1½ CUPS)

Making bitters from scratch allows you to put your personal stamp on cocktails. Change the ratios or ingredients to tweak the flavor. Bitters add uncommon depth to countless cocktails. A few drops mixed into seltzer is an age-old stomach soother thanks to gentian root's purported medicinal properties. The warm spices in this recipe complement aged spirits like bourbon, scotch, or cognac.

¼ cup dried Montmorency cherries)

2 tablespoons dried orange peel

2 tablespoons gentian root chips

2 tablespoons cinchona bark chips

1 teaspoon cinnamon cassia chips

½ teaspoon whole cloves

½ teaspoon wild cherry bark chips

5 green cardamom pods, cracked

2 cinnamon sticks

2 dried juniper berries

1 vanilla bean, split lengthwise

16 ounces (2 cups) high-proof alcohol (over 100 proof) (such as rye bourbon or grain alcohol)

16 ounces (2 cups) water

1 ounce (2 tablespoons) unsulfured molasses

1. Place the first 11 ingredients, the cherries through vanilla bean, in a 1-quart lidded glass jar. Add the alcohol and cover. Store at room temperature in a dark place for 2 weeks, shaking the jar daily.

2. After 2 weeks, strain through a cheesecloth-lined funnel into a clean 1-quart lidded glass jar, reserving solids. Cover and set aside the alcohol mixture. Place reserved solids in a small saucepan. Rinse out the original jar; set aside.

3. Add the 2 cups water to the solids in the saucepan. Bring to a boil over medium-high. Cover, reduce the heat to medium-low, and simmer 10 minutes. Remove from the heat, and let cool completely, about 30 minutes. Transfer the solids mixture to the original jar. Cover, and store both jars at room temperature in a dark place for 1 week, shaking the jar of solids daily.

4. After 1 week, pour the solids mixture through a cheesecloth-lined funnel placed over the jar containing the strained alcohol. Add the molasses. Cover with the lid, and shake well.

5. Store at room temperature for 3 days. Uncover, skim surface, and pour through a cheesecloth-lined funnel into a 2-cup glass measuring cup. Portion into smaller jars, and label. Store at room temperature up to 1 year.

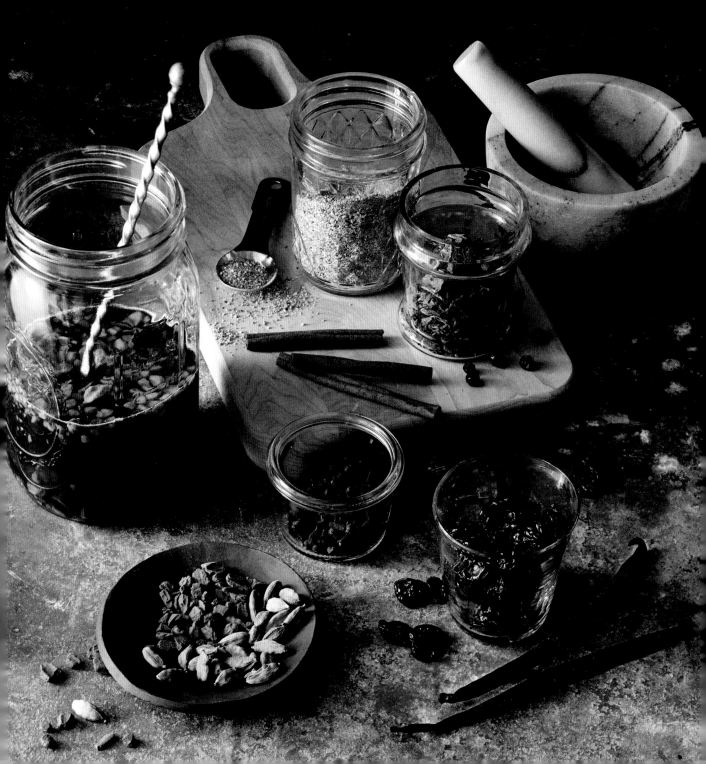

ROASTED PEANUT BITTERS

MAKES 16 OUNCES (2 CUPS)

The nutty peanut flavor in this bitters adds a distinctive Southern note to cola-based cocktails, drinks with aged spirits, or those with jammy fruit flavors. *Photograph not shown*

12 ounces unsalted, dry-roasted shelled peanuts

3 tablespoons cinnamon cassia chips

1 teaspoon dried orange peel

1 teaspoon black peppercorns

8 whole cloves

1 vanilla bean, split lengthwise

1 cinnamon stick

16 ounces (2 cups) high-proof alcohol (over 100 proof) (such as Wild Turkey 101 bourbon)

8 ounces (1 cup) water

½ to 1 ounce (1 to 2 tablespoons) unsulfured molasses

1. Place the peanuts, cinnamon cassia chips, orange peel, peppercorns, cloves, vanilla bean, and cinnamon stick in a 1-quart glass jar with a tight-fitting lid. Add the alcohol, and cover the jar with the lid. Store at room temperature out of direct sunlight for 2 weeks, shaking jar daily.

2. After 2 weeks, pour the liquid through a cheesecloth-lined funnel into a clean 1-quart glass jar with a tight-fitting lid, reserving the solids in funnel. Cover the jar with the lid, and set the strained alcohol aside. Transfer the reserved solids to a small saucepan. Rinse out the original jar, and set aside.

3. Add the 1 cup water to the solids in the saucepan; bring to a boil over high. Cover the saucepan, reduce heat to medium-low, and simmer 10 minutes. Remove from the heat, and let cool completely, about 30 minutes. Transfer the solids mixture to the original jar. Cover the jar with the lid, and store both jars at room temperature out of direct sunlight for 1 week, shaking the jar with the solids mixture daily.

4. After 1 week, pour the solids mixture through a cheesecloth-lined funnel placed over the jar containing the strained alcohol. Add the molasses to the jar; cover with the lid, and shake well.

5. tore at room temperature for 3 days. Uncover the jar, skim the surface of any debris, and pour through a cheesecloth-lined funnel into a 2-cup glass measuring cup. Using a funnel, portion into smaller jars, and label. Store at room temperature for up to 1 year.

SATSUMA-PECAN ORGEAT SYRUP

MAKES 8 OUNCES (1 CUP)

Traditionally made from barley or almonds and orange flower water, this Southern spin on the flavor-infused syrup is a key component of the tiki bar cocktails. It's a bar basic that should not be overlooked thanks to aromatic notes it lends to tropical drinks and even rarely retooled classics like the Brandied Milk Punch (page 206). *Photograph not shown*

3 cups toasted pecans

2¼ cups cane sugar

16 ounces (2 cups) water

2 tablespoons satsuma zest (from 5 satsumas)

1. Process the pecans in a food processor until finely ground, about 5 seconds.

2. Bring the sugar and the water to a boil in a medium saucepan over medium-high, whisking often. Stir in the pecans and the zest. Reduce the heat to medium-low; bring the mixture to a simmer, and cook, stirring often, until fragrant, about 3 minutes.

3. Remove from the heat; cover and let stand at room temperature 3 hours.

4. Press half of the mixture through a fine mesh strainer into a medium bowl, using bottom of a ladle to squeeze out liquid and discarding the solids. Repeat procedure with remaining pecan mixture.

5. Press the pecan mixture through fine mesh strainer lined with 2 layers of cheesecloth into another medium bowl, using ladle to squeeze out the liquid. Store in an airtight container in the refrigerator for up to 3 months.

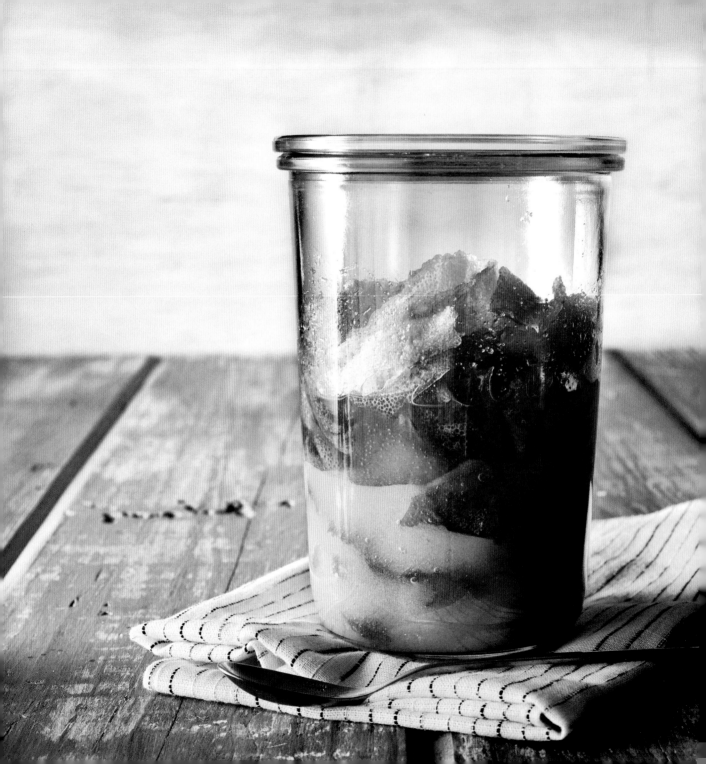

OLEO-SACCHARUM

MAKES 16 OUNCES (2 CUPS)

Literally translated as "oil sugar," this medium for mixologists is made from granulated sugar that has soaked up potent oils from citrus rinds. The infused sugar is then simmered to create a flavor-fortified syrup that is the pure essence of the citrus fruits used. Oleo-Saccharum is a classic component of many tiki bar punches and should be used in place of simple syrup where the flavor-forward notes of citrus are welcome. *Photograph at left*

4 oranges

4 lemons

1 grapefruit

2 cups granulated sugar

8 ounces (1 cup) boiling water

1. Wash and dry the citrus. Remove the zest from the fruit in wide strips using a Y-shaped peeler, leaving the bitter white pith. Place the zest and sugar in a medium bowl, stirring to combine. Cover the mixture, and let stand at room temperature 6 hours to overnight. (The longer the mixture stands the more potent it becomes.)

2. Uncover and pour the boiling water over the mixture, stirring constantly, until sugar dissolves. Cool completely, about 20 minutes. Pour the mixture through a fine-mesh strainer into a lidded jar. Cover, and store in the refrigerator for up to 1 month.

SOUTHERN CHERRY GRENADINE

MAKES 12 OUNCES (1½ CUPS)

Shirley Temples and Jazz Fest Hurricanes wouldn't have that telltale ruby glow without grenadine. This from-scratch version is simple to make and relies on one of the handful of cherry cultivars that do well in some corners of the South. *Photograph not shown*

16 ounces (2 cups) pure Montmorency cherry juice

2 cups granulated sugar

½ ounce (1 tablespoon) fresh lime juice (from 1 lime)

1. Bring the cherry juice and sugar to a boil in a medium saucepan over medium-high, stirring constantly. Cook, stirring constantly, until the sugar is dissolved, about 5 minutes. Remove from the heat; let cool completely, about 30 minutes.

2. Stir in the lime juice. Place in a jar with a tight-fitting lid; cover with the lid. Store in the refrigerator up to 1 month.

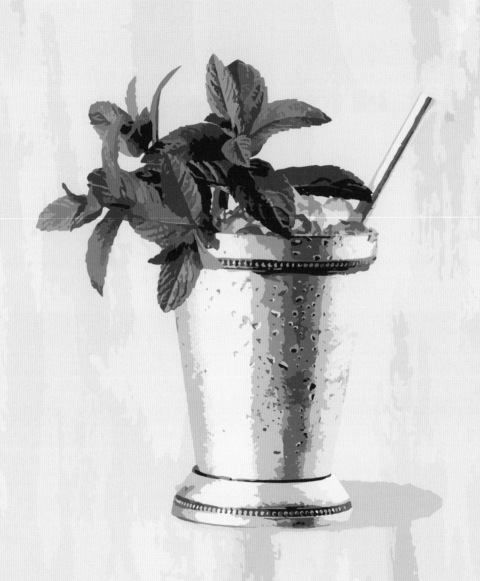

STORIED SOUTHERN SIPS

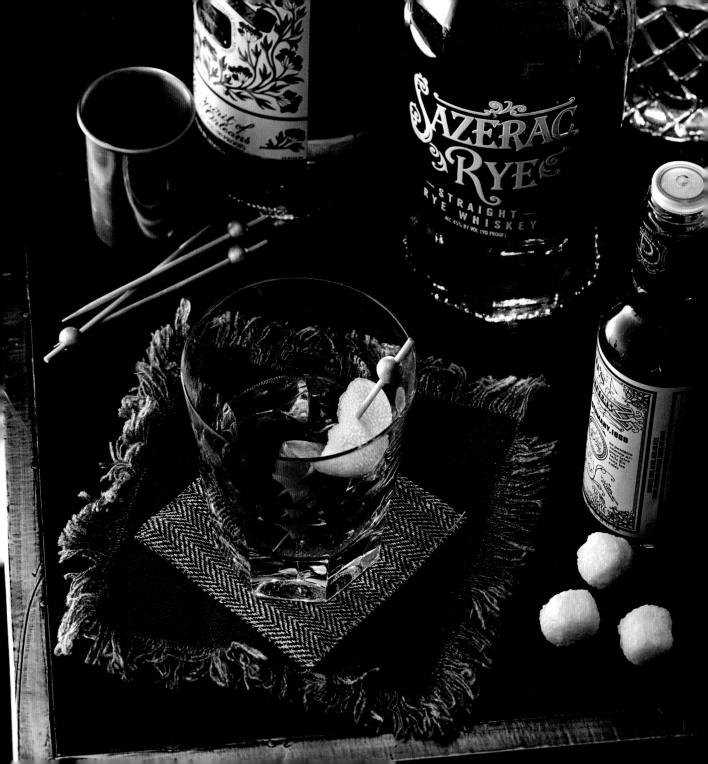

SAZERAC

SERVES 1

New Orleans pharmacist Antoine Peychaud, inventor of the eponymous Peychaud's bitters, created his "curative" at his Royal Street pharmacy in the 1830s. He used an eggcup called a "coquetier" (pronounced "ko-k-tay") to measure the ingredients for what is often touted as the world's first cocktail. The word "cocktail" first appeared in print in a Hudson, New York newspaper in 1806 and referred to any type of spirit mixed with sugar, water, and bitters.

Peychaud's Sazerac stakes claim to first cocktail fame. Peychaud's preferred base spirit was Sazerac de Forge et Fils cognac, his namesake bitters, sugar, and a dash of absinthe. Over time, the drink evolved with a change of available ingredients and tastes. In 1933, the Sazerac Company of New Orleans began bottling rye whiskey, which displaced the brandy in the recipe. Shortly after, Herbsaint, an absinthe liqueur, was introduced, filling in for the banned wormwood-distilled original.

Countless bars serve the Sazerac in New Orleans. Still, the most famous is the Roosevelt Hotel's Sazerac Bar, which has served the cocktail continuously since opening in 1938.

1 cube sugar

3 dashes of Peychaud's bitters

1½ ounces (3 tablespoons) Sazerac rye whiskey or bourbon

¼ ounce (1½ teaspoons) Herbsaint

Garnish: lemon peel strip

Pack an old-fashioned glass with ice. In a second old-fashioned glass, place the sugar cube. Add the bitters and then crush the sugar cube with the back of a spoon or a muddler. Add the rye or bourbon to the glass with the bitters and sugar. Empty the ice from the first glass, add the Herbsaint, and swirl to coat the glass; discard the liquid. Pour the whiskey mixture into the chilled glass accented with the Herbsaint, and garnish as desired.

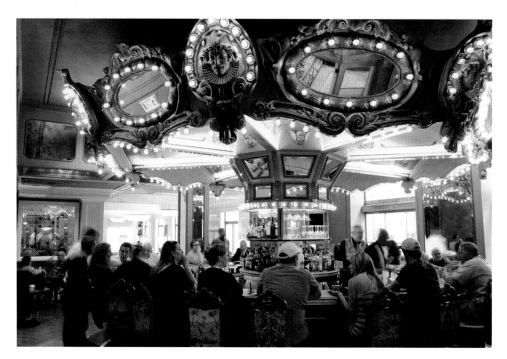

Patrons seated at The Carousel Bar in New Orleans spin whether they're drinking or not.

VIEUX CARRÉ

SERVES 1

The Carousel Bar is truly an only-in-New Orleans institution where patrons can take a seat at a functioning, slow-spinning carousel that was once ridden by authors Tennessee Williams and William Faulkner. In the 1930s, bartender Walter Bergeron first stirred whiskey, cognac, and sweet vermouth with Bénédictine, Angostura, and Peychaud's bitters to create the classic quaff called the Vieux Carré.

Crushed ice

1 ounce (2 tablespoons) rye whiskey

1 ounce (2 tablespoons) cognac

1 ounce (2 tablespoons) sweet vermouth

⅛ ounce (1 teaspoon) Bénédictine liqueur

2 dashes of Peychaud's bitters

2 dashes of Angostura bitters

Fill an 8-ounce glass with crushed ice. Pour the rye whiskey, cognac, sweet vermouth, Bénédictine, Peychaud's bitters, and Angostura bitters into the glass; stir to chill and combine. Serve immediately.

OLD FASHIONED

SERVES 1

Made with bourbon, sugar, Angostura bitters, and an orange twist (or make it fancy with a candied orange wheel and a cherry), the Old Fashioned has been a standard on bar menus from coast to coast since its invention at Kentucky's Pendennis Club. Its sweet-and-smoky depth brightened with a hint of citrus, makes it a 5 o'clock-anywhere favorite to sip and savor.

1 ounce (2 tablespoons) Simple Syrup (page 27)

3 dashes of Homemade Digestive Bitters (page 32) or Angostura bitters

1 Boozy Stone Fruit cherry (page 22)

1 orange Candied Citrus Wheel (page 23)

1½ ounces (3 tablespoons) bourbon

Garnish: orange peel strip

1. Muddle the syrup, bitters, cherry, and orange slice in an old-fashioned glass. After muddling, remove the peel from the orange slice in the glass, and discard. Add enough ice cubes to the glass to cover the mixture, and top with the bourbon; stir to combine.

2. Rub the orange peel strip around the rim of the glass, and squeeze the strip over the top of cocktail to release the oils from the peel. Add the strip to the cocktail, and serve.

BAR TALK
Muddle
Don't skip this step. It's all about infusing a drink with flavor by crushing and mashing ingredients against the sides of the glass or cocktail shaker with the back of a bar spoon to release flavor. A baseball bat-shaped bar tool called a muddler (page 10) may also may be used.

American Whiskey

This whiskey is made from the distillation of grain. American varieties include bourbon, blended whiskey, corn whiskey, rye, and Tennessee whiskey. Bourbon is a mix of at least 51 percent corn combined with other grains made using the sour mash method and then aged in charred oak barrels. Blended whiskeys combine a neutral spirit with at least 20 percent straight whiskey of any variety. Corn whiskey, including moonshine, is clear alcohol made from 80 percent (or more) corn. It is then rested in new barrels. Tennessee whiskey is both a type and protected designation of bourbon that must go through a charcoal filtration process, which yields a mellower-tasting product.

CLASSIC MINT JULEP

SERVE 1

Few cocktails symbolize a region and a storied event the way the mint julep does. Conceived just below the Mason-Dixon Line at the Greenbrier Hotel in Sulphur Springs, West Virginia, the julep took on a life of its own. It became the signature drink of the Kentucky Derby, where more than 100,000 are served each May at Churchill Downs. Served at genteel soirées from Easter to Labor Day, to many it is the classic Southern cocktail. A proper mint julep is comprised of four ingredients: crushed ice, bourbon, simple syrup or powdered sugar, and mint.

3 fresh mint leaves

½ ounce (1 tablespoon) Herb Simple Syrup, using mint (page 27) or 4 teaspoons powdered sugar

1½ ounces (3 tablespoons) bourbon

1 fresh mint sprig

Powdered sugar (optional)

Place the mint leaves and syrup or the powdered sugar in a chilled julep cup. Gently press the leaves against the cup with the back of a spoon to release the herb's flavors. Pack the cup tightly with crushed ice; pour the bourbon over the ice. Insert a straw and a mint sprig and sprinkle the top of the cocktail with powdered sugar, if desired. Serve immediately.

BAR TALK
Why the julep cup?
The classic silver or pewter julep cup is meant to be held by the band at the rim or base to allow a frost to develop on the exterior, which helps keep the drink chilled. Many vintage julep cups started off as trophies before being enlisted into service for Kentucky's famous cocktail. Now you can find glass, copper, and brass julep cups, but the drink somehow tastes better sipped from heirloom silver.

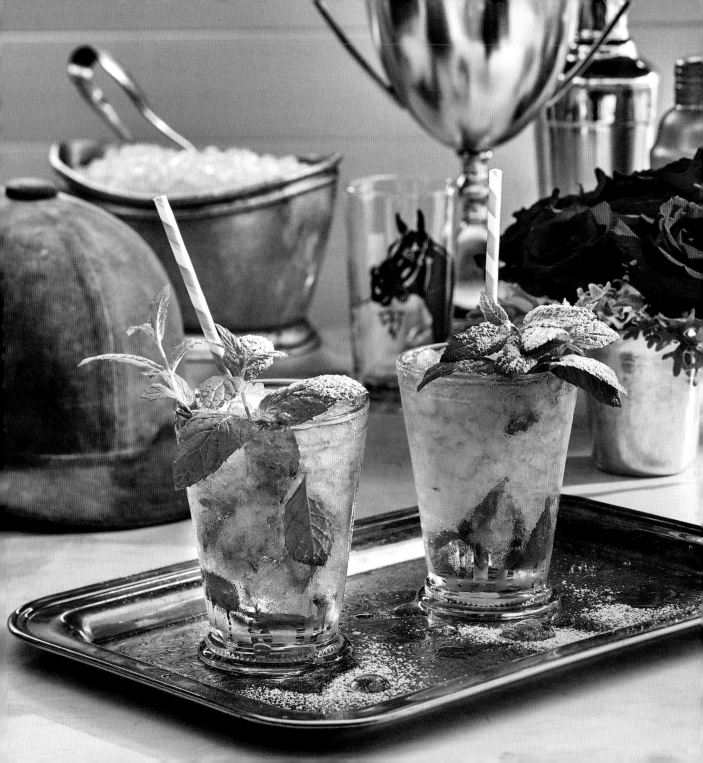

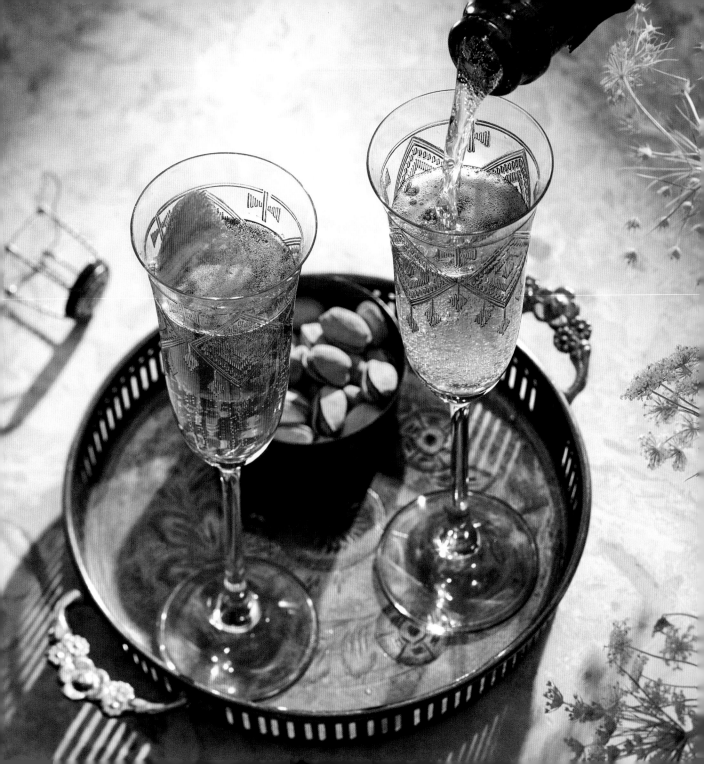

SEELBACH

SERVES 1

The story behind this cocktail was created by Adam Seger, a former restaurant director at Louisville, Kentucky's Seelbach Hotel. Twenty years ago, Seger claimed he uncovered a tattered old recipe in the hotel's basement that dated from pre-Prohibition Days and was said to be the bar's signature cocktail. He made the drink, loved it, and began offering the "historic" cocktail to patrons. Truth is, he made up the entire story to create a namesake cocktail with a provenance that would match the hotel's storied clientele, including F. Scott Fitzgerald among others. Truth or fiction, his ruse was accompanied by one delicious drink.

1 ounce (2 tablespoons) bourbon

½ ounce (1 tablespoon) orange liqueur (such as Triple Sec)

5 dashes of Homemade Digestive Bitters (page 32) or Angostura bitters

5 dashes of Peychaud's bitters

5 ounces (½ cup plus 2 tablespoons) sparkling wine

Garnish: orange peel strip

Fill a mixing glass with ice, and add the bourbon, orange liqueur, and bitters; stir to combine. Strain the mixture into a Champagne flute. Top with the sparkling wine, and garnish as desired.

BAR TALK

ANGOSTURA BITTERS

The recipe for Angostura hasn't changed since 1824, when Johann Gottlieb Benjamin Siegert created his health-boosting formula from foraged herbs in Angostura, Venezuela. It's said to contain over forty ingredients but only 5 people know the actual recipe. His top-secret blend is used in common cocktails such as the Old Fashioned (page 45) and Manhattan (page 152). Beyond the bar, digestive bitters like Angostura are often taken to calm an upset stomach.

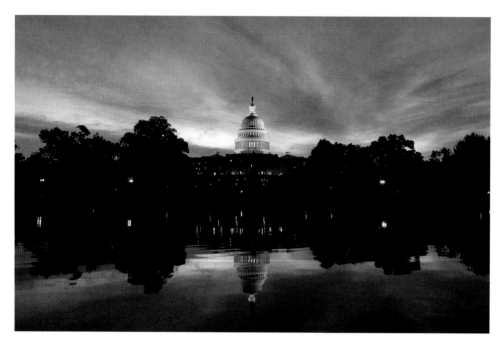

The Capitol rotunda and reflecting pool on the National Mall take on a rosy glow at cocktail hour.

COLONEL JOE RICKEY

SERVES 1

Washington D.C.'s Shoomaker's Saloon is said to be the birthplace of the rickey cocktail, named for Colonel Joe Rickey, a Democratic lobbyist. He was known to stop by daily for his morning pick-me-up: bourbon poured over a lump of ice and topped off with siphoned soda water. Then, his comrade, Colonel Hatch, suggested the bartender add the juice of half a lime to the drink, and with that, the "rickey" was complete. Nowadays, gin rickeys (see variation) predominate, but the original bourbon tipple should not be overlooked. In 2011, the rickey was declared Washington's official native cocktail.

½ lime

3 ounces (1½ tablespoons) bourbon

Soda water

Garnish: lime wedge

Place ice cubes in a highball glass. Squeeze the lime over the ice, and drop it into the glass. Add the bourbon, and stir with a bar spoon. Top off with the soda water, and garnish as desired.

VARIATION

Gin Rickey: Substitute 3 ounces gin for the bourbon.

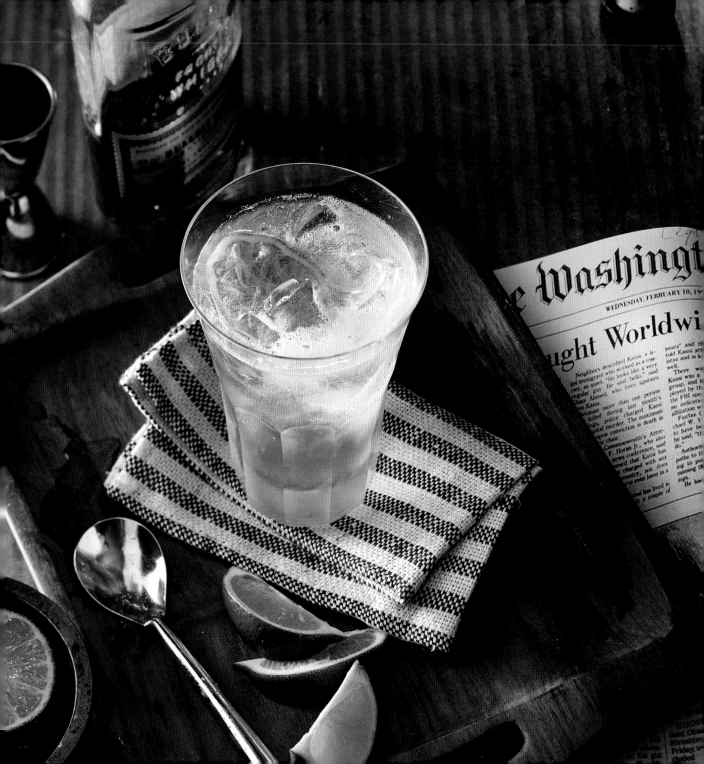

Moonshine

This class of potent, clear, unaged liquor gets its name from the nighttime hours during which early settlers produced the booze to avoid detection and thus taxation in colonial days. This high-proof, unaged corn whiskey, also called firewater, hooch, and white lightning, among other creative monikers, was initially produced in homemade stills. However, today it is commercially available straight, flavored, or mixed into bottled and canned cocktails.

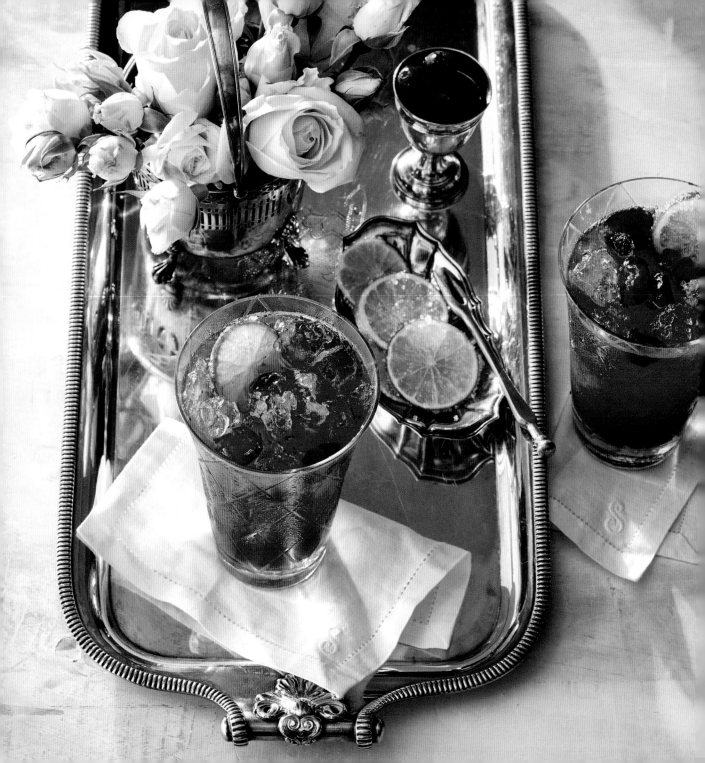

A burst of red blooms surrounds the wrap-around porch of this Alabama home. Roses grow best with full sun, heat, and moist soil—making the South an ideal host.

THORNLESS ROSE

SERVES 1

This sublime sip is worth adding to your bar repertoire. It was featured in a 1950s ad for a cranberry drink and is a pleasing mix of sweet and sour spiked with Southern Comfort, a whiskey-based, fruit-and-spice liqueur that gives it a comforting kick without much bite.

¼ cup fresh cranberries

1½ tablespoons granulated sugar

2 ounces (¼ cup) fresh lime juice (from 2 limes)

2 ounces (¼ cup) Southern Comfort

Garnish: lime Candied Citrus Wheel (page 23)

1. Muddle the cranberries, sugar, and lime juice in a mixing glass until the cranberries are broken down and have released their juices.

2. Pour the cranberry mixture into a highball glass filled with ice cubes. Add the Southern Comfort, and stir to combine. Garnish as desired.

BRANDY CRUSTA

SERVES 1

In the 1850s, a New Orleans bartender named Joseph Santini created this cocktail that gets its name from its crusty sugared rim. The drink inspired other classic rimmed cocktails, such as the Margarita (page 120).

Lemon wedge

Citrus Rim Sugar, using orange zest (page 17) or granulated sugar

½ ounce (1 tablespoon) fresh lemon juice

2 ounces (¼ cup) cognac

¼ ounce (1½ teaspoons) orange liqueur (such as Triple Sec)

½ ounce (1 tablespoon) maraschino liqueur

2 dashes of Homemade Digestive Bitters (page 32) or Angostura bitters

Garnish: lemon peel strip

1. Rub the rim of a coupe glass with the lemon wedge, and invert the glass onto a shallow plate covered with a thin layer of the rim sugar. Twist the glass to coat the rim.

2. Add the lemon juice, cognac, Triple Sec, maraschino liqueur, and bitters to an ice-filled cocktail shaker. Cover with the lid, and shake vigorously until thoroughly chilled, about 30 seconds. Strain into the prepared glass. Garnish as desired.

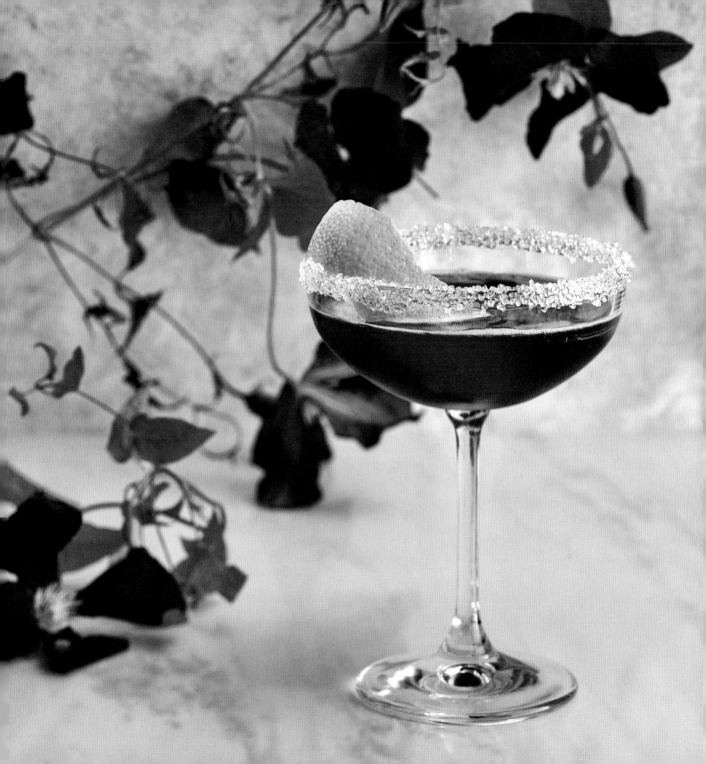

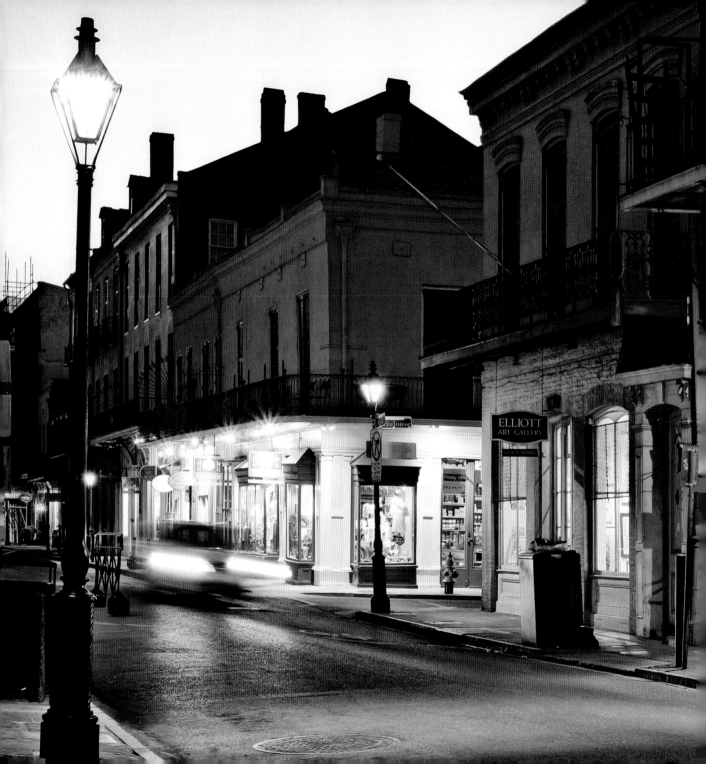

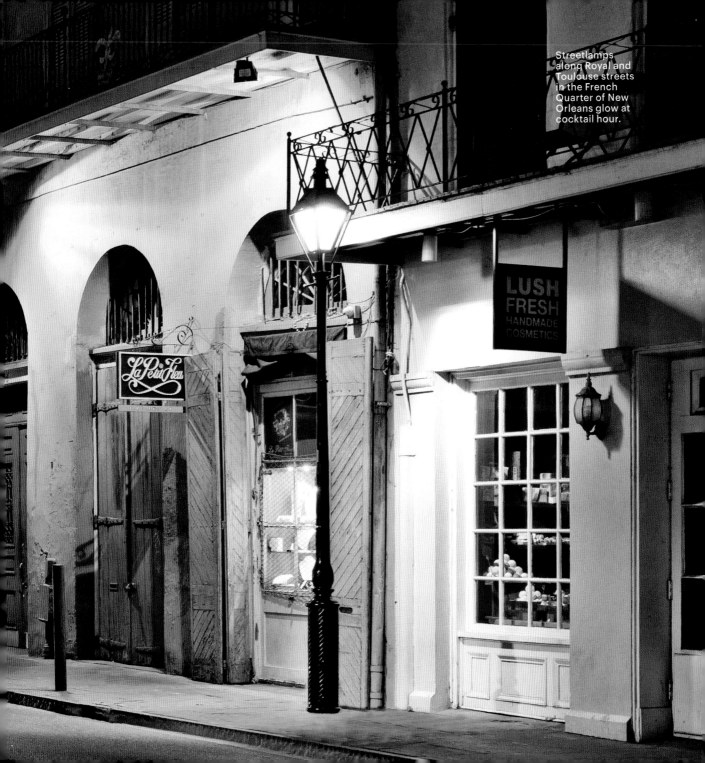

Streetlamps along Royal and Toulouse streets in the French Quarter of New Orleans glow at cocktail hour.

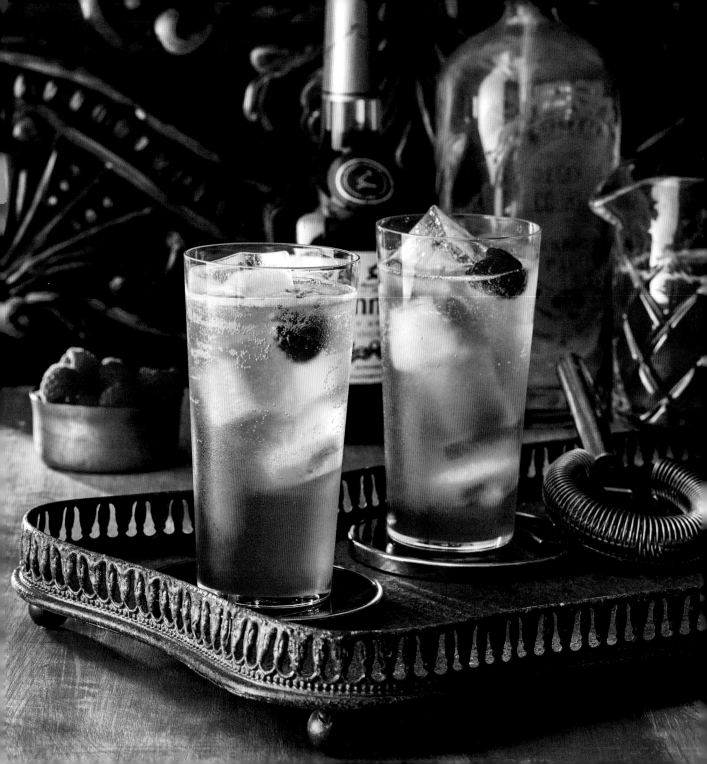

ROFFIGNAC

SERVES 1

The Roffignac was named for Count Louis Philippe Joseph de Roffignac, the last French-born mayor of New Orleans who served in the 1820s. He's credited for cobbling the rues and avenues of the city with cobblestones and illuminating them with gaslights during his tenure. The origin of his namesake drink is a mystery. However, it was the signature cocktail at Maylie's, a Creole restaurant near Poydras Market that endured for 110 years until it closed its doors in the late 1980s.

2½ ounces (5 tablespoons) Raspberry Shrub (page 29)

1½ ounces (3 tablespoons) cognac or whiskey

½ ounce (1 tablespoon) Simple Syrup (page 27)

2 ounces (¼ cup) seltzer water

Garnish: raspberries

Combine the shrub, cognac or whiskey, and syrup in an ice-filled cocktail shaker. Cover with the lid, and shake vigorously until thoroughly chilled, about 30 seconds. Strain the mixture into a highball glass filled with ice cubes, and top with the seltzer water; stir gently. Garnish as desired and serve immediately.

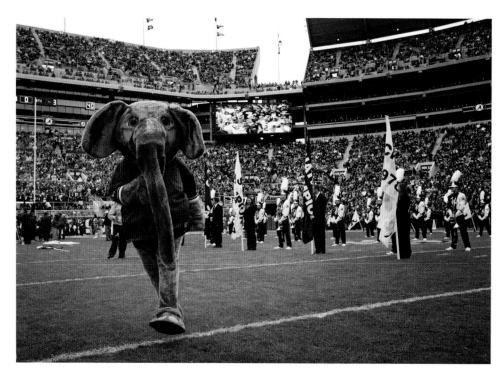

The sea of crimson and houndstooth in this stadium leaves little doubt what campus you are on if you hadn't already noticed the University of Alabama's Million Dollar Band on the field.

ALABAMA SLAMMER

SERVES 1

Many red solo cups may brim with Yellowhammer (page 77) cocktails on game days in Tuscaloosa, but this 1960s highball is another enduring fan favorite. Use bourbon in place of the Southern Comfort and grenadine for the sloe gin (see page 91) if you wish.

Citrus Rim Salt, using lemon zest (page 17)

1 ounce (2 tablespoons) Southern Comfort

1 ounce (2 tablespoons) amaretto

½ ounce (1 tablespoon) sloe gin

3 ounces (6 tablespoons) fresh orange juice (from 1 orange)

½ ounce (1 tablespoon) fresh lemon juice (from 1 lemon)

Garnish: orange wedge and maraschino cherry

Rim a highball glass with the rim salt; fill a glass with ice. Combine the Southern Comfort, amaretto, sloe gin, and orange and lemon juices in an ice-filled cocktail shaker. Cover with the lid, and shake vigorously until thoroughly chilled, about 20 seconds; strain into the prepared glass. Garnish as desired.

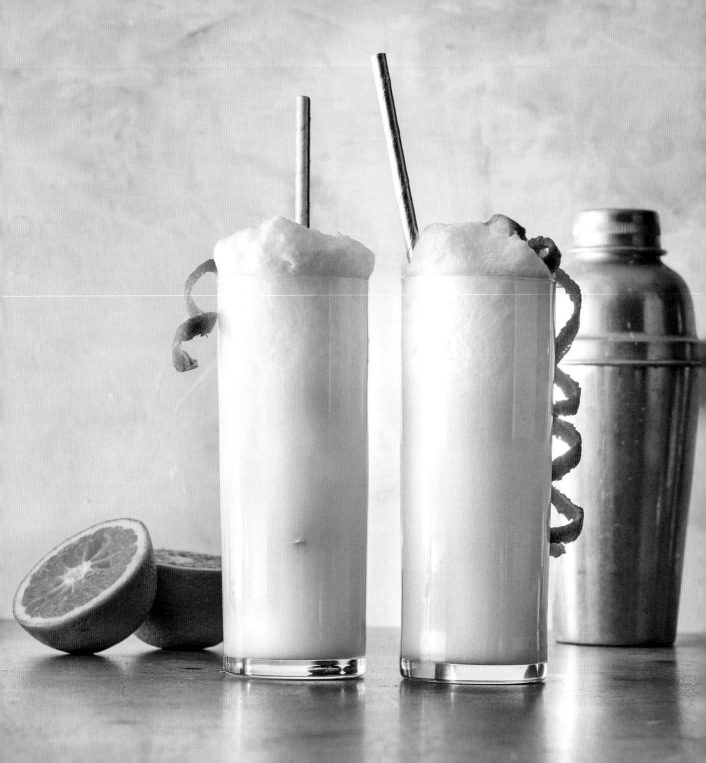

RAMOS GIN FIZZ

SERVES 2

Don't let the raft of egg-white foam deter you from ordering up this famous quenching quaff created by New Orleans' bartender Henry C. Ramos. It is tart, refreshing, and said to be the king of hangover cures.

4 teaspoons superfine granulated sugar

¼ teaspoon orange flower water

¾ ounce (1½ tablespoons) lemon juice

1 extra-large pasteurized egg white

1 ounce (2 tablespoons) heavy cream

⅛ teaspoon vanilla extract

2 ounces (¼ cup) gin

Club soda

Garnish: orange twists

Process the first 7 ingredients in a blender until frothy, about 1 minute. Pour the mixture over crushed ice in a cocktail shaker. Cover with the lid, and shake vigorously until thoroughly chilled, about 30 seconds. Strain the drink into 2 glasses. Top off each glass with the club soda and garnish as desired.

BAR TALK

Orange Flower Water

A drop of orange flower (or orange blossom) water adds a welcome floral note to cocktails like this one. It is an aromatic byproduct of the distillation of fresh bitter-orange blossoms that is often used in Mediterranean and Middle Eastern cooking. Add a few drops to plain seltzer water, or try chilled and spritzed on the neck or wrist for a refreshing pick-me-up on balmy days.

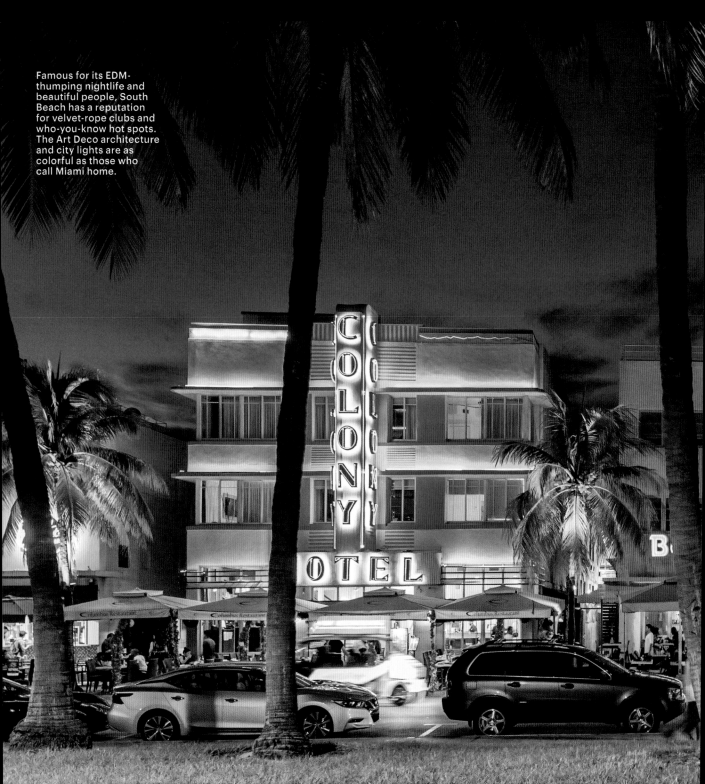

Famous for its EDM-thumping nightlife and beautiful people, South Beach has a reputation for velvet-rope clubs and who-you-know hot spots. The Art Deco architecture and city lights are as colorful as those who call Miami home.

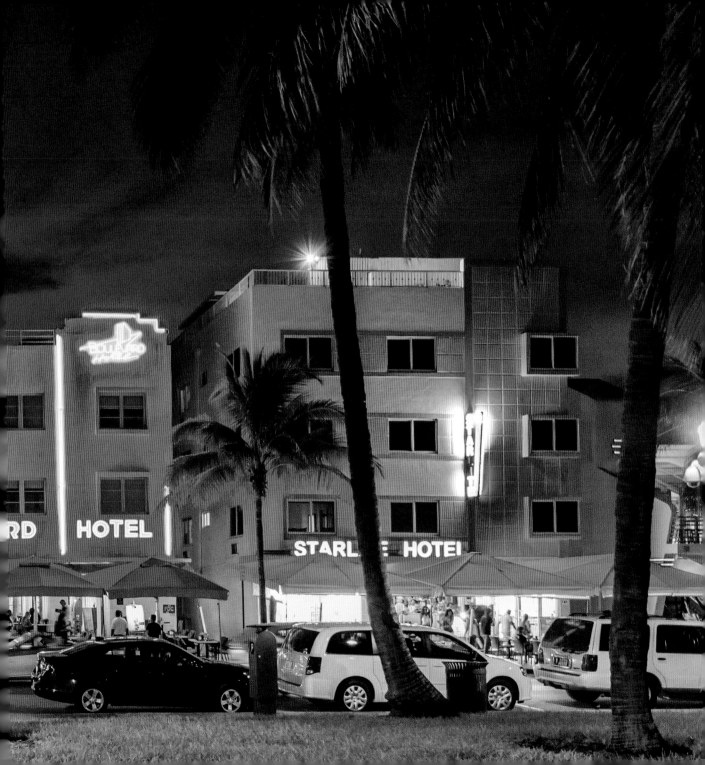

SEX ON THE BEACH

SERVES 1

Peach schnapps was introduced in the late 1980s, and bartenders began incorporating the sour fruit brandy or eau de vie into cocktails. The origin story goes that a bartender at Confetti's Bar in South Florida entered a contest that the schnapps distributor was promoting to see who could sell the most of the product. He named his winning recipe "Sex on the Beach" to entice the throngs of Spring Breakers to order it and thus tilt the win in his favor.

1½ ounces (3 tablespoons) citrus-infused vodka

1½ ounces (3 tablespoons) cranberry juice

1½ ounces (3 tablespoons) orange juice

½ ounce (1 tablespoon) peach schnapps

Garnish: orange Candied Citrus Wheel (page 23)

Combine the vodka, cranberry juice, orange juice, and schnapps in an ice-filled cocktail shaker. Cover with the lid, and shake vigorously until thoroughly chilled, about 30 seconds. Strain the drink into an ice-filled highball glass, and garnish as desired.

SOUTH BEACH COSMO

SERVES 1

The origin of the cosmo, like many spirited drinks, is hazy. It was a hugely popular drink on the 1980s nightclub scene and a favorite of Carrie Bradshaw in "Sex and the City." Southern bartender Cheryl Cook ("The Martini Queen of South Beach") is credited with giving the martini an update with feminine appeal. Her blushing blend of citrus-infused vodka, lime juice, Triple Sec, and a splash of cranberry juice was all the rage until the next craft cocktail displaced it from the trendy list. Popular or passé, it remains a refreshingly sippable cocktail.

1½ ounces (3 tablespoons) citrus-infused vodka

1 ounce (2 tablespoons) Triple Sec

½ ounce (1 tablespoon) freshly squeezed lime juice

Splash of cranberry juice

Garnish: lime wheel or twist

Combine the vodka, Triple Sec, lime juice, and cranberry juice in an ice-filled cocktail shaker. Cover with the lid, and shake vigorously, about 30 seconds. Strain into a chilled martini glass. Garnish as desired.

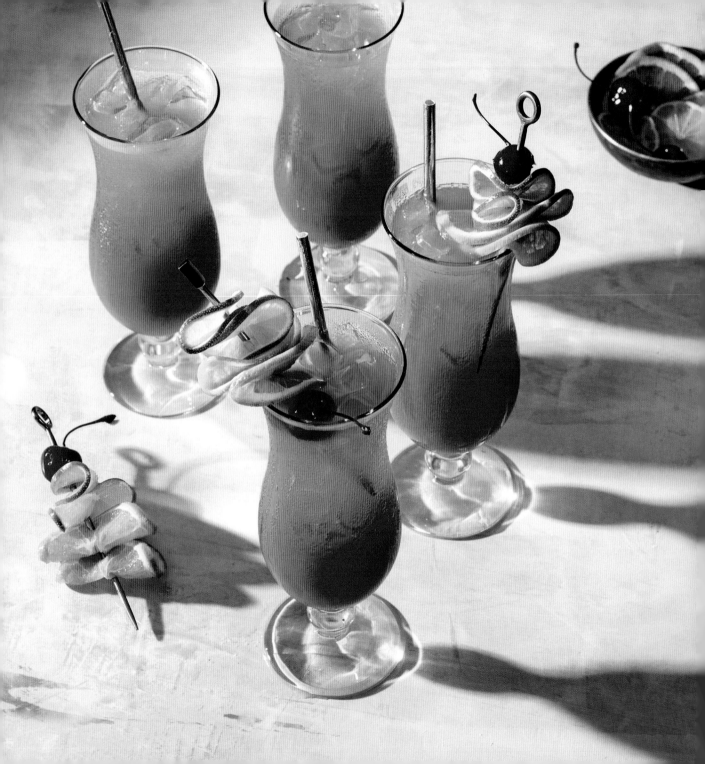

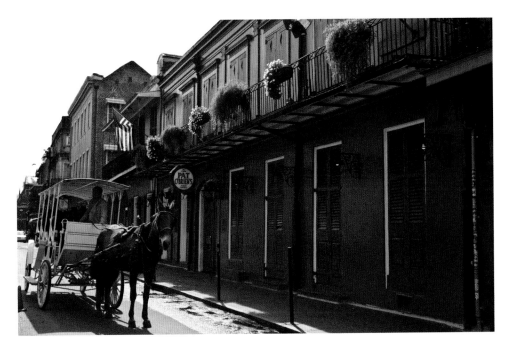

Since 1933, Pat O'Brien's has been quenching thirsts in the French Quarter.

73

HURRICANE

SERVES 1

This fruity concoction packs a hurricane's punch with a mix of light and dark rums. Bartenders at Pat O'Brien's in New Orleans created the drink to plow through the excess rum that a distributor forced them to buy in order to get the select booze they wanted. The result became a high-proof hit!

2 ounces (¼ cup) each light rum and dark rum

2 ounces (¼ cup) passion fruit juice

1 ounce (2 tablespoons) fresh orange juice (from 1 orange)

¾ ounce (1½ tablespoons) fresh lime juice (from 1 lime)

½ ounce (1 tablespoon) Simple Syrup (page 27)

½ ounce (1 tablespoon) Southern Cherry Grenadine (page 37) or store-bought grenadine

Garnish: maraschino cherry and range slice

Combine the rums, passion fruit juice, orange and lime juices, syrup, and grenadine in an ice-filled cocktail shaker. Cover with the lid, and shake vigorously until chilled, about 20 seconds. Strain into a hurricane glass filled halfway with ice. Garnish as desired.

RUM RUNNER

SERVES 1

This Key West cocktail was born at Holiday Isle Tiki Bar in Islamorada, Florida and named after the bootleggers who smuggled in rum during Prohibition days, and then continued long afterward to avoid taxes.

1 ounce (2 tablespoons) fresh orange juice

1 ounce (2 tablespoons) pineapple juice

1 ounce (2 tablespoons) light rum

1 ounce (2 tablespoons) dark rum

½ ounce (1 tablespoon) blackberry liqueur

½ ounce (1 tablespoon) banana liqueur

½ ounce (1 tablespoon) Southern Cherry Grenadine (page 37) or store-bought grenadine

1 cup ice cubes

Garnish: fresh pineapple slice and orange twist

Process the orange and pineapple juices, light and dark rums, blackberry and banana liqueurs, Southern Cherry Grenadine, and ice cubes in a blender until slushy, about 30 seconds. Pour into a hurricane glass, and garnish as desired.

BAR TALK

To Freeze or Not to Freeze...

The popularity of frozen cocktails soared when Americans vacationed in Cuba and the Caribbean during Prohibition, where they sipped daiquiris and frozen mojitos in the tropical heat. Order a drink "frozen" or "on the rocks" to suit your fancy, but not because there are hard and fast rules.

BAMA BREEZE

SERVES 1

At LuLu's in Gulf Shores, Alabama, Lucy Buffet serves up Bama Breeze cocktails as a nod to her famous brother Jimmy's wistful song of the same name. His song is a serenade to the juke joints and funky beach bars along the Gulf Coast frequented by locals and tourists alike. This recipe is inspired by Buffet's cocktail creation.

3 ounces (¼ cup plus 2 tablespoons) cran-cherry juice

2 ounces (¼ cup) Absolut Citron vodka

1 ounce (2 tablespoons) coconut rum

1½ ounces (3 tablespoons) fresh lime juice (from 1 lime)

½ ounce (1 tablespoon) Simple Syrup (page 27)

Garnish: lime wedges and Luxardo cherry

Fill a highball glass with crushed ice. Add the cran-cherry juice, vodka, rum, lime juice, and syrup; stir to chill and combine. Garnish as desired.

YELLOWHAMMER

SERVES 1

Don't look for a "Gallettes Bar" sign near the towering Bryant-Denny Stadium in Tuscaloosa, Alabama, because there hasn't been one since the bar opened in 1976. The long line of people queued up at a nondescript red brick building just down the street is your best clue. The line moves fast at the famous watering hole with its row of beverage dispensers bubbling with this quenching game-day elixir. Be safe and sip this spin on their closely-guarded recipe slowly.

Citrus Rim Sugar, using orange zest (page 17)

1½ ounces (3 tablespoons) light rum

1½ ounces (3 tablespoons) vodka

1 ounce (2 tablespoons) amaretto

4 ounces (½ cup) pineapple juice

2 ounces (¼ cup) fresh orange juice (from 1 orange)

Garnish: maraschino cherries and orange slice

Rim a highball glass with the rim sugar; fill a highball glass with ice. Stir together the rum, vodka, amaretto, pineapple and orange juices in a mixing glass; pour over the ice in the prepared glass. Garnish as desired.

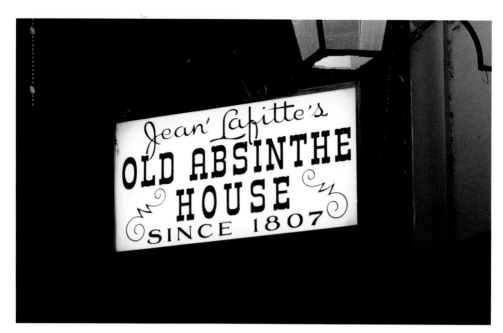

ABSINTHE FRAPPÉ

SERVES 1

In the late 1800s, Cayetano Ferrer, a bartender at The Absinthe Room (later renamed Old Absinthe House) in the Big Easy, invented this verdant anise-flavored refresher. Until absinthe was banned in the United States in 1912, the bar continued to churn out frappés to an appreciative clientele, including notable figures like Mark Twain, Franklin D. Roosevelt, Oscar Wilde, and Frank Sinatra.

6 fresh mint leaves

1½ ounces (3 tablespoons) absinthe

½ ounce (1 tablespoon) Simple Syrup (page 27)

2 ounces (¼ cup) seltzer water

Garnish: fresh mint leaves

1. Muddle the mint in a cocktail shaker. Fill the shaker halfway with ice cubes and add the absinthe and syrup to the shaker. Cover with the lid, and shake vigorously until thoroughly chilled, about 30 seconds.

2. Strain the mixture into a Collins glass filled with crushed ice; top with the seltzer water, and stir gently. Garnish as desired and serve immediately.

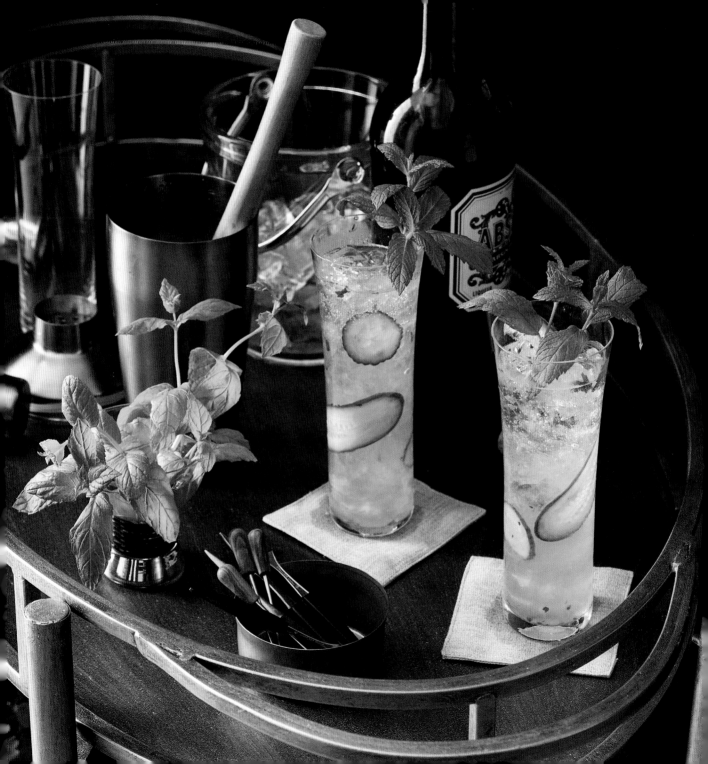

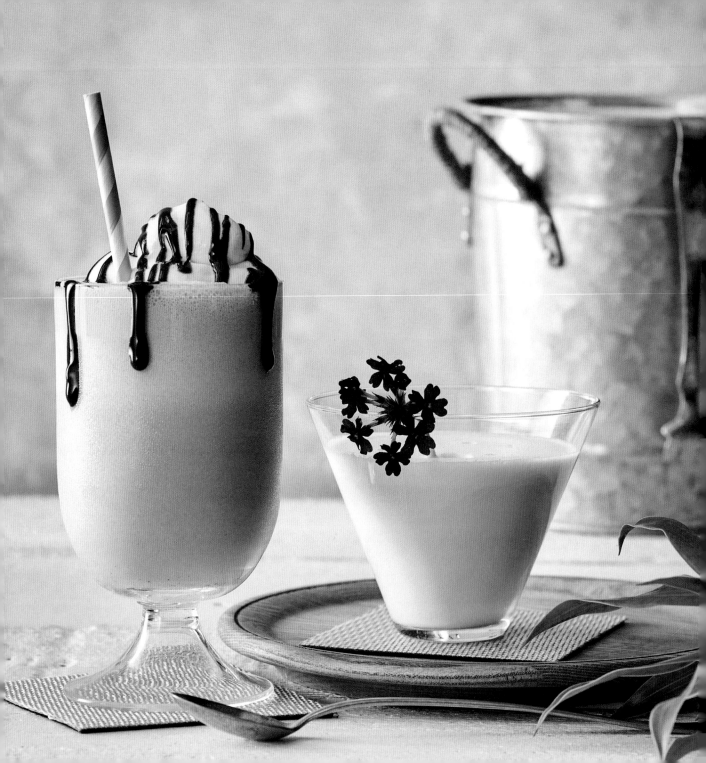

REDNECK RIVIERA BUSHWACKER

SERVES 1

Enjoyed summer or winter, this rum-infused milkshake from the Flora-Bama Lounge is knee-buckling delicious. Referred to as "the last great roadhouse," the bar's official address is Perdido Key, Florida, even though the building sits on the state line dividing Florida and Alabama. Locals refer to the dive simply as "Bama Bar."

1½ ounces (3 tablespoons) white rum

1 ounce (2 tablespoons) coconut rum

1 ounce (2 tablespoons) Kahlúa

1 ounce (2 tablespoons) crème de cacao

1 scoop vanilla bean ice cream

1 cup ice

Garnish: whipped cream, chocolate syrup, and Boozy Stone Fruit cherry (page 22)

Process the white and coconut rums, Kahlúa, crème de cacao, ice cream, and ice in a blender until smooth. Pour the mixture into a hurricane glass, and garnish as desired. Serve with a straw and an iced tea spoon.

GRASSHOPPER

SERVES 1

This creamy drink gets its seafoam-green tinge from green crème de menthe. Created by Philip Guichet, owner of Tujagues in the French Quarter of New Orleans, the liqueur was a popular, mid-century after-dinner drink.

1 ounce (2 tablespoons) green crème de menthe

1 ounce (2 tablespoons) white crème de cacao

¾ ounce (1½ tablespoons) heavy cream

½ cup crushed ice

Combine all the ingredients in a cocktail shaker. Cover with the lid, and shake vigorously until thoroughly chilled, about 10 seconds. Strain the drink into a martini glass.

CHAPTER 3

CLASSIC & CRAFT COCKTAILS

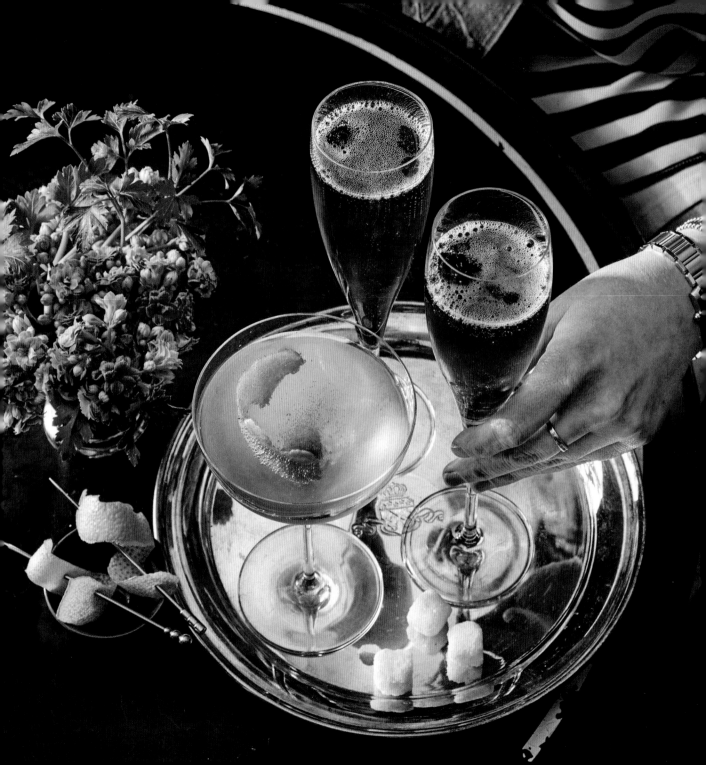

CHAMPAGNE COCKTAIL

SERVES 1

One of the earliest references to this cocktail is in the Jerry Thomas *Bartender Guide* of 1862. Considered the "Father of American Mixology," Thomas did not include any brandy in his Champagne Cocktail, so we've made it optional here. Order one nowadays and it most likely will include it.

Sugar cube

2 to 3 dashes Homemade Digestive Bitters (page 32) or Angostura bitters

½ ounce (1 tablespoon) cognac or brandy (optional)

4 ounces (¼ cup) Champagne

Garnish: lemon twist

Place a sugar cube in the bottom of a coupe glass. Sprinkle the bitters, and cognac if using, on the sugar cube. Slowly top off with the Champagne and garnish as desired.

KIR ROYALE

SERVES 1

A delicate glass, bubbling Champagne, and a rosy elixir combine in this genteel cocktail reminiscent of an evening sunset. The classic Kir came to be in the middle of the 20th century when the mayor of Dijon, France—Canon Felix Kir—mixed the region's white burgundy with its beloved black currant liqueur, crème de cassis. The Kir Royale ups the festive ante of the original by swapping the white wine for Champagne's tiny bubbles. Find a big-batch Kir Imperial on page (171).

½ ounce (1 tablespoon) crème de cassis

6 ounces (¾ cup) sparkling white wine or Champagne

Garnish: blackberries

Pour the crème de cassis in the bottom of a Champagne flute and slowly top it off with the sparkling wine or Champagne. Garnish as desired.

VARIATION

Kir: Use a dry white wine in place of the Champagne for a classic Kir.

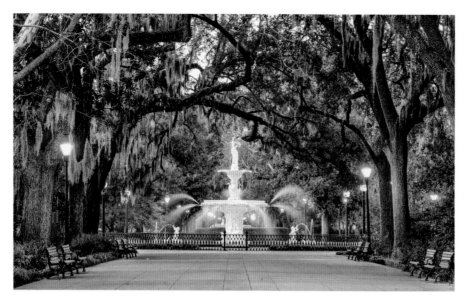

The arching spray of Savannah's Forsyth Park fountain harmonizes with the dripping Spanish moss.

SAVANNAH SUPPRESSOR

SERVES 1

Suppressors are a class of low-ABV cocktails created as an alternative to the punch-you-in-the-face potent cocktails that abound. This one is inspired by the "Frutteto Fizz" that was served at The Florence in Savannah, Georgia (an establishment that is sadly no longer). Floral liqueur and bitters truly blossom in this refreshing mix of sparkling wine and dry vermouth.

1 ounce (2 tablespoons) blanc vermouth

1 ounce (2 tablespoons) elderflower liqueur (such as St-Germain)

2 dashes chamomile bitters (such as 18.21)

1½ ounces (3 tablespoons) sparkling wine

Lemon peel strip

Combine the vermouth, elderflower liqueur, and chamomile bitters in an ice-filled cocktail shaker. Cover with lid, and shake vigorously until chilled, about 30 seconds. Strain into a coupe glass. Top with sparkling wine. Garnish as desired.

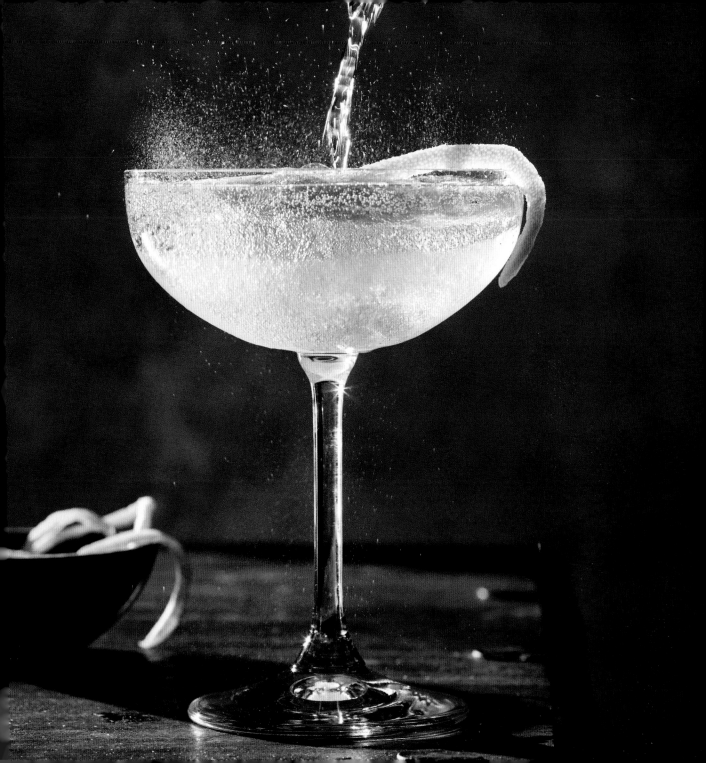

MIMOSA

SERVES 1

The mimosa shares its name with an invasive tree native to Asia that French botanist Andre Michaux planted in his Charleston, South Carolina garden in the late 1700s. In no time, it became a veritable kudzu of trees in the South. Equally pervasive, the mimosa cocktail is a Southern brunch standard. Surprisingly, a New Jersey newspaper first mentioned mimosas being poured at The Shandy Pub at Point Pleasant Beach "for those who can't take the rough stuff early in the day." For over half a century, the sparkling citrus cocktail has shared the brunch spotlight with the bloody Mary with no sign of waning popularity.

3 ounces (¼ cup) freshly squeezed orange juice, chilled

3 ounces (about ⅓ cup) Brut Champagne

Orange slice (optional)

Pour equal parts of chilled fresh orange juice and Champagne into a Champagne flute. Garnish as desired.

BELLINI

SERVES 1

Harry's Bar in Venice is credited with the 1931 invention of the Bellini, named for Venetian Renaissance painter Giovanni Bellini. Fresh ripe peaches are hand-squeezed to extract their sweet juices, which get blended with chilled prosecco for a glass of sparkling deliciousness reminiscent of summertime in the South.

2 ounces (¼ cup) chilled peach nectar

4 ounces (½ cup) chilled prosecco or sparkling white wine

Garnish: Boozy Stone Fruit peach (page 22) slice or fresh peach slice and mint sprigs

Pour the peach nectar into a Champagne flute or wine glass and top off with sparkling wine. Garnish as desired.

VARIATION

Basil Bellini: Drop in basil leaf that you've clapped between palms. This cupboard essential pairs well with fruits, making it a natural complement to the peach puree in this celebratory brunch beverage.

Gin

A clear botanical-flavored spirit with dominant juniper notes, gin is almost exclusively blended into cocktails rather than served neat or on the rocks. Bottles labeled dry gin, London gin, or London dry gin are neutral grain spirits distilled with juniper berries and proprietary botanicals with no sweeteners or colorings. The result is clear, potent liquor with a minimum of 70% ABV. Navy-strength gin (and rum) has a minimum ABV of 57%. Old Tom gin and Dutch jenever have less-pronounced juniper notes and softer finishes. Bottles labeled distilled gin or simply gin must be a minimum of 40% ABV but can include artificial colors, additives, flavorings, or sweeteners. In these, the classic juniper flavor isn't necessarily evident. Finally, sloe gin isn't a liquor but a gin-based liqueur made from the plum-like fruit of the sloe plant (also called blackthorn).

MARTINI

SERVES 1

John D. Rockefeller was said to be a fan of a glass of vermouth-kissed gin at Manhattan's Knickerbocker Hotel. Just as iced tea comes sweetened in the South, unless you request otherwise, a martini is made of gin. Be sure to request a "vodka martini" if that's your fancy.

1½ ounces (3 tablespoons) vermouth

½ cup (4 ounces) dry gin

Garnish: large pimiento-stuffed Spanish olive and cocktail onion

1. Fill a cocktail shaker with ice; add vermouth. Cover with the lid, and shake until thoroughly chilled. Strain the vermouth into a chilled martini glass. Swirl it around to coat the glass. Discard the vermouth.

2. Add the gin to the ice in the shaker and cover with the lid; shake 30 seconds. Pour into the martini glass. Garnish as desired.

VARIATION

Dirty Martini: Add 3 tablespoons olive brine from the jar to the gin or vodka in the ice-filled cocktail shaker before shaking and straining into the prepared glass.

ALASKA COCKTAIL

SERVES 1

This golden elixir first appeared in *Straub's Manual of Mixed Drinks* published in 1913 using Old Tom gin (see page 91). The Brits served up a revised recipe for the cocktail in *The Savoy Cocktail Book* of 1930, trading sweet Old Tom for London Dry gin. *Photograph not shown*

2 ounces Old Tom gin (such as Copper & Kings)

¾ ounce yellow Chartreuse

1 dash Homemade Digestive Bitters (page 32) or orange Angostura bitters

Garnish: lemon twist

Fill a cocktail shaker filled with crushed ice, combine the gin, Chartreuse, and bitters and stir with a mixing spoon until thoroughly chilled. Strain into a chilled martini glass. Garnish as desired.

> **BAR TALK**
> ### Bitter truth
> Much like you season food, bitter extracts are added to improve and align the flavors of a cocktail. Aromatic bitters impart a balanced botanical flavor, while digestive bitters, often taken with ice at the end of a meal, are thought to aid digestion.

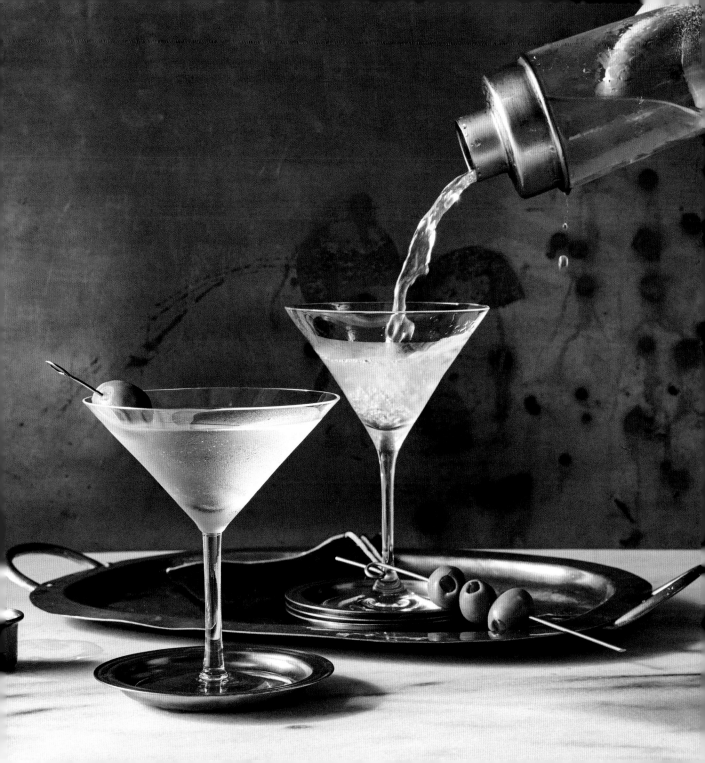

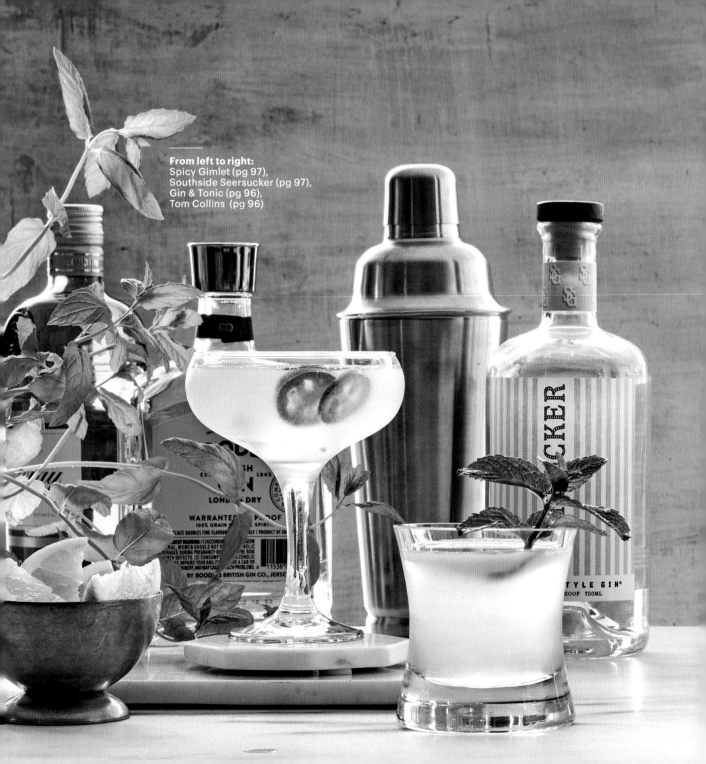

From left to right:
Spicy Gimlet (pg 97),
Southside Seersucker (pg 97),
Gin & Tonic (pg 96),
Tom Collins (pg 96)

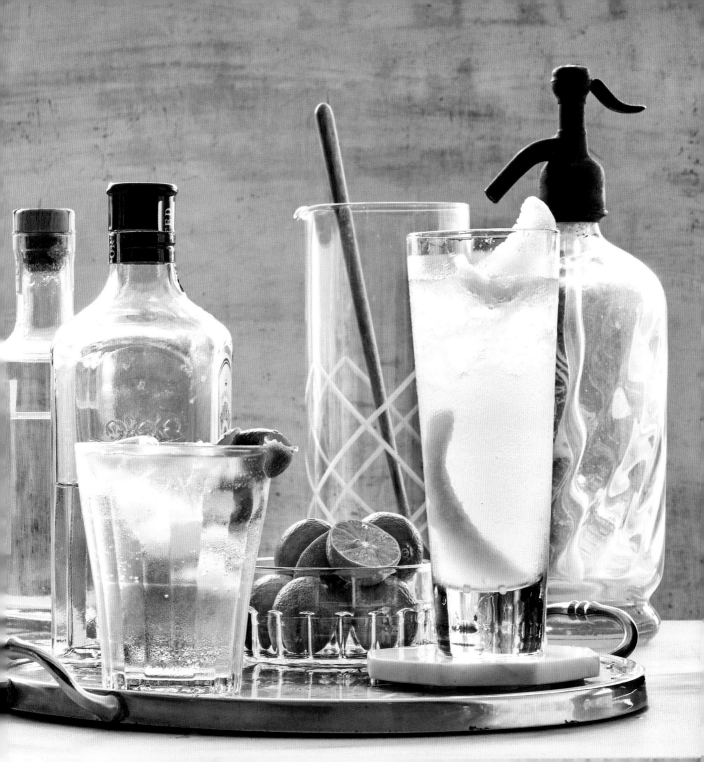

GIN & TONIC

SERVES 1

Historical perspective gives the concept of "gin and juice" a new level of cache. To understand, turn your attention to quinine, the alkaloid extraction of the bark of the quina-quina (or cinchona) tree of South America. Jesuit monks in the Andes mountains in the 1700s had observed the protective qualities that extracts of the bark had against mosquito-borne illnesses in the villages that they served. News traveled back to England and the British adopted quinine as a malaria preventative and treatment.

It didn't take long for some British sailor to realize that his daily bitter dose of quinine powder went down easier when mixed with seltzer, sugar, and his evening ration of gin. Later British officials mandated a daily ration of lime juice to prevent scurvy, so sailors and soldiers added that to the concoction and the original gin and juice cocktail—tempered with life-saving tonic—was born. *Photograph on pg 95*

1 (1-inch) Key lime peel strip, plus 1½ teaspoons fresh juice (from 1 Key lime)

3 tablespoons (1½ ounce) Navy-strength gin (such as Plymouth Navy Strength Gin)

¼ cup tonic water

Fill an 8-ounce glass with ice cubes; add lime peel strip, lime juice, and gin. Pour tonic water into glass, and stir gently; serve immediately.

TOM COLLINS

SERVES 1

Appearing in 1876 *Bartenders Guide* by Jerry Thomas, the Tom Collins was believed to be a spin on the John Collins created at London's Limmer's Hotel and named for its bartender. The drink's name was changed to Tom Collins of the Old Tom gin used.

Stateside, a cocktail of the same name was making rounds as the subject of a far-reaching prank. First, an unsuspecting person would be told that they had been spoken rudely of at the local tavern by a loud buffoon named Tom Collins. Then, when the slighted party appeared at the bar demanding Tom Collins, the bartender would serve up this sour gin cocktail to the roar of patron laughter instead. *Photograph on pg 95*

2 ounces (¼ cup) Old Tom gin (such as Tanqueray Old Tom Gin)

¾ ounce (1½ tablespoons) lemon juice

½ ounce (1 tablespoon) Oleo-Saccharum (page 37) or Simple Syrup (page 27)

Garnish: lemon twist

Fill a Collins glass with crushed ice. Combine the gin, lemon juice, and syrup in an ice-filled cocktail shaker. Cover, and shake vigorously for 30 seconds. Strain into the prepared glass. Garnish as desired.

SPICY GIMLET

SERVES 1

Webster's Dictionary defines "gimlet" as "having a piercing or penetrating quality." The original combined equal parts gin and the original Lauchlin Rose's lime juice formula, which certainly gave it those effects. Over the years barkeeps and home mixologists have created countless spins on the OG. This one, sweetened with a spicy honey syrup, adds a tinge of heat to the limey mix. *Photograph on pg 94*

2 ounces (¼ cup) gin

1½ teaspoons fresh lime juice (from 1 lime)

1½ teaspoons Jalapeño-Honey Syrup (page 29)

½ cup crushed ice

Fresh jalapeño pepper slices

Combine the gin, lime juice, syrup, and ice in a cocktail shaker. Cover with the lid, and shake vigorously until the outside of shaker is frosty, about 30 seconds. Strain into a chilled coupe glass. Add fresh jalapeño slices, if desired. Serve immediately.

SOUTHSIDE SEERSUCKER

SERVES 1

The Southside cocktail adds muddled mint to the basic gimlet formula. Use Seersucker southern-style gin for its citrusy, floral qualities and notes of mint, which pair perfectly in this cocktail hour standard. *Photograph on pg 94*

6 fresh mint leaves, plus more for garnish

¾ ounce (1½ tablespoons) Simple Syrup (page 27)

2 ounces (¼ cup) gin (such as Seersucker Southern Style Gin)

½ ounce (1 tablespoon) fresh lime juice (from 1 lime)

Muddle 6 mint leaves and the syrup in a cocktail shaker. Fill the shaker with ice and add the gin and lime juice. Cover with the lid, and shake vigorously until chilled, about 20 seconds. Strain into a chilled old-fashioned glass with additional mint leaves, if desired.

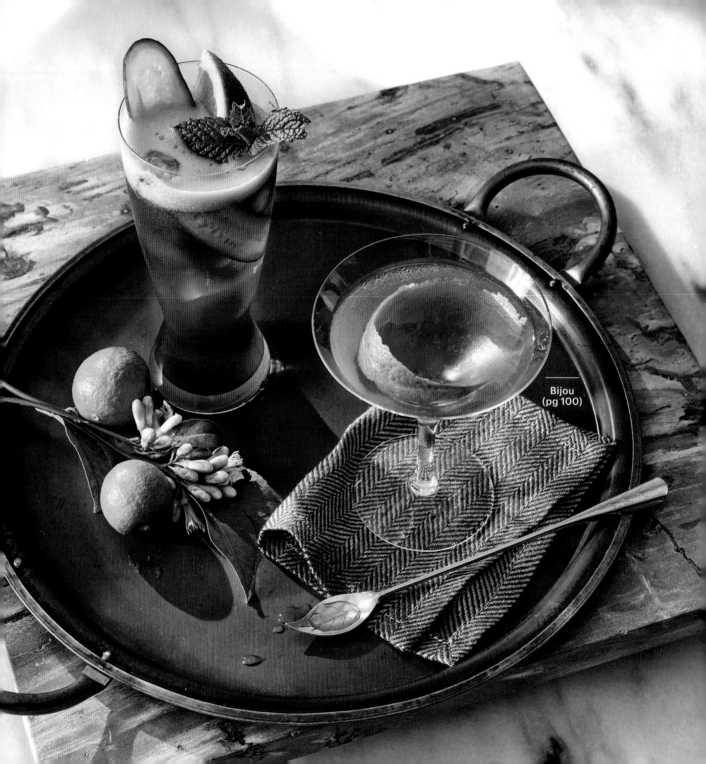

Bijou
(pg 100)

PIMM'S CUP

SERVES 1

English restaurateur, James Pimm, created his namesake liqueur—a proprietary blend of fruit, herbs, spices, and gin—as a mixer for cocktails that would pair spectacularly with the briny shellfish served at his oyster bar. His goal was to craft something his patrons would sip rather than gulp so that they would linger and order more. Situated directly across the street from Buckingham Palace, the Royal Family were regulars. James marketed his Pimm's Cup as a curative and served it in ice-filled mugs. At one point there were six Pimm's varieties. Today just three remain. Though he died a century and a half ago, Pimm invented a taste of summer in a glass that has endured for generations.

2 ounces (¼ cup) Pimm's No. 1

¼ ounce (½ tablespoon) freshly squeezed lemon juice

Chilled ginger ale

Garnish: orange slice, Candied Ginger (page 25), lengthwise strip peeled cucumber, and mint sprig

Pour the Pimm's and lemon juice into an ice-filled highball or pilsner glass and top with the ginger ale. Gently stir and garnish as desired.

BAR TALK
Pimm's no.

At its height, Pimm's distilled six different fruit cups, each with a different alcohol base. They included:

Pimm's No. 1: Gin-based and the most popular blend
Pimm's No. 2: Scotch-based and no longer produced
Pimm's No. 3: Brandy-based but phased out. Pimm's Winter Cup, a short-lived seasonal release, has a brandy base

Pimm's No. 4: Rum-based and no longer produced
Pimm's No. 5: Rye-based and no longer produced
Pimm's No 6: Vodka-based and produced in limited quantities

BIJOU

SERVES 1

This jewel of a cocktail from the late 1800s gets its name from the diamond, russet, and emerald tones of the gin, vermouth, and Chartreuse of which it is comprised. It's a concoction credited to Harry Johnson, who included it in his *New and Improved Bartender Manual* of 1900. We think it could just as easily have been called a "Bisou" because it's so lovely you'll wish you could kiss Harry for creating it. *Photograph on pg 98*

1½ ounces (2 tablespoons) dry gin

1 ounce (2 tablespoons) sweet vermouth

¾ ounce (1½ tablespoons) green Chartreuse

3 dashes Homemade Digestive Bitters (page 32) or orange Angostura bitters

Garnish: orange twist

Combine all the ingredients in a mixing glass with ice and strain into a martini or coupe glass. Garnish as desired.

CORPSE REVIVER

SERVES 1

Corpse Revivers are a 19th century category of mixed drinks meant to banish regrets...but mostly hangovers. They are the earliest hair-of-the-dog remedies for those seeking relief from being overserved the night before. The first published recipe of the same name appeared in the 1871 *Gentleman's Table Guide* by E. Ricket and C. Thomas. (And who doesn't like the added mystery surrounding a pair only willing to share their first initials?) That recipe was comprised of just three ingredients—brandy, bitters, and maraschino liqueur. Proving that the first isn't always best and that getting the ingredients right is key, the recipe that has kept the corpse reviver alive all these years is the one for The Corpse Reviver No. 2 that appeared in Harry Craddock's *The Savoy Cocktail Book*. It's dry, citrusy, and bracing. Isn't bracing what a hangover cure should be?

½ ounce (1 tablespoon) absinthe

¾ ounce (1½ tablespoons) lemon juice

¾ ounce (1½ tablespoons) dry gin

¾ ounce (1½ tablespoons) Cointreau

¾ ounce (1½ tablespoons) Lillet Blanc

Garnish: orange twist

Pour the absinthe into a chilled coupe and swirl around. Discard the absinthe and set coupe aside. Add the lemon juice, gin, Cointreu and Lillet Blanc to an ice-filled cocktail shaker. Cover with the lid, and shake vigorously until chilled, about 20 seconds. Strain the cocktail into the prepared glass and garnish as desired.

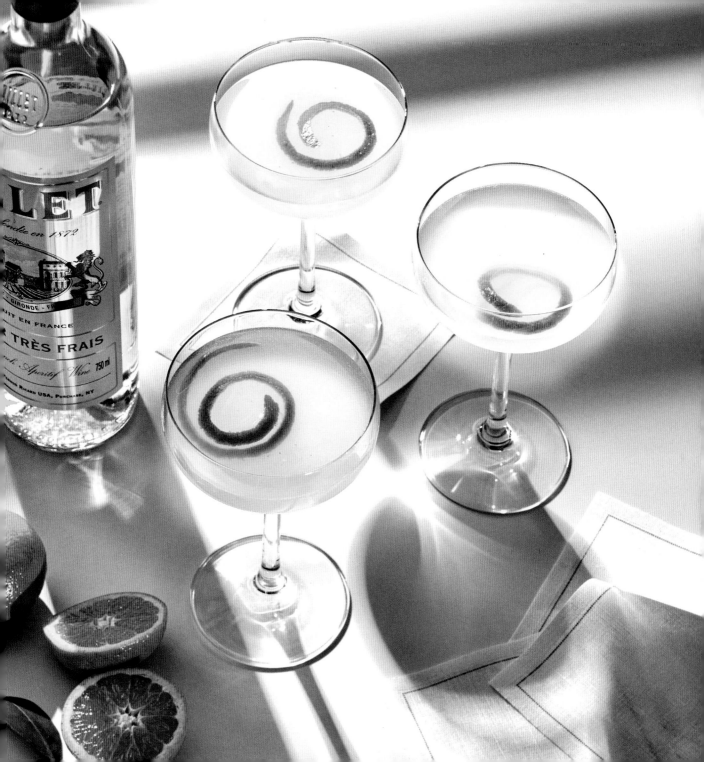

CLASSIC MOJITO

SERVES 1

Destination Zero for what is undoubtedly one of the most popular bar orders of the past decade is Havana, Cuba. An assistant of Sir Francis Drake is credited for concocting the precursor to the mojito—a drink he called "El Draque," or the dragon, for his boss—using a more primitive form of rum called *aguardiente*, freshly squeezed lime juice, sugar from nearby cane fields, and crushed fresh mint leaves.

Herb Rim Sugar made with mint (page 18)

10 fresh mint leaves

2 tablespoons sugar

1 ounce (2 tablespoons) freshly squeezed lime juice

2 ounces (¼ cup) light rum

Splash of club soda

Garnish: lime wedge and mint sprig

1. Rub the rim of a highball glass with a lime wedge and invert the glass onto a shallow plate covered with a thin layer rim sugar. Twist the glass to coat the rim.

2. Combine the mint leaves, sugar, and lime juice in the mug and crush the mint using the back of a bar spoon.

3. Add the rum, and stir; add ice cubes. Top with a splash of club soda. Garnish as desired.

BAR TALK
When to stir?
Stirring is best when a spirit is combined with minimal mixers or with carbonated liquids. A drink may be built in a cocktail shaker, stirred with a bar spoon to combine, and then strained into the serving glass, or it may be mixed from start to finish directly in the glass in which it will be served.

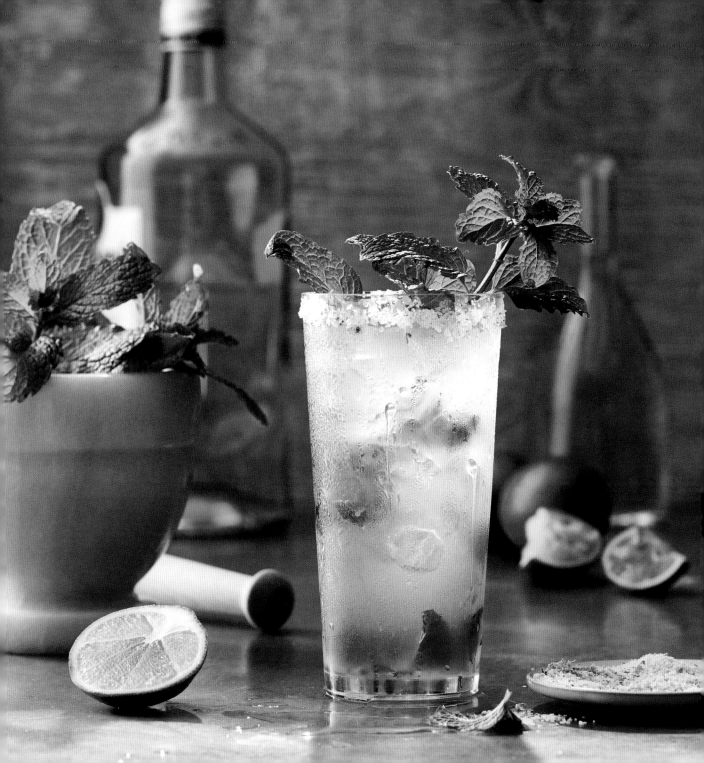

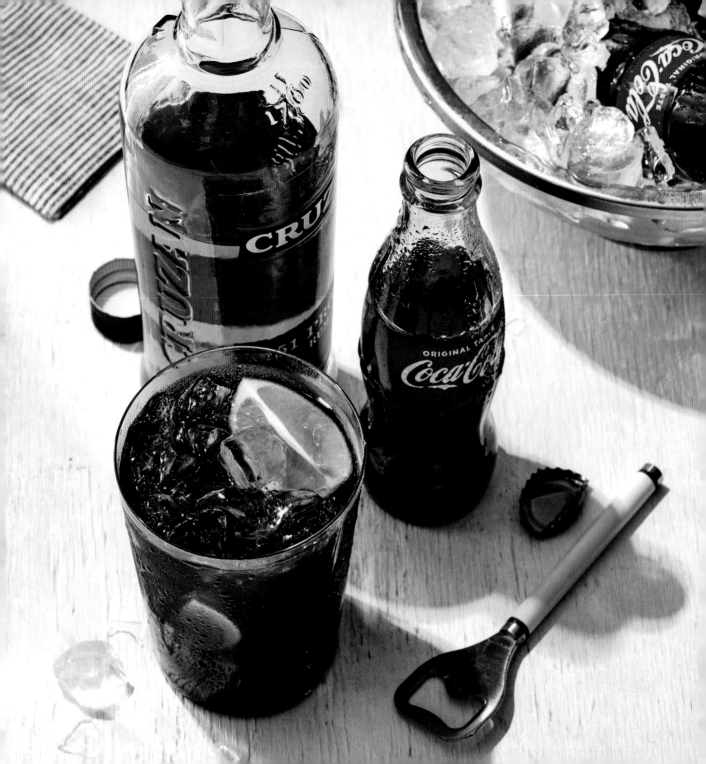

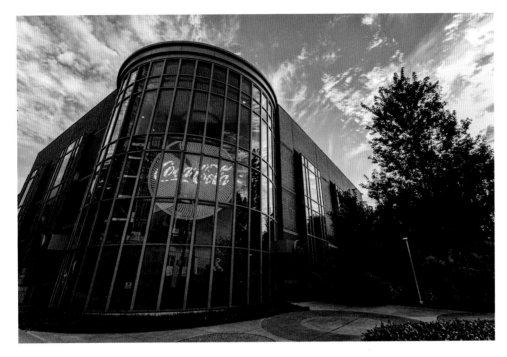

The illuminated Coca Cola sign in the World of Coca Cola entrances in Atlanta glows like a harvest moon.

105

CUBA LIBRE

SERVES 1

The "Free Cuba" cocktail is often touted as a Spanish-American War creation, but Southern coca-cola didn't arrive on the island until after the war ended. In 1966, a Barcardi rum ad featured an affidavit from a man who claimed to have been present when a Bacardi executive in Cuba asked a local bartender to mix Bacardi rum with Coke. America sailors overhead and asked for a round for themselves. The drink's popularity spread to the States in no time.

1 lime

2 ounces (¼ cup) gold rum

4 ounces (½ cup) cola

Garnish: lime wedge

Cut the lime in half and squeeze all the juice from both halves into a highball glass. Drop one spent lime half into the glass and muddle with the juice. Add the rum to glass and fill the glass half way with ice. Top with the cola and gently stir to mix. Garnish as desired.

RUM SWIZZLE

SERVES 1

The swizzle cocktail gets its name from the forked allspice or sassafras branch originally used to stir them. The rum-based Swizzle is the national drink of Bermuda.

½ cup shaved ice

2½ ounces (5 tablespoons) light rum

3 ounces (1½ tablespoons) fresh lime juice (from 1 lime)

2 teaspoons granulated sugar

Dash of Homemade Digestive Bitters (page 32)

Dash grenadine (optional)

Garnish: lime zest strips

Combine all the ingredients in a glass pitcher. Stir vigorously until the mixture foams, about 20 seconds. Pour into an ice-filled double old-fashioned glass. Garnish as desired.

SOUTHERN TWIST
Texas Swagger
Substitute blanco tequila for the rum and Jalapeno-Honey Syrup (page 29) for the sugar.

RUM EASTER SOUR

SERVES 1

Sours quench thirst and make you salivate for more. Citrus, shrubs (page 29), and tart fruits often figure in the mix. This recipe is a classic medley of orange and lemon juices leveled with a dense simple syrup and a nutty, citrus one.

¾ cup shaved ice

1 ounce (2 tablespoons) fresh orange juice (from 1 orange)

½ ounce (1 tablespoon) fresh lemon juice (from 1 lemon)

1 teaspoon Satsuma-Pecan Orgeat Syrup (page 35)

½ teaspoon rock candy syrup (see note)

2 ounces (4 tablespoons) light rum

Garnish: mint sprig and orange slice

Combine ½ cup of the shaved ice, orange juice, lemon juice, Orgeat Syrup, rock candy syrup, and rum in a cocktail shaker. Cover with lid, and shake vigorously, 15 seconds. Strain into a cocktail glass. Add the remaining ¼ cup shaved ice to the glass. Garnish as desired. Serve with a straw.

NOTE

Rock Candy Syrup is a sweeter, thicker spin on Simple Syrup (page 27) prepared with 2 parts sugar to 1 part water. It is commercially available but easily made from scratch.

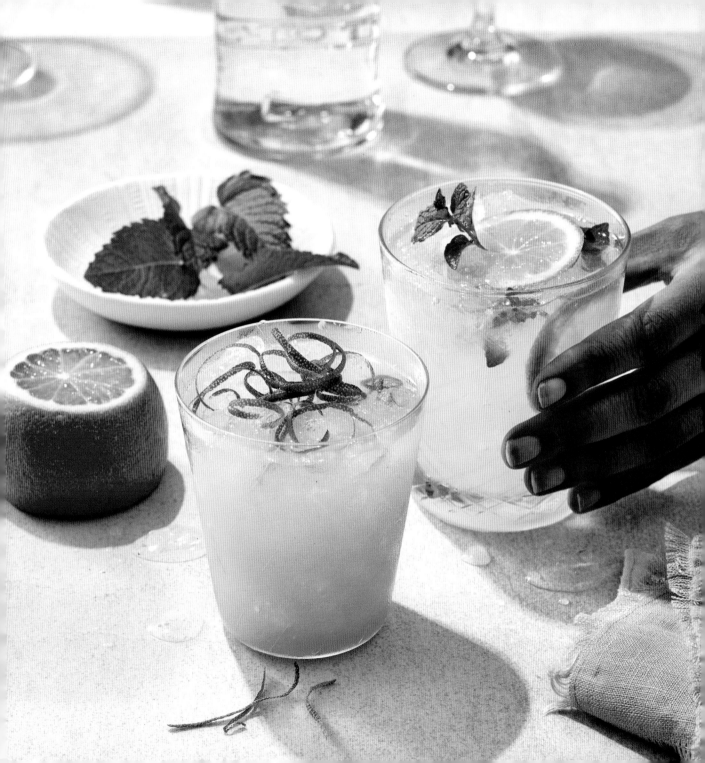

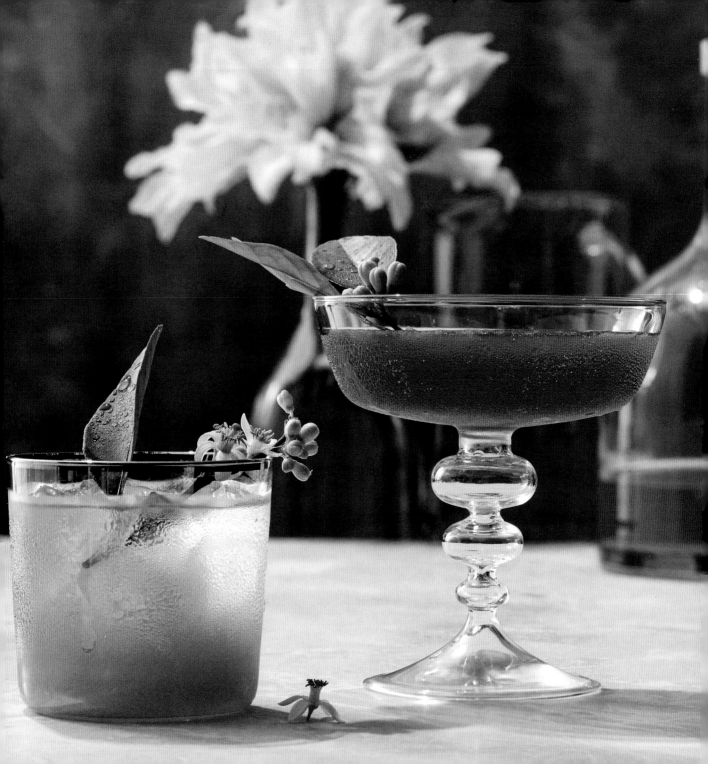

RHUM AGRICOLE DAIQUIRI

SERVES 1

Made from pressed cane sugar instead of rum's fermented cane juice, this tiki spirit has French-Caribbean agricultural roots. It must be made in Martinique to be called "Rhum Agricole AOC Martinique." Unlike rum, rhum agricole has an earthy, vegetal essence that works well blended with more complex flavors, but it also shines on its own. Sip it and taste the terroir. It stands up to the smoky flavors in this uncommon daiquiri.

¼ cup (2 ounces) Rhum Agricole (such as Rhum Barbancourt)

1½ teaspoons agave nectar

1 ounce (2 tablespoons) fresh lime juice, plus 1 wedge for garnish (from 1 lime)

1 ounce (2 tablespoons) Smoked Simple Syrup (page 28)

Combine Rhum Agricole, agave nectar, lime juice, and Smoked Simple Syrup in an ice-filled cocktail shaker. Cover with lid, and shake vigorously until chilled, about 30 seconds. Strain into an ice-filled old-fashioned glass. Garnish as desired.

PINK DAIQUIRI

SERVES 1

The classic daiquiri is just rum, fresh lime juice, and sugar. Ernest Hemingway is credited with the addition of the maraschino liqueur and grapefruit juice that made this icy refresher blush. Paint this rendition rose-colored by using the grenadine instead of granulated sugar.

1½ teaspoons granulated sugar or 2 teaspoons Southern Cherry Grenadine (page 37)

½ ounce (1 tablespoon) fresh Key lime juice (from 2 Key limes)

1½ ounces (3 tablespoons) light rum

¼ cup crushed ice

Stir together sugar or grenadine and lime juice in a measuring cup until sugar is dissolved; transfer to a blender. Add rum and ice to blender. Process until smooth, about 30 seconds. Pour into a 3½-ounce coupe glass, and serve immediately.

VARIATION

Chilled Daiquiri: Serve this "up" by increasing ice to ½ cup. Stir together the sugar or grenadine and lime juice in a measuring cup until the sugar is dissolved; transfer to a cocktail shaker. Add the rum and ice; cover with the lid, and shake vigorously 30 seconds. Strain into a 3½-ounce cocktail glass, and serve immediately.

The waters off of any
of the 1,700 islands of
the Florida Keys beckon
beachgoers, but only
43 of the islands are
connected by bridges.

PIÑA COLADA

SERVES 1

Puerto Rico's fancy-sounding national drink translated to English is "strained pineapple," which sounds much less exotic. Anyone who's tried this rich blend of icy coconut milk and tantalizing pineapple juice spiked with rum knows the heady mix is anything but ho hum.

1½ ounces (3 tablespoons) white rum

2 ounces (1½ tablespoons) canned coconut milk, shaken well

2 ounces (1½ tablespoons) fresh pineapple juice

1 ounce (2 tablespoons) Satsuma-Pecan Orgeat Syrup (page 35)

Garnish: maraschino cherry, fresh pineapple wedge, and pineapple leaves

Combine the rum, coconut milk, pineapple juice, and orgeat in an ice-filled cocktail shaker. Cover with the lid and shake vigorously for 20 seconds. Strain into a chilled hurricane glass. Garnish as desired.

BAR TALK

If You Like Piña Coladas

...or know the rest of that refrain, you'll appreciate this roundup of tasty variations.

Chi-Chi: Use vodka in place of rum
Lava Flow: Mix ½ Piña Colada with ½ Pink Daiquiri (page 109)
Piñita Colada: Skip the rum altogether

Soda Colada: Use soda in place of the coconut milk
Amaretto Colada: Substitue amaretto for the rum

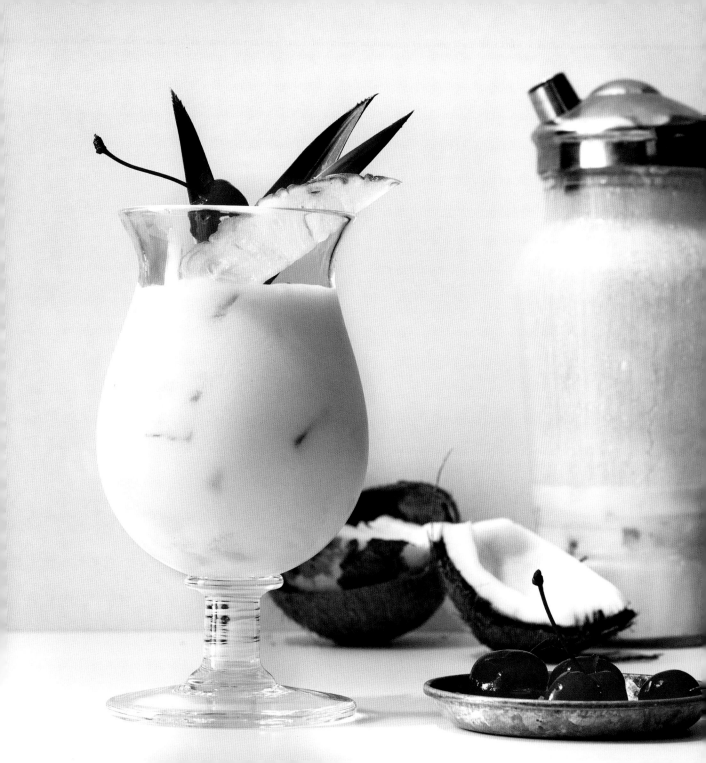

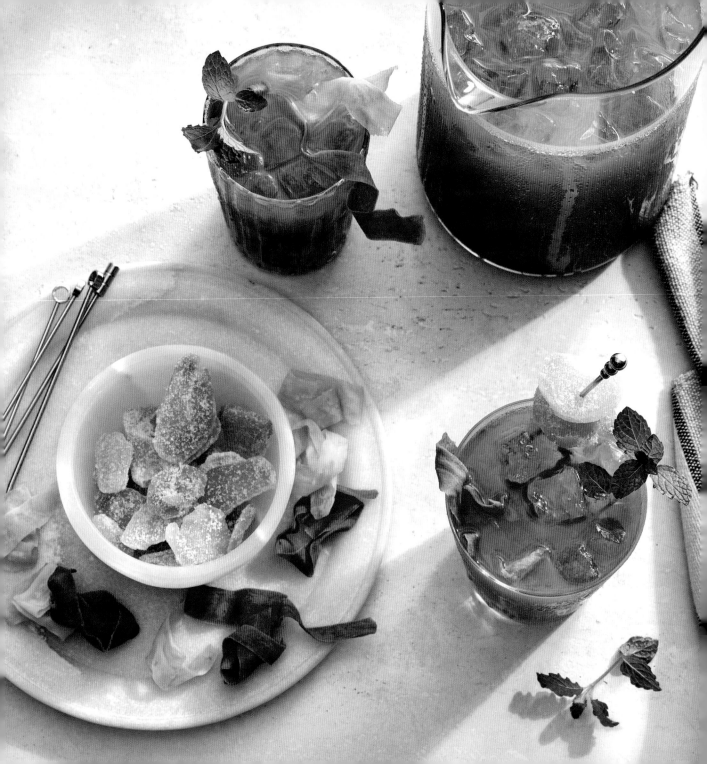

CARROT-GINGER BEER

SERVES 4

For drinks made with clear liquids like gin, use white granulated sugar in your simple syrup, but for dark rum drinks like this Carrot-Ginger Beer, try brown sugar instead for a deeper, richer flavor. This recipe uses fresh, aromatic mint leaves in the simple syrup. Steeping aromatics in a syrup is an easy way to add another layer of flavor to a drink. You can also try using citrus zest or vanilla pods. Once you have added your preferred aromatics to a syrup, remove the pan from heat and let them steep in the mixture for about half an hour as it cools. Pour the syrup through a mesh strainer and discard all the solids. If you have extra syrup, keep it in an airtight container in your fridge for up to a month. This cocktail is perfect for the warm summer days, so keep plenty of the minty syrup on hand.

8 ounces (1 cup) water

½ cup packed dark brown sugar

6 large mint sprigs

4 ounces (½ cup) cold-pressed carrot juice

2 ounces (¼ cup) fresh lime juice (from about 2 limes)

8 ounces (1 cup) spiced rum

2 (12-ounced) bottles chilled ginger beer

Garnish: mint sprigs and Candied Carrot Curls (page 24)

1. Combine the water, brown sugar, and mint sprigs in a small saucepan. Bring to a boil over medium-high, stirring just until sugar is dissolved. Remove from heat, and cool completely (about 30 minutes). Discard mint sprigs.

2. Combine the mint syrup, carrot juice, and lime juice in a pitcher, and chill until very cold, about 2 hours. For each serving, pour 6 tablespoons of the mixture over ice in a 12-ounce glass, and stir in 3 tablespoons of the spiced rum. Top each serving with ¾ cup chilled ginger beer. Garnish as desired.

SOUTHERN TWIST
PeachSnap
Substitute peach nectar for the carrot juice and garnish with Boozy Stone Fruit peach (page 22) slices in place of the Carrot Curls.

RUM FLIP

SERVES 1

The original flip was made with beer and heated with a hot iron, which made it bubble and froth. Over time sugar and egg whites were added to maintain the foamy froth and the drink was served chilled.

1 pasteurized egg white

1 teaspoon Simple Syrup (page 27) or Smoked Simple Syrup (page 28)

2 ounces (¼ cup) golden rum

Freshly grated nutmeg

Combine the egg white, syrup, and rum with ice in a cocktail shaker. Shake vigorously for 30 seconds; strain into a chilled brandy snifter or stemmed cocktail glass. Top with nutmeg.

BAR TALK
When to shake?
When dairy, egg whites, or fresh juices need to be blended with spirits in a cocktail, bartenders turn to the cocktail shaker to blend and aerate ingredients. Egg whites, especially, require vigorous shaking to develop into the rich, thick texture that lends body to classic cocktails like flips, fizzes, and sours.

HOT BUTTERED RUM

SERVES 1

With European roots, this hot tipple has helped drinkers stave off Winter's chill for ages.

Warm Spiced Rim Sugar (page 19)

8 ounces (1 cup) water

2 tablespoons unsalted butter, softened

1 tablespoon dark brown sugar

⅛ teaspoon ground cinnamon

⅛ teaspoon ground nutmeg

1 (3-inch) cinnamon stick

1½ ounce (3 tablespoons) dark rum

1½ teaspoons fresh lemon juice (from 1 lemon)

1. Rub a dampened finger around the rim of an Irish coffee mug. Invert onto a shallow plate covered with a thin layer Warm Spiced Rim Sugar. Twist the glass to coat the rim.

2. Bring water to a boil in a small saucepan. Let cool 5 to 10 minutes.

3. Stir together the butter, brown sugar, cinnamon, and nutmeg in a small bowl. Spoon into an Irish coffee mug. Top with a cinnamon stick. Pour in ¾ cup of the hot water; discard any remaining hot water. Stir the butter until frothy. Add the rum and lemon juice and serve.

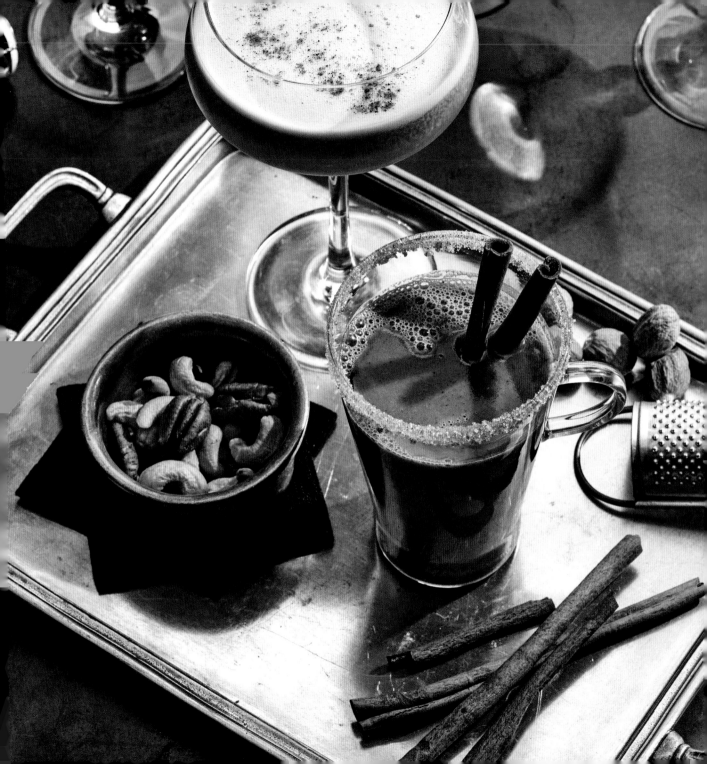

Mezcal & Tequila

Mezcal refers to the entire category of agave-based spirits and a singular style of liquor produced in the state of Oaxaca from various types of agave roasted in pits over wood coals before fermentation and distillation. This method gives the liquor a distinctive smoky taste. Tequila is a designated mezcal appellation named for the small town in the state of Jalisco, Mexico, that made the spirit famous. Tequila is made by steaming or oven-roasting agave, a process that does not add smokiness to the finished product. Tequila can only be produced in the states of Jalisco, Guanajuato, Michoacan, Nayarit, and Tamaulipas and solely from the blue Weber agave. Tequila that spends 2 to 12 months in oak barrels before bottling is called reposado, which means "rested." When barreled for at least a year, it is labeled añejo for "aged."

MARGARITA

SERVES 1

This is the only recipe you'll ever need for one of summertime's happy hour favorites.

Citrus Rim Salt made with lime zest (page 17)

Fresh lime wedge

2½ ounces (about ⅓ cup) fresh lime juice

1½ ounces (3 tablespoons) Cointreau

1½ ounce (3 tablespoons) tequila

⅓ to ½ cup powdered sugar

Garnish: lime slice

1. Rub rim of a chilled margarita glass with lime wedge, and dip rim in salt to coat.

2. Fill cocktail shaker half full with ice. Add lime juice, liqueur, tequila, and powdered sugar; cover with lid, and shake until thoroughly chilled. Strain into prepared glass. Garnish as desired.

PALOMA

SERVES 1

Add a wisp of smokiness to this rosy spin on the margarita by using mezcal in place of the tequila.

Lime wedge

Citrus Rim Salt made with grapefruit or lime zest (page 17)

2 ounces (¼ cup) white tequila or mezcal

½ ounce (1 tablespoon) fresh lime juice

2½ ounces (about ⅓ cup) fresh ruby red grapefruit juice

¼ ounce (2 teaspoons) Oleo-Saccharum (page 37) or Simple Syrup (page 27)

Club soda

Garnish: lime wedge and grapefruit twist

Rub the rim of a coupe glass with the lime wedge and invert the glass onto a shallow plate covered with a thin layer of salt. Twist the glass to coat the rim. Combine tequila or mezcal, lime juice, grapefruit juice, and Oleo Saccharum or simple syrup in a highball glass. Add ice and top with club soda. Garnish as desired.

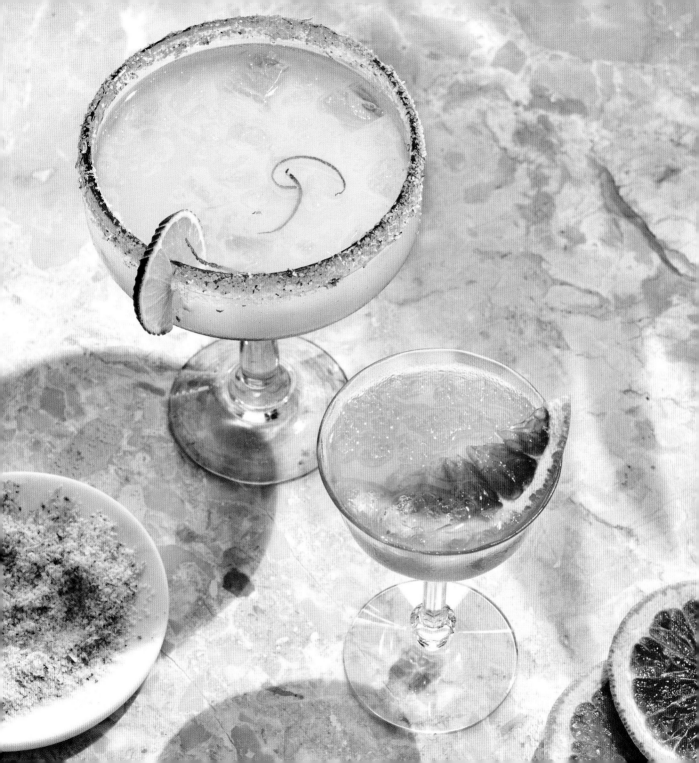

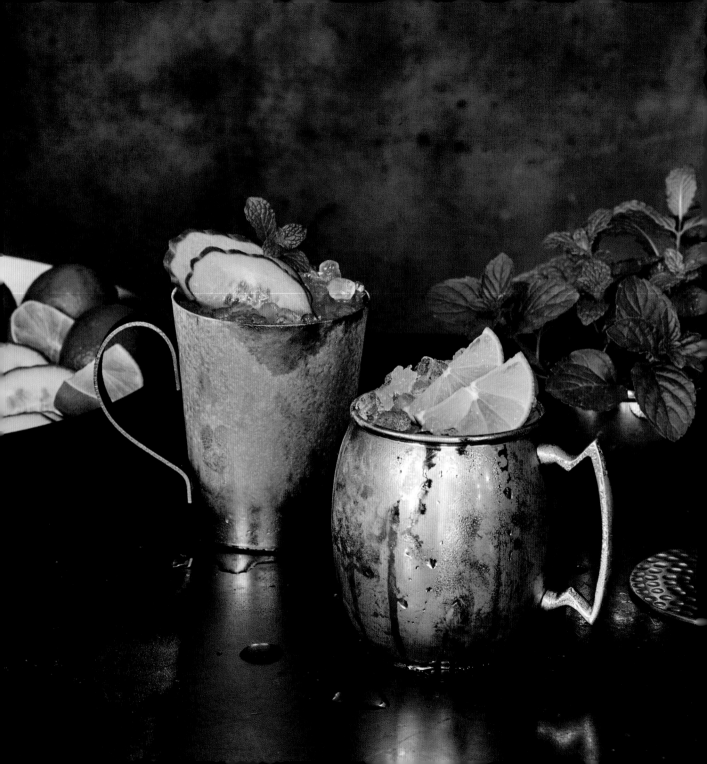

MOSCOW MULE

SERVES 1

While the copper mugs traditionally used to serve this refreshing ginger-spiked drink
are functional and pretty, they aren't required.

2 ounces (¼ cup) vodka

4 ounces (½ cup) ginger beer

½ ounce (1 tablespoon) lime juice

Garnish: lime wedge and Candied Ginger (page 25)

Combine the vodka, ginger beer, and lime juice in a chilled copper mug. Fill with crushed ice. Garnish as desired.

VARIATION

Montgomery Mule: Substitute moonshine for the vodka, lemon juice for the lime juice, and add a dash of Angostura bitters to the mix.

BAR TALK

Copper Cups

The classic copper mule mug isn't just for looks, like the signature silver or pewter julep cups, copper's conductiveness amplifies the chill of any drink while it's sipped. Don't limit your mule mugs for cocktails alone. Enlist them into service for iced tea and lemonade too.

TEQUILA SUNRISE

SERVES 1

When bartender Bobby Lozoff handed this layered cocktail to Keith Richards, rather than the margarita he'd ordered, perhaps he thought the Rolling Stone wouldn't notice the swap. Instead, it was a decision that put The Trident bar in Sausalito, California on the map and made the Tequila Sunrise a 1970s cocktail classic.

3 ounces (6 tablespoons) orange juice

1½ ounces (3 tablespoons) tequila

½ ounce (1 tablespoon) Southern Cherry Grenadine (page 37)

Garnish: Boozy Stone Fruit cherry (page 22) or maraschino cherry, Candied Orange Citrus Wheel (page 23) or orange wheel

Combine the orange juice and tequila in an ice-filled highball and give a stir. Slowly add the grenadine, which will sink to the bottom of the glass. Do not stir. Garnish as desired.

BAR TALK
Layered Cocktails
Eye-catching and fun to watch being made, here are some other fun layered cocktails to try.

Black-and-Tan: Pale ale topped with stout that is slowly poured over the back of a spoon
Irish Coffee: Dark, sweetened coffee topped with heavy cream
White Russian: A mix of vodka and Kahlúa topped with a raft of heavy cream
B-52 Shot: Kahlúa topped with Baileys Irish Cream topped with Grand Marnier

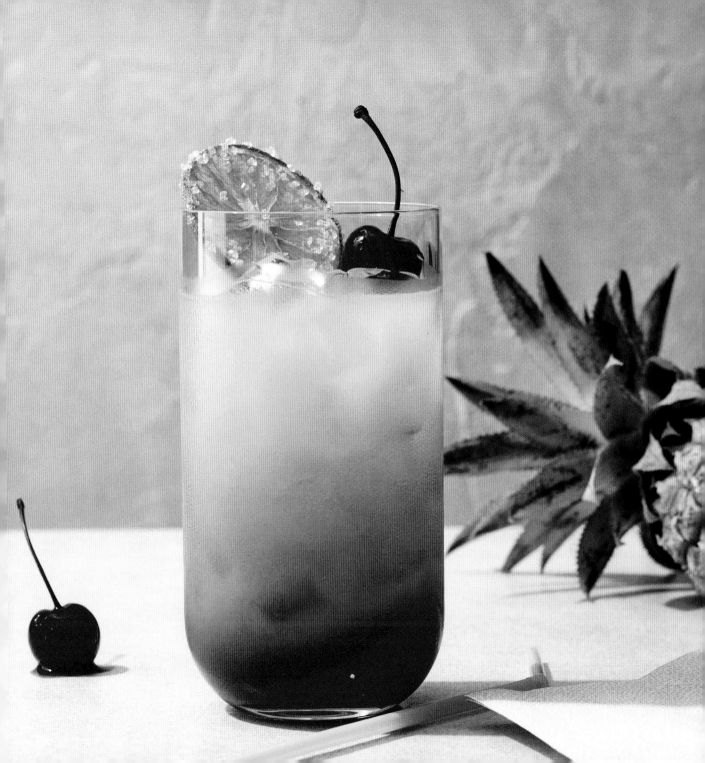

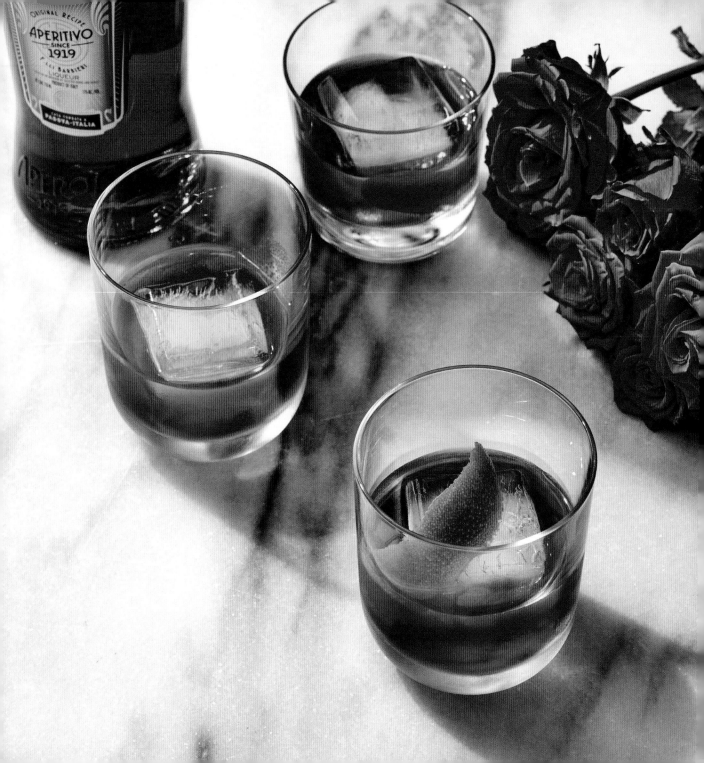

SMOKY NEGRONI

SERVES 1

The classic negroni's pleasing bitterness is met with mezcal's woodsy distinctiveness for a delightful new spin on this slow-sipper. The original gin Negroni came to be when Count Negroni asked for gin instead of soda in his favorite cocktail, The Americano. Here, dry vermouth takes the place of sweet while Aperol stands in for the usual Campari.

1 ounce (2 tablespoons) mezcal

½ ounce (1 tablespoon) sweet vermouth

½ ounce (1 tablespoon) dry vermouth

1 ounce (2 tablespoons) Aperol

1 (2-inch) orange peel strip (from 1 orange)

Combine mezcal, sweet vermouth, dry vermouth, and Aperol in an ice-filled old-fashioned glass; stir well. Rub glass rim with orange peel strip, and add strip to drink.

VARIATION

Classic Negroni: Combine 1½ ounces (3 tablespoons) gin, 1½ ounces (3 tablespoons) Campari, and 1 ounce (2 tablespoons) sweet vermouth in an ice-filled old-fashioned glass; stir well. Rub the rim with an orange peel strip and drop the strip into the drink to serve.

BAR TALK
Italian Aperitivos
Aperol and Campari are alcoholic aperitivos (pre-dinner drinks) meant to prime the palate for the meal to come. Both are bitter spirits made from herbs and aromatics. Crimson Campari came first in 1860 and is the more bitter and potent of the two at 48-proof. Until 2006 it got its hue from crushed cochineal insects (today synthetic dye is used). Sweeter Aperol was created in 1919—the source of its orange tinge is a mystery—and it is lighter at 22-proof.

HONEYSUCKLE SPRITZ

SERVES 1

As Southern as sweet tea, honeysuckle conjures childhood summers, lawn sprinklers, and lemonade stands. Here it infuses vodka in an adults-only refresher.

4 (¼-inch-thick) cucumber slices, plus more for garnish (from 1 cucumber)

½ ounce (1 tablespoon) fresh lemon juice (from 1 lemon)

1 ounce (2 tablespoons) elderflower liqueur (such as St-Germain)

1½ ounces (3 tablespoons) honeysuckle-flavored vodka (such as Cathead Honeysuckle)

Club soda

Muddle 4 cucumber slices, lemon juice, elderflower liqueur, and vodka in a cocktail shaker to release flavors. Fill the shaker with ice cubes. Cover with the lid, and shake vigorously until chilled, about 30 seconds. Strain into an ice-filled old-fashioned glass. Top with club soda, and garnish as desired.

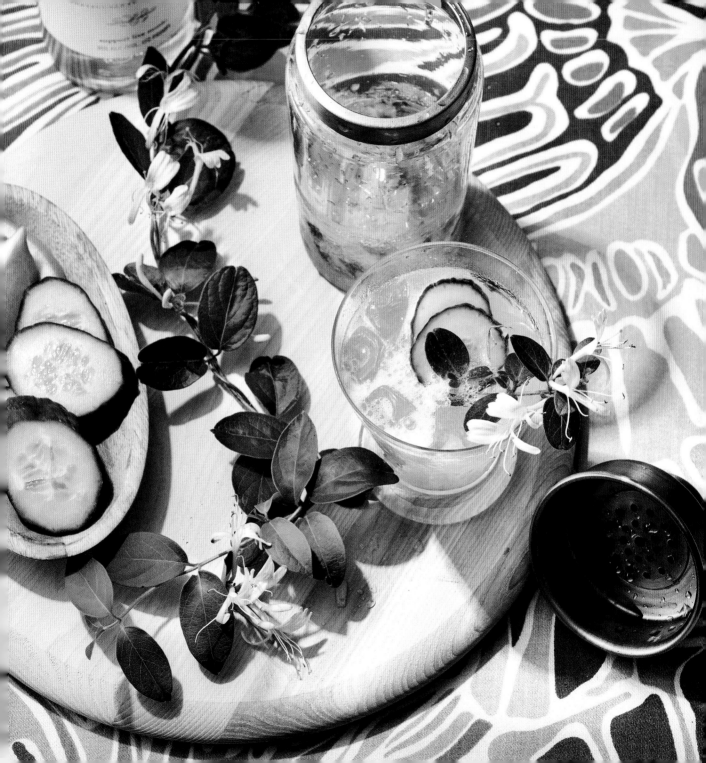

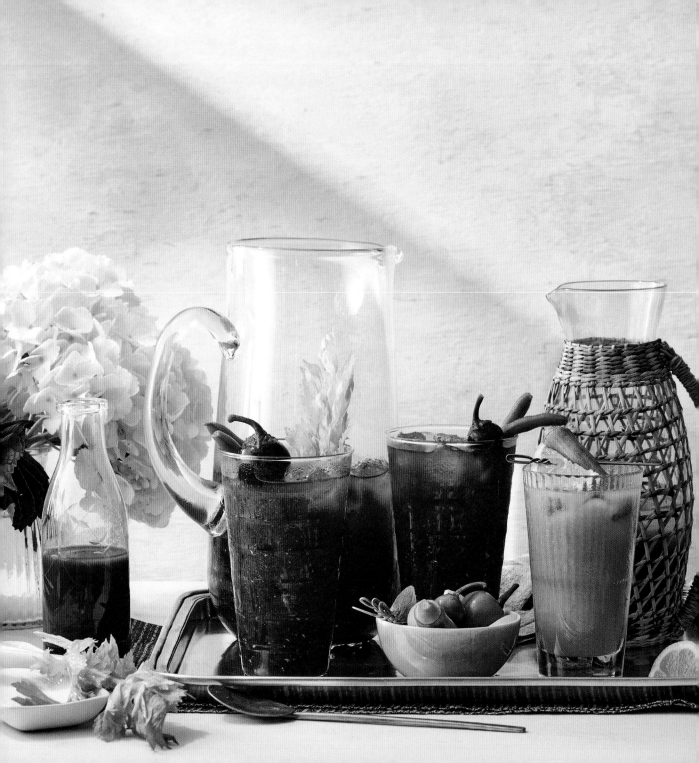

MADE-TO-ORDER BLOODY MARY

SERVES 1

While the South can't lay claim to the Bloody Mary (though even cocktail experts can't agree on its origin), it is a fixture at weekend brunches and game day tailgates.

Lime wedge

Black Pepper-Bacon Rim Salt (page 19)

8 ounces (1 cup) tomato juice, chilled

1½ ounces (3 tablespoons) vodka

1½ ounces (3 tablespoons) lemon or lime juice

¾ teaspoon Worcestershire sauce

4 drops hot sauce

½ teaspoon prepared horseradish

¼ teaspoon pepper

¼ teaspoon celery salt

¼ teaspoon salt

Garnish: lime wedges, pickled green beans, and pickled peppers

1. Rub the rim of a pint glass with a lime wedge. Invert the glass onto a plate with a thin layer of Black Pepper-Bacon Rim Salt; twist to coat.

2. Add the tomato juice and next 8 ingredients to the prepared glass, stirring until blended. Add ice to the glass. Garnish as desired.

GREEN TOMATO BLOODY MARY

MAKES ABOUT 5 CUPS

Fried green tomatoes are fine, but green tomatoes in a Bloody Mary are divine!

4 medium-size green tomatoes (about 1½ pounds), cored and quartered

10 fresh tomatillos (about 15 ounces), husks removed and cored

2 green onions

6 ounces (¾ cup) vodka

½ cup loosely packed assorted fresh herbs

1½ ounces (3 tablespoons) lime juice

1½ ounces (3 tablespoons) green hot sauce

1 garlic clove, minced

1 teaspoon celery salt

½ teaspoon salt

Garnish: halved pickled okra and lemon slices

1. Boil the first 2 ingredients in salted water to cover 3 minutes. Transfer to an ice bath; drain.

2. Process the tomatoes, tomatillos, green onions, and next 7 ingredients in a blender until smooth. Pour the mixture through a fine wire-mesh strainer into a pitcher, discarding solids. Serve over ice. Garnish as desired.

RAZORBACK

SERVES 1

The surprisingly complex flavors of this mix may have you yelling "Sooie!" so beware of the company you keep. No matter your football fan persuasion, this is one delicious drink.

¾ ounce (1½ tablespoons) amaretto (almond liqueur)

¾ ounce (1½ tablespoons) vodka

¾ ounce (1½ tablespoons) light rum

¾ ounce (1½ tablespoons) Kahlúa, or other coffee-flavored liqueur

Garnish: orange slice and maraschino cherry

Combine amaretto, vodka, rum, and Kahlúa in an ice-filled cocktail shaker. Cover with the lid, and shake vigorously until frothy, about 20 seconds. Strain into an ice-filled old-fashioned glass, and garnish as desired.

CHERRY BOUNCE

SERVES 1

Versions of the Cherry Bounce have bounced around since Colonial days. Traditionally made by macerating cherries and sugar in brandy or whiskey for days to months, this impatient-man's version muddles tart cranberries with sugar, citrus, and vodka and gets topped off with ginger beer for a flavorful approximation in a flash.

7 fresh cranberries, plus more for garnish

2 teaspoons granulated sugar

1 (2-inch) lemon peel strip, 1 tablespoon fresh juice (from 1 lemon)

2 ounces (¼ cup) cherry-flavored vodka

1 cup ice cubes, plus more for glass

2 ounces (¼ cup) non-alcoholic ginger beer (such as Barritt's Ginger Beer)

Garnish: Boozy Stone Fruit cherry (page 22) and Candied Ginger (page 25)

Muddle cranberries, sugar, lemon peel strip, and lemon juice in the mixing glass of a Boston shaker until cranberries are broken down. Add cherry-flavored vodka and 1 cup ice cubes, cover with shaker tin, and shake vigorously until chilled, about 20 seconds. Strain into an ice-filled Collins glass. Top with ginger beer, and stir gently. Garnish as desired.

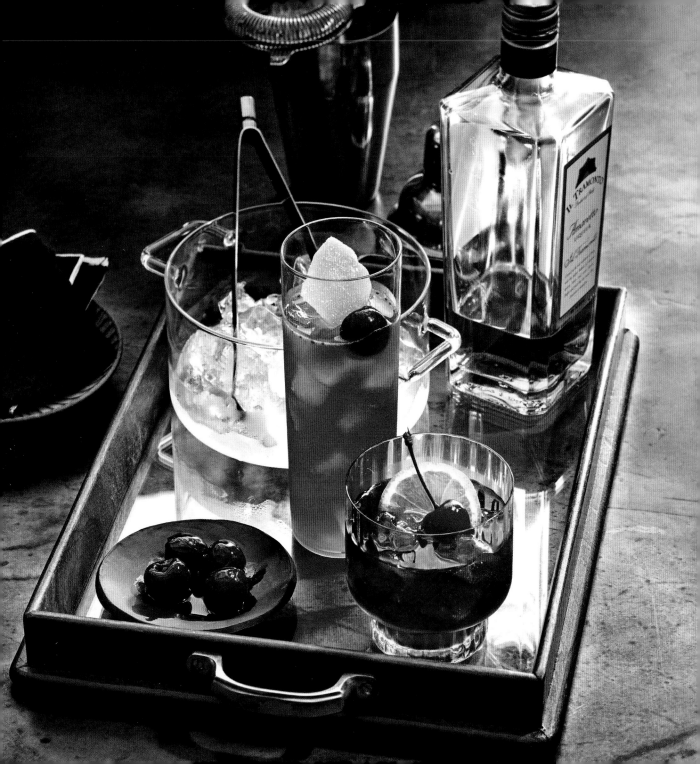

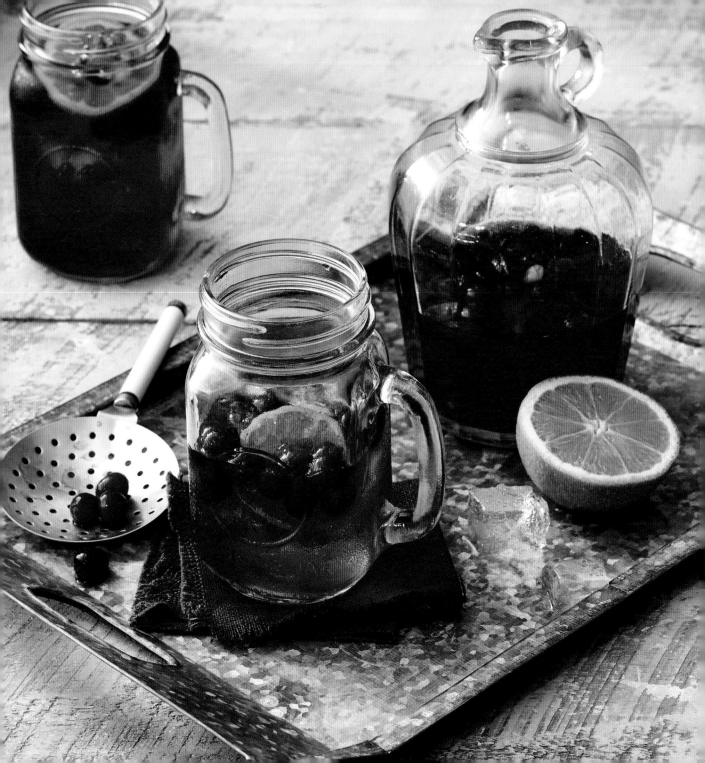

CRANBERRY-INFUSED MOONSHINE

MAKES ABOUT 3¼ CUPS

Moonshine is a potent, neutral spirit that is ideal for infusing with other flavors. Change up the fruit to suit your tastes.

1 cup fresh cranberries

¼ cup sugar

1½ ounces (3 tablespoons) water

1 (750-milliliter) bottle moonshine

2 (2- x 1-inch) orange peel strips

Cook cranberries, sugar, and water in a saucepan over medium heat 5 minutes or until sugar dissolves, liquid begins to turn a light pink color, and cranberries just begin to pop. Let cool slightly (about 10 minutes). Pour mixture into a large glass jar; stir in moonshine and orange peel strips. Let stand at room temperature 3 days. Pour through a fine wire-mesh strainer into a bowl; discard solids. Return moonshine mixture to the jar. Store in the refrigerator up to 2 months.

CRANBERRY-MOONSHINE COCKTAIL

SERVES 1

The spirited kick of this drink is tempered by the effervescent sweetness of blood orange soda.

2 cups ice cubes

1½ ounces (3 tablespoons) Cranberry-Infused Moonshine

½ ounce (1 tablespoon) orange liqueur

Blood orange Italian soda, chilled

Combine the ice cubes, Cranberry-Infused Moonshine, and orange liqueur in a cocktail shaker. Cover with the lid, and shake until chilled. Remove the lid, and strain into a chilled glass; top with the chilled blood orange Italian soda. Serve immediately.

REDNECK FLU SHOT

SERVES 1

Who needs bourbon and coke when you can mix up Cheerwine & moonshine?

1½ ounces (3 tablespoons) moonshine

3 ounces (1½ tablespoons) Cheerwine soda

Garnish: Boozy Stone Fruit cherry (page 22) or maraschino cherry

Combine the moonshine and Cheerwine in an ice-filled old-fashioned glass and stir. Garnish as desired.

BAR TALK
Give Me Proof
Determining the proof of a liquor is simple addition. Double the ABV, or alcohol by volume percentage to get the proof. If a liquor is 35% ABV, then it is 70-proof.

PEANUT WHISKEY-AND-COLA

MAKES 1 SERVING

This drink is a bit like putting the nibbles inside your happy hour cocktail. The flavor of peanuts marries beautifully with a classic vanilla coke spiked with Kentucky bourbon.

1 tablespoon crushed dry-roasted peanuts

2 ounces (¼ cup) bourbon

3 dashes Roasted Peanut Bitters (page 34)

¼ teaspoon vanilla extract

Cola soft drink, chilled

Dip rim of a rocks glass in water and then invert the glass onto a shallow plate covered with crushed peanuts. Twist the glass to coat the rim. Fill with ice. Add bourbon and vanilla extract. Top with chilled cola.

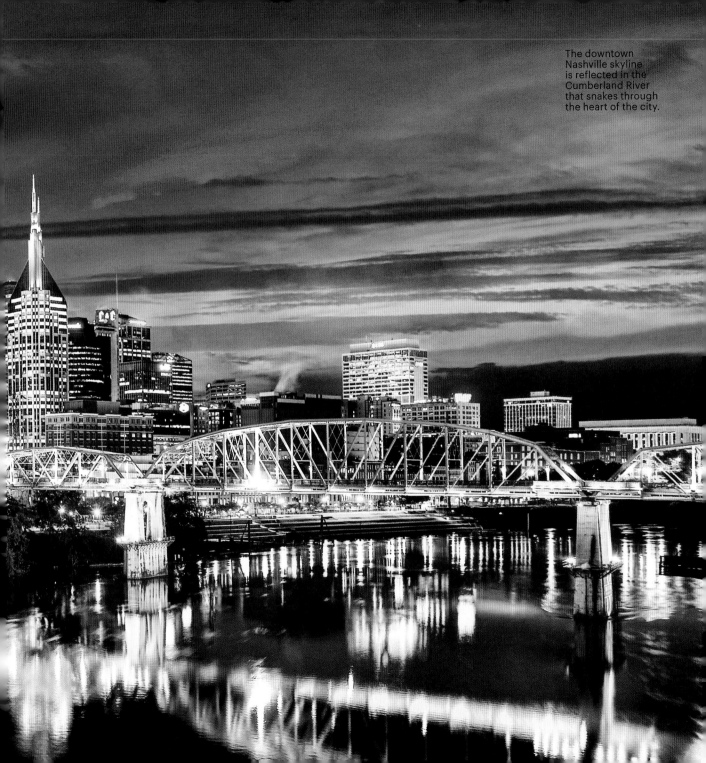

The downtown Nashville skyline is reflected in the Cumberland River that snakes through the heart of the city.

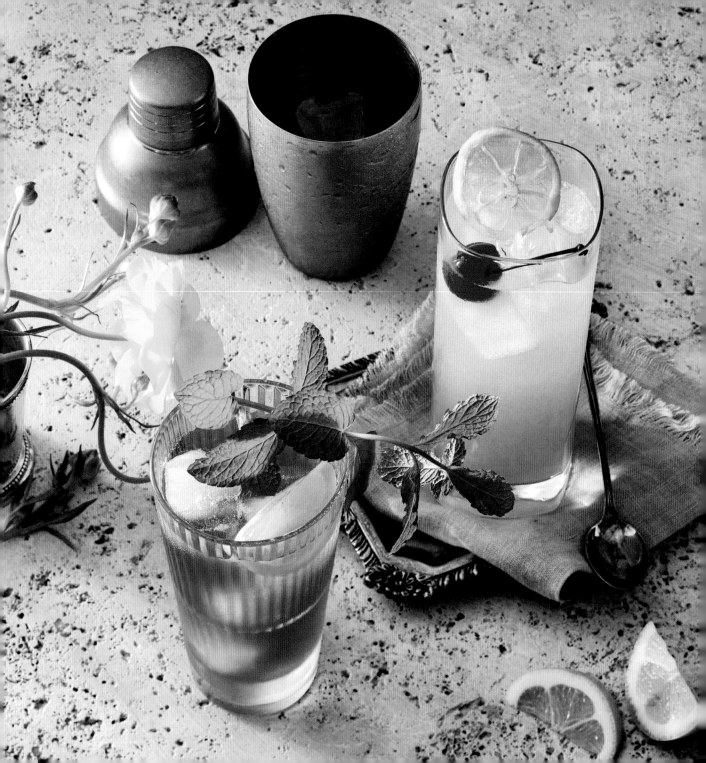

GENTLEMAN JOHNSON

SERVES 1

Developed at Nashville's Capitol Grille, where Dinah Shore once performed, some say legendary Delta blues man Robert Johnson is the inspiration for this cocktail. Southern folklore opines that Johnson made a deal with the devil at a Southern crossroads one dark midnight, exchanging his eternal soul for unparalleled musical talent. Soon after, his young bride died in childbirth. His relatives blamed the death on the curse Johnson brought upon himself for playing secular music. Whatever the inspiration, this spirited take on sweet tea does indeed have a devilish kick.

1½ ounces (3 tablespoons) bourbon

½ ounce (1 tablespoon) dry orange curaçao (such as DeKuyper)

4 ounces (½ cup) strongly brewed sweetened iced tea

Garnish: mint spring and lemon wedge

Fill a highball glass with ice cubes. Add the bourbon, curaçao, and tea, and stir to combine. Garnish as desired.

JOHN COLLINS

SERVES 1

This tall, dark, and handsome sibling of the Tom Collins (page 96) is worth adding to your cocktail hour repertoire.

2 ounces (¼ cup) bourbon

1 ounce (2 tablespoons) fresh lemon juice (from 1 lemon)

1 ounce (2 tablespoons) Smoked Simple Syrup (page 28) or Simple Syrup (page 27)

2 ounces (¼ cup) club soda

Garnish: lemon Candied Citrus Wheel (page 23) and maraschino cherry

Fill a cocktail shaker half full of ice cubes. Add bourbon, lemon juice, and Smoked Simple Syrup. Cover with the lid, and shake vigorously until chilled, about 30 seconds. Strain into an ice-filled Collins glass. Top with club soda, and stir gently to combine. Garnish as desired.

A thoroughbred grazes at Kentucky's Coolmore American Ashford Stud Horse Farm in bourbon country.

WHISKEY SOUR

SERVES 1

An egg white added to this mix makes it a Boston Sour.

1½ ounces (3 tablespoons) bourbon

1½ teaspoons sugar

½ ounce (1 tablespoon) fresh lemon juice (from 1 lemon)

½ cup crushed ice

Large ice cubes

Garnish: orange Candied Citrus Wheel (page 23) and Boozy Stone Fruit cherry (page 22)

Combine bourbon, sugar, lemon juice, and ice in a cocktail shaker. Cover with lid, and shake vigorously until thoroughly chilled. Strain into a double old-fashioned glass filled with ice. Garnish as desired.

VARIATION

Amaretto Sour: Use a combo of 1½ ounces (3 tablespoons) amaretto and ¾ ounce bourbon, and ½ ounce egg white (optional) with the sugar, lemon juice and ice in the cocktail shaker and proceed with the recipe.

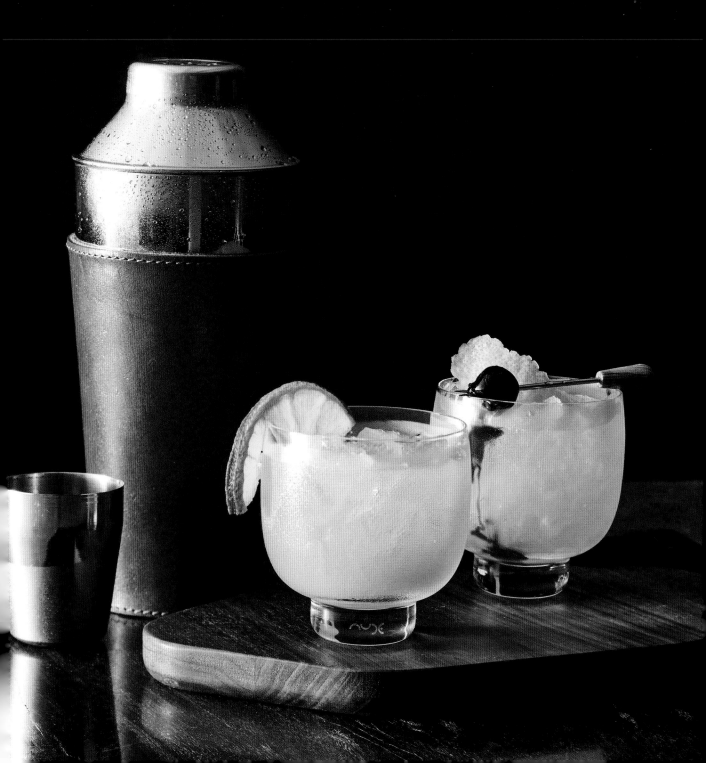

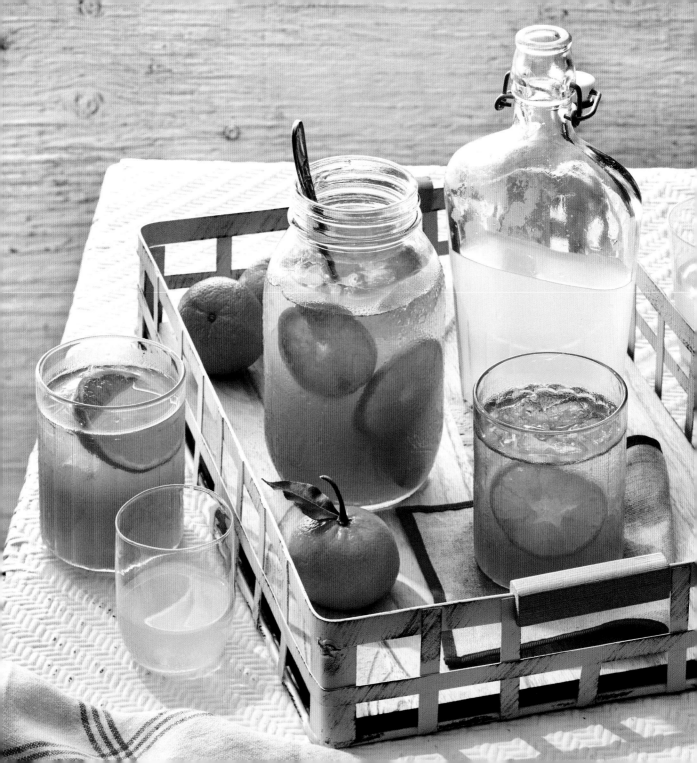

SATSUMA OLD-FASHIONED

SERVES 4

Orange and bourbon have an affinity for one another. When in season, seek out Southern satsumas, a mandarin variety that is sweeter and more aromatic than standard navel oranges.

1 cup Satsuma-Cello (recipe follows)

4 ounces (½ cup) bourbon

4 dashes Homemade Digestive Bitters (page 32) or Angostura bitters

4 dashes Peychaud's bitters

2 cups ice

2 cups club soda

Mix Satsuma-Cello, bourbon, Angostura bitters, and Peychaud's bitters in a pitcher. Stir in ice and club soda.

SATSUMA-CELLO

MAKES ABOUT 3 QUARTS

Italians have their limoncello, so it makes sense for Southerners to make Satsuma-cello. Jars of this citrus liqueur make a great gift for any host.

20 satsuma oranges*

2 (750-milliliter) bottles vodka

4 cups sugar

1. Peel the satsumas, reserving the flesh for another use. Scrape the bitter white pith from the orange rind strips, and discard pith. Place the orange rind strips in a 3-quart glass pitcher or jar with the vodka. Cover and let stand at room temperature 7 to 10 days.

2. Bring the sugar and 5 cups water to a boil in a large saucepan over medium heat. Reduce the heat to low, and simmer, stirring occasionally, 1 minute or until sugar is dissolved. Remove from heat; let stand 30 minutes. Pour syrup into vodka mixture. Cover and let stand at room temperature 24 hours.

3. Pour the mixture through a fine wire-mesh sieve into another pitcher, discarding orange rind strips. Pour into sealable bottles or Mason jars. Seal and chill 4 hours before serving. Store in refrigerator up to 1 month.

NOTE

*15 minneola tangelos may be substituted.

Ruby Red grapefruit are the state fruit of Texas where they are grown from November through May in the Rio Grande Valley.

BROWN DERBY

SERVES 1

Texas grapefruit and jalapeño gives this Brown Derby a decidedly Lone Star flavor.

Herb Rim Sugar made with basil (page 18)

1 ounce (2 tablespoons) fresh Ruby Red grapefruit juice

1½ ounces (3 tablespoons) bourbon

¼ ounce (½ tablespoon) Jalapeño-Honey Syrup (page 29)

2 basil leaves

Garnish: Boozy Stone Fruit cherry (page 22) and a grapefruit slice

1. Dampen the rim of an old-fashioned glass and invert it onto a shallow plate covered with the rim sugar. Twist the glass to coat the rim.

2. In a cocktail shaker, combine the grapefruit juice, bourbon, Jalapeño-Honey Syrup, and basil. Fill a chilled rocks glass with ice. Add 5 ice cubes to the shaker and shake well. Strain the drink into the ice-filled rocks glass. Garnish as desired.

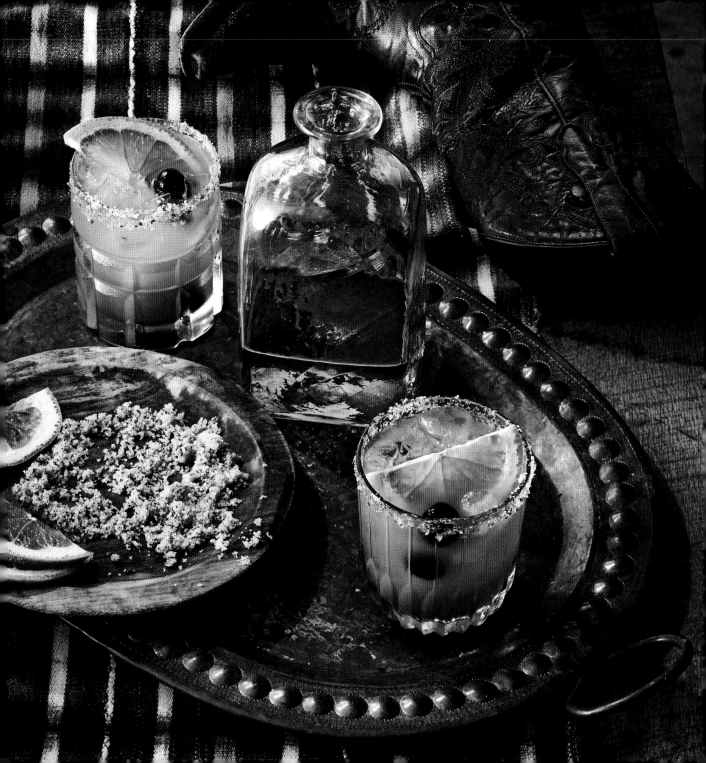

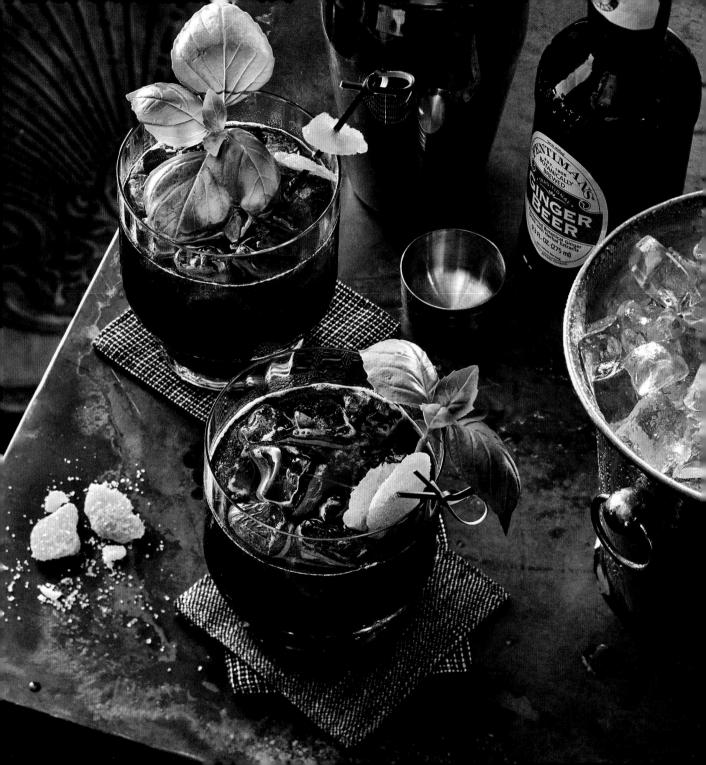

BUFALA NEGRA

SERVES 1

Atlanta bartender Jerry Slater created this inspired cocktail while working at a James Beard dinner at the Seelbach Hotel in Louisville, Kentucky. The cocktail's name is a nod to the Buffalo Trace bourbon used and the dark color that the balsamic vinegar gives the drink. Since its circa 2007 creation, the cocktail has appeared in *The New York Times, Imbibe* magazine, and on many bar menus.

3 basil leaves

1 teaspoon aged balsamic vinegar

½ ounce (1 tablespoon) Simple Syrup (page 27)

1½ ounces (3 tablespoons) bourbon

1½ ounces (3 tablespoons) chilled ginger beer

Garnish: Candied Ginger (page 25) and a basil sprig

In a cocktail shaker, muddle the basil leaves with the vinegar and syrup. Add ice and the bourbon and shake well. Strain the drink into an ice-filled rocks glass, stir in the ginger ale. Garnish as desired.

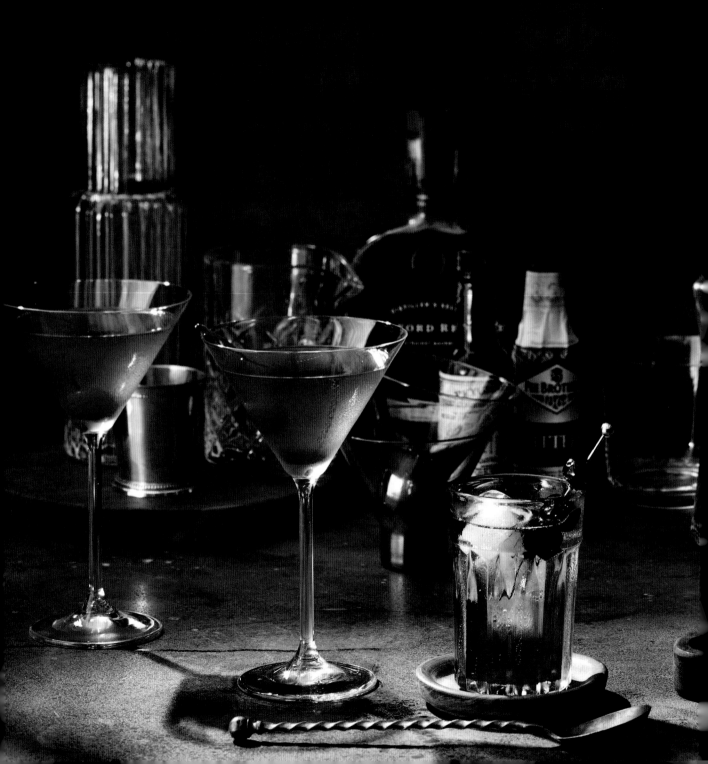

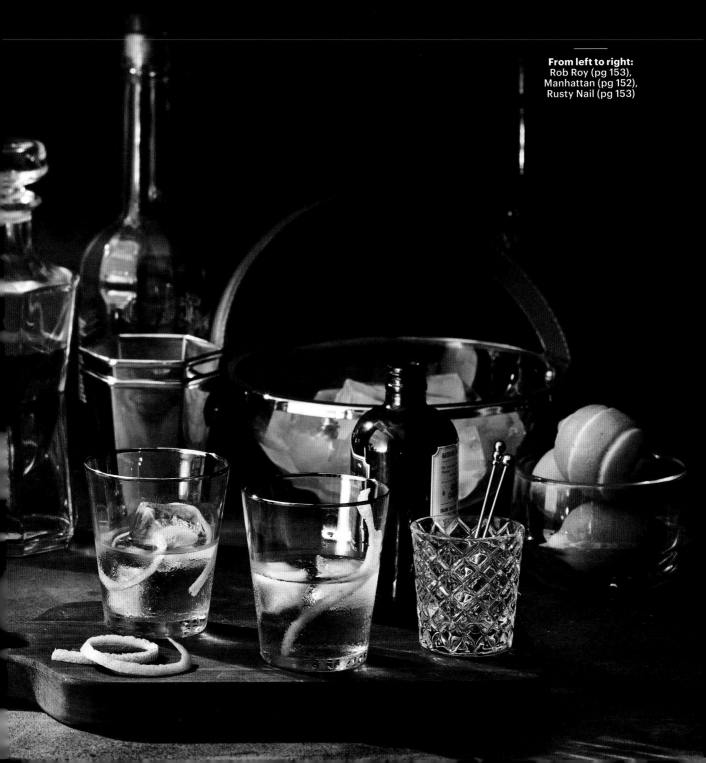

From left to right:
Rob Roy (pg 153),
Manhattan (pg 152),
Rusty Nail (pg 153)

The mash for American rye whiskey must contain at least 51% rye grain, and must age at least 2 years in new charred oak barrels. The resulting spirit cannot be more than 125-proof or 62.5% ABV.

MANHATTAN

SERVES 1

The myth of the Manhattan is rooted in the 1870s when it is said that Winston Churchill's mother, Lady Randolph, hosted New York Governor and presidential candidate Samuel J. Tilden at New York City's Manhattan Club. This was the signature drink served at the party. It was a hit, as was Tilden, who won the popular vote for President, yet Rutherford B. Hayes won the office. Substitute dry vermouth here if you prefer. *Photograph on pg 150*

1½ ounces (3 tablespoons) rye whiskey or bourbon

¾ ounce (1½ tablespoons) sweet vermouth

Dash of Peychaud's bitters

½ cup crushed ice

Garnish: Boozy Stone Fruit cherry (page 22)

Combine the bourbon, vermouth, and bitters in a cocktail shaker. Stir in the ice, and strain into a cocktail glass. Garnish as desired.

ROB ROY

SERVES 1

Named for an operetta that premiered in the late 1800s, this is a Scotch variation on the Manhattan, which is in the class of martini drinks. *Photograph on pg 150*

2 ounces (¼ cup) Scotch whisky

1 ounce (2 tablespoons) sweet vermouth

2 dashes Homemade Digestive Bitters (page 32) or Angostura bitters

Garnish: maraschino or luxardo cherry

Combine the Scotch and vermouth in an ice-filled mixing glass. Add the Angostura bitters and stir with a bar spoon. Strain into a chilled martini glass to serve up or in an ice-filled old-fashioned glass to serve on the rocks. Garnish as desired.

VARIATIONS

Dry Rob Roy: use dry vermouth in place of the cherry and garnish with an orange twist.

Perfect Rob Roy: use ½ ounce (1 tablespoon) each of sweet and dry vermouth and garnish with a cherry and a lemon twist.

RUSTY NAIL

SERVES 1

This can be served on the rocks or neat in an old-fashioned glass, or served up in a stemmed glass. *Photograph on pg 151*

2 ounces (¼ cup) Scotch whisky

½ ounce (1 tablespoon) Drambuie

Garnish: lemon twist

Combine the Scotch and Drambuie in an old-fashioned glass filled halfway with ice. Stir to mix. Garnish as desired.

VARIATIONS

Rusty Bob: swap the Scotch for bourbon.

Rusty Spur: swap the Scotch for mezcal. or tequila.

BAR TALK
Vermouth
This fortified and aromatized wine is spiked with brandy and infused with herbs and spices. Sweet, red vermouth is originally from Italy while white, dry vermouth hails from France. If you have extra vermouth, use it in your cooking. Dry vermouth adds depth to savory dishes like French onion soup while sweet vermouth works in both sweet and savory dishes.

CLASSIC & CRAFT COCKTAILS

BLACKBERRY BRAMBLE PISCO SOURS

MAKES 4 SERVINGS

Pisco is a South American grape brandy popular in Peru and Chile. If you can't find it in your area, feel free to substitute white tequila or un-aged brandy. Don't be alarmed by the strength of this new classic; it's a cocktail that's meant to be sipped and savored.

1 cup fresh blackberries

8 ounces (1 cup) pisco, chilled

2½ ounces (⅓ cup) fresh lime juice

3 large pasteurized egg whites

2½ ounces (⅓ cup) Blackberry Simple Syrup (page 27)

Homemade Digestive Bitters (page 32) or Angostura bitters

Garnishes: fresh basil leaves and fresh blackberries

1. Process theh blackberries in a blender until smooth. Pour through a wire-mesh strainer into a 1-quart jar with a tight-fitting lid, discarding solids.

2. Add the pisco and next 3 ingredients to the jar. Cover with lid, and shake vigorously 30 seconds or until foamy. Pour the mixture into 4 (10-ounce) glasses filled with ice. Top each with a dash of bitters. Garnish as desired. Serve immediately.

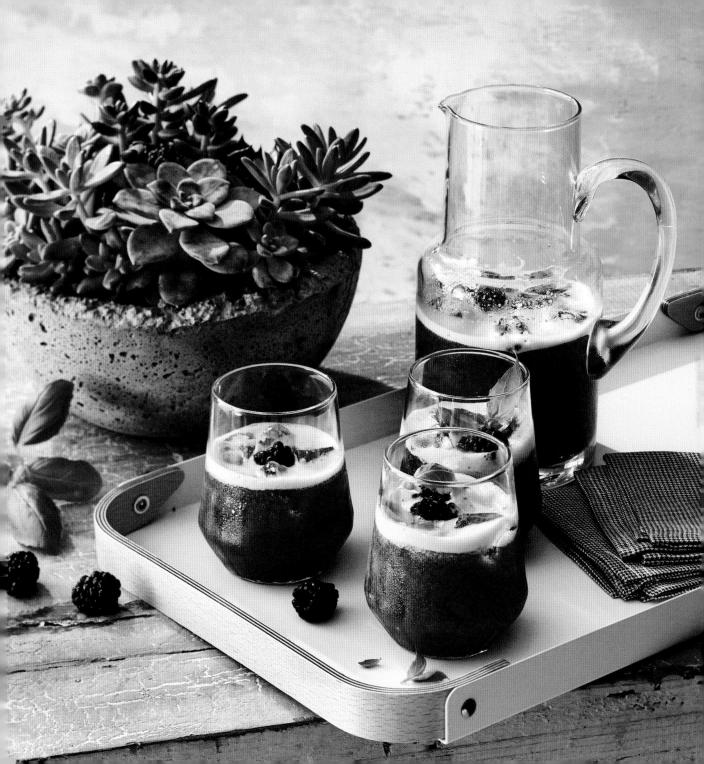

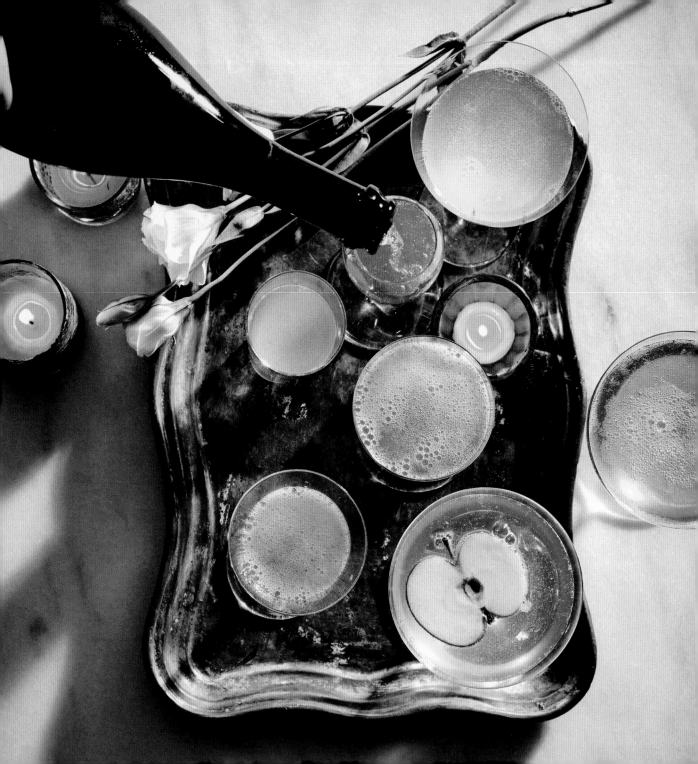

FRENCH 75

SERVES 1

Traditionally made with gin, brandy, or Cognac, this Parisian cocktail is said to have the same punch as a French 75 mm field gun.

1½ ounces (3 tablespoons) gin or brandy

½ ounce (1 tablespoon) orange liqueur

1 lemon wedge

1 lemon twist

4 ounces (½ cup) Champagne or sparkling wine

Combine the brandy, orange liqueur, and crushed ice in a cocktail shaker. Cover with lid, and shake until thoroughly chilled. Strain into a glass. Squeeze the juice from the lemon wedge into the glass. Add the lemon twist and Champagne or sparkling wine.

SOUTHERN 75

MAKES 3½ CUPS

This big-batch spin on the French 75 is ideal for front porch sipping with friends.

8 ounces (1 cup) bourbon

4 ounces (½ cup) lemon juice

2½ ounces (⅓ cup) powdered sugar

16 ounces (2 cups) chilled hard cider (such as Angry Orchard)

Garnish: apple slices

Stir together the bourbon, lemon juice, and powdered sugar in a pitcher until the sugar dissolves (about 30 seconds). Cover and chill 3 hours. Divide among 8 Champagne flutes; top each with ¼ cup chilled hard cider (such as Angry Orchard). Garnish as desired.

NOTE

Mix together the first 3 ingredients of this twist on a classic French 75 up to 24 hours ahead.

THE CORDUROY JACKET

MAKES 1 SERVING

This retro-inspired cocktail is tailor made for cool weather sipping. Substitute hard cider or Champagne for the sparkling apple cider for a more potent drink.

Warm Spiced Rim Sugar (page 19)

1 fresh orange slice

1 brown sugar cube

2 dashes Angostura bitters

2 ounces (¼ cup) cognac

3 ounces (6 tablespoons) chilled sparkling apple cider

Garnish: orange peel strip and fresh thyme sprig

1. Rub an orange around the rim of a stemmed 10-ounce glass to moisten. Invert the glass in the rim sugar and twist to coat.

2. Muddle the orange slice, brown sugar cube, and Angostura bitters in a cocktail shaker to release flavors.

3. Fill a shaker with ice cubes, and add cognac; cover with lid, and shake vigorously until thoroughly chilled (about 30 seconds). Strain into the prepared glass.

4. Top with sparkling apple cider. Garnish as desired.

Make this classic with a Southern brew like Birmingham, Alabama's Good People's Coffee Oatmeal Stout.

161

SPICED STOUT COCKTAIL

SERVES 1

Brandy, stout, and a cinnamon stick come together to form the beer-lover's new favorite cocktail.

1 ounce (2 tablespoons) brandy

1 ounce (2 tablespoons) Spicy Simple Syrup (page 27)

Stout beer

Garnish: cinnamon stick

Combine the brandy and Spicy Simple Syrup in a pint glass over ice. Top with the chocolate stout, and stir. Garnish as desired.

BRANDY ALEXANDER

SERVES 1

A throwback to the rich after-dinner drinks of the 1950s, the original recipe for this cocktail was published in 1916's *Recipes for Mixed Drinks* and made with gin. This creamy old-school drink is worth resurrecting.

1½ ounces (3 tablespoons) brandy

¾ ounce (1½ tablespoons) crème de cacao

½ ounce (1 tablespoon) heavy cream

½ cup crushed ice

Combine all the ingredients in a cocktail shaker. Cover with the lid, and shake vigorously until thoroughly chilled, at least 30 seconds. Strain into a cocktail glass.

SOUTHERN TWIST
Bourbon Alexander
Substitute bourbon for the brandy and praline pecan liqueur for the crème de cacao.

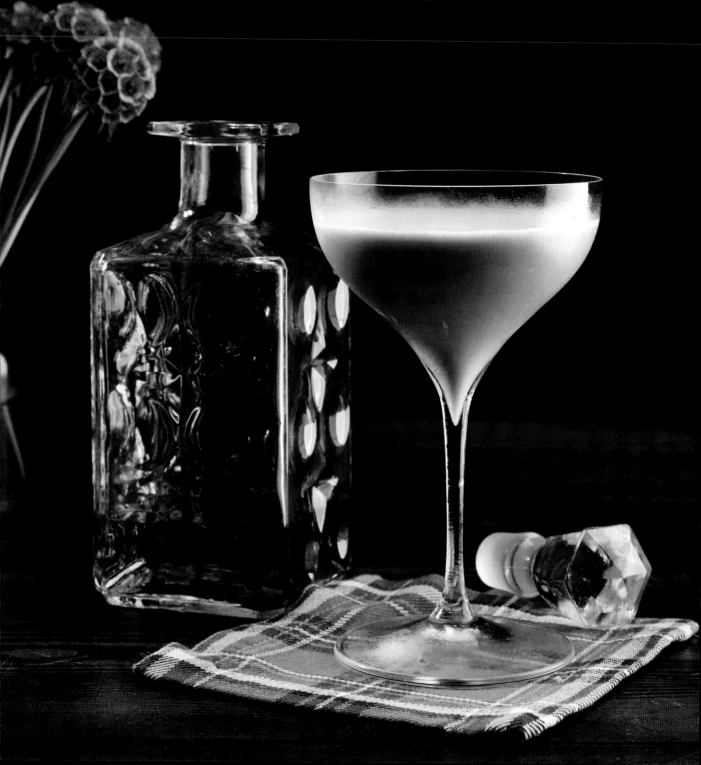

PITCHERS & PUNCH BOWLS

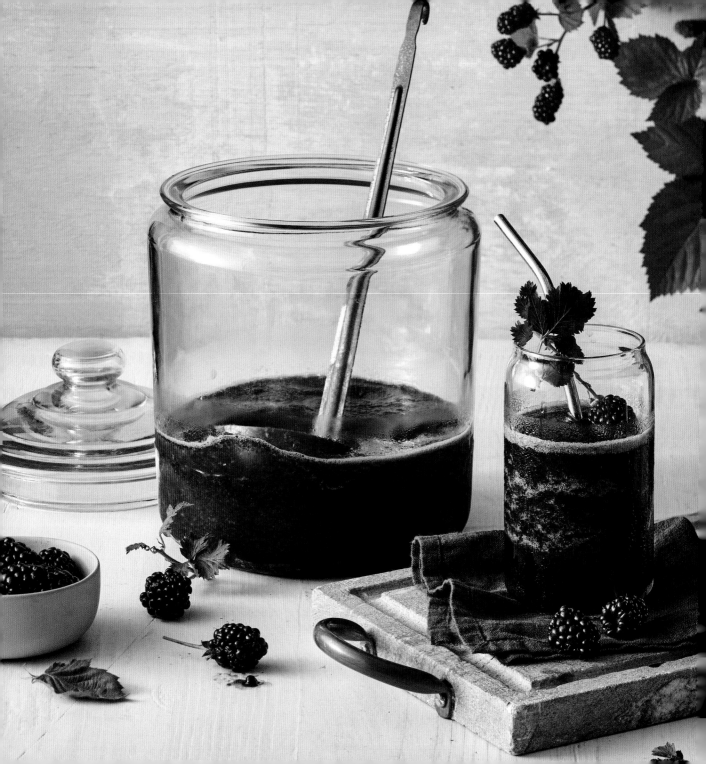

BIG-BATCH BLACKBERRY FROSÉ

SERVES 10

In the South, blackberries hold an honored place on tables and in memories. They are some of the first fruits of spring. White flowers appear on canes before clusters of fruit that turn from green to red to purple on their way to sweet, juicy almost-black ripeness. This refreshing homage to the berry bramble gets its hue from rosé made from red wine grapes.

2 (750-milliliter) bottles Pinot Noir or Merlot rosé

8 ounces (1 cup) Blackberry Simple Syrup (page 27)

4 ounces (½ cup) Lillet Blanc

4 ounces (½ cup) fresh lemon juice (from 3 lemons)

2 cups crushed ice

Garnish: fresh blackberries

1. Pour each bottle of rosé into a separate 13- x 9-inch baking dish. Freeze until wine is almost solid, at least 6 hours and up to 8 hours.

2. Scrape the partially frozen rosé into a blender. Add the Blackberry Simple Syrup, Lillet Blanc, lemon juice, and crushed ice; process until smooth. Place the blender container in the freezer, and freeze until thickened, 35 to 40 minutes.

3. Place the container back on the blender base, and process until slushy. Divide among highball glasses, and garnish as desired. Serve immediately with a straw.

CAVA SANGRIA

SERVES 8 TO 10

Work with your wine purveyor to select a Spanish Cava with a flavor profile—
dry or sweet—to suit your crowd's tastes.

16 large mint leaves

2 (750-milliliter) bottles Cava sparkling wine, chilled*

12 ounces (1½ cups) white grape juice, chilled

1 cup sliced fresh strawberries

4 ounces (½ cup) orange liqueur

Press the mint leaves against the sides of a large pitcher with back of a wooden spoon to release flavors. Stir in the sparkling wine and next 3 ingredients. Serve immediately over ice.

BAR TALK
Tiny Bubbles
Asti: Sparkling sweet Italian white
Cava: Sparkling dry to sweet Spanish white or rosé
Cremant: Sparkling, aged French white and rosé
Franciacorta: Sparkling dry to sweet white or red
Lambrusco: Dry to sweet, sparkling, or "frizzante," red
Prosecco: Sparkling, light Italian white

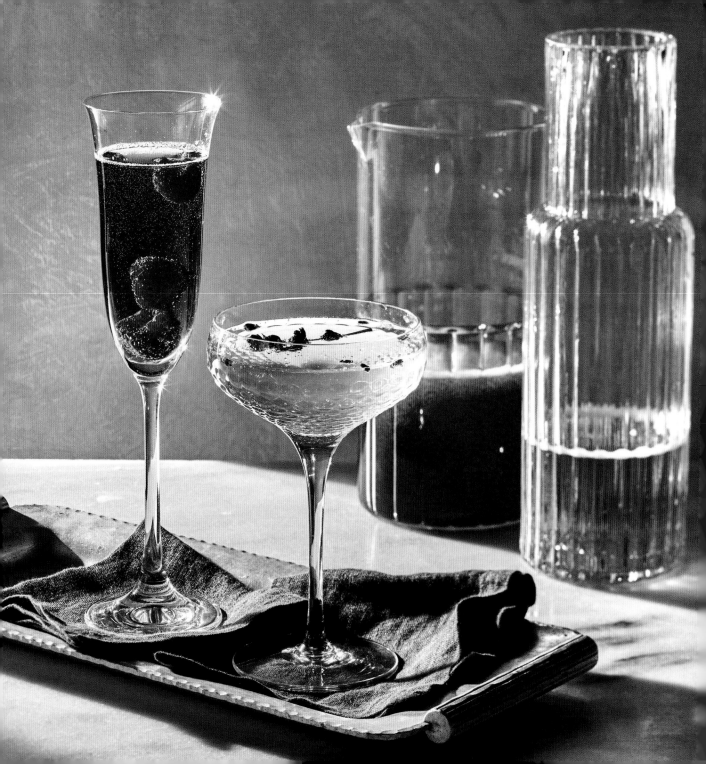

KIR IMPERIAL

SERVES 4

This riff on the Kir Royale (page 85) substitutes Chambord, a raspberry liqueur, for crème de cassis.

2½ ounces (5 tablespoons) Chambord

1 (750-milliliter) bottle Champagne

Garnish: fresh raspberries

Pour the liqueur into a pitcher; add the Champagne. Garnish as desired.

CHAMPAGNE PUNCH

SERVES 8

In its early days, Champagne was still (had no bubbles) and pink or red from the pinot noir grapes used. It was also quite green so often mixed like this with stronger spirits and flavorings to create a more complex and potent punch.

1 (750-milliliter) bottle Champagne or Prosecco

8 ounces (1 cup) dry gin

2½ ounces (5 tablespoons) Simple Syrup (page 27)

2 ounces (¼ cup) fresh lemon juice

Garnish: dried lavender sprig

Stir together the ingredients in a punch bowl or pitcher. Garnish as desired.

SOUTHERN TWIST

Muscadine Punch

Substitute sparkling Southern muscadine wine for the Champagne and bourbon for the gin.

SPIKED ARNOLD PALMER

SERVES 10

Famed golfer, Arnold Palmer, went for 3 parts unsweetened tea to 1 part lemonade in his preferred non-alcoholic refreshment. These two Southern favorites—iced tea and lemonade—are tailor made for a shot of bourbon and leisurely front-porch sipping with friends.

32 ounces (4 cups) boiling water

5 regular-size tea bags

¾ cup sugar

1 teaspoon lemon zest

32 ounces (4 cups) cold water

8 ounces (1 cup) bourbon

4 ounces (½ cup) fresh lemon juice

Garnish: lemon slices

1. Pour the boiling water over the tea bags, sugar, and lemon zest in a large bowl. Stir until the sugar is dissolved; cover and steep 5 minutes.

2. Pour the mixture through a fine-mesh strainer into a large pitcher, discarding the tea bags and zest. Stir in the 4 cups cold water and next 2 ingredients. Cover and chill 30 minutes to 12 hours. Serve in an ice-filled Collins or highball glass. Garnish as desired.

VARIATION

Substitute vodka for the bourbon to make a John Daly.

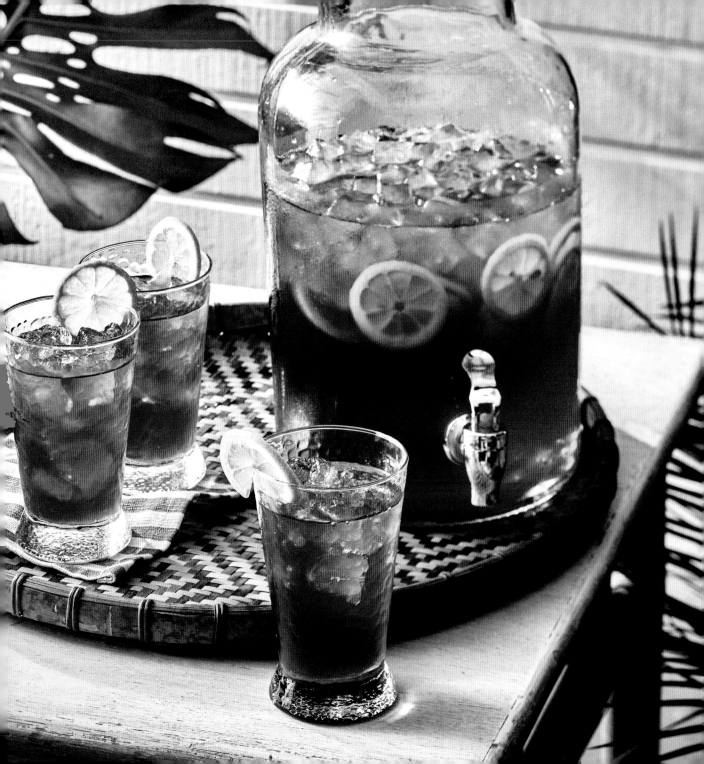

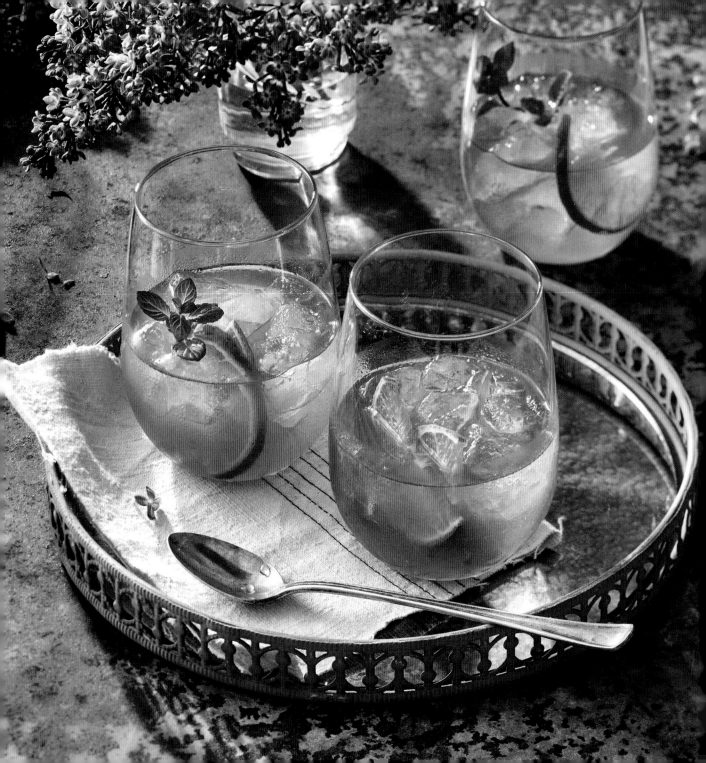

SHOO-FLY PUNCH

SERVES 4

If shoo-fly pie is a spiced molasses cake served in a pie crust, consider this an orange-scented gingersnap in a glass. Pour over crushed ice and accent with sweet oranges and garden mint, and you're well on your way to a most perfect summertime sipper.

10 ounces (1¼ cups) bourbon

4 ounces (½ cup) ginger liqueur (such as Domaine de Canton)

2 ounces (¼ cup) fresh lemon juice

2 ounces (¼ cup) Simple Syrup (page 27)

1 teaspoon Homemade Digestive Bitters (page 32) or orange bitters

12 ounces (1½ cups) nonalcoholic ginger beer, chilled

Garnishes: orange slices and fresh mint sprigs

Stir together the first 5 ingredients in a pitcher. Add crushed ice. Top with the ginger beer, and stir gently to combine. Pour into stemless wineglasses. Garnish as desired. Serve immediately.

BAR TALK

Liqueurs

Liqueurs, like schnapps, Chambord, Kahlúa, or Triple Sec, blend a base spirit like whiskey or gin or a fortified wine like brandy with sugar and flavorings. Typically lower in alcohol than liquor, a liqueur may be sipped straight before or after a meal or used as an ingredient in cocktails.

Crowds gather in The Grove on game day at Ole Miss. Tailgating here is serious business, but don't think that means business-casual. Here, they dress to win!

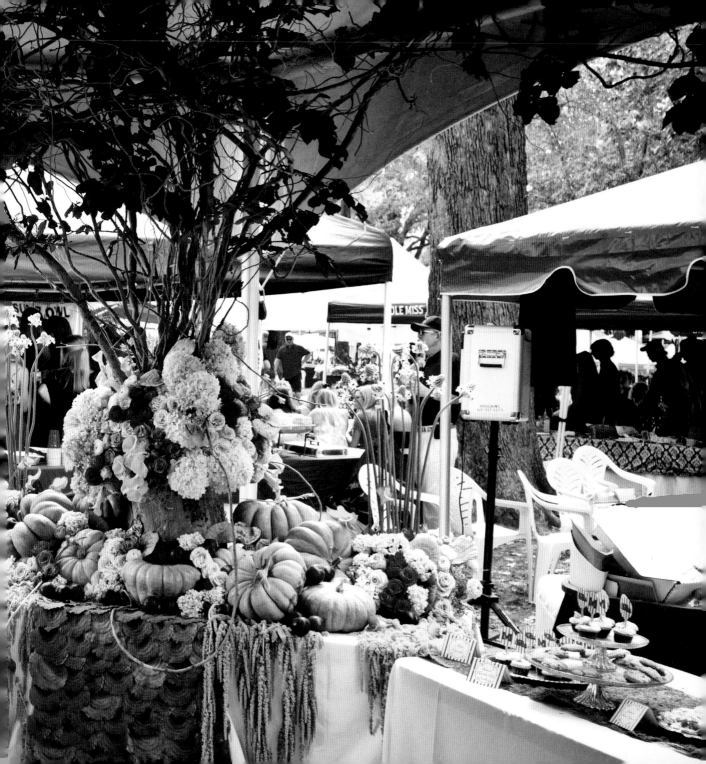

GAME DAY WHISKEY SOUR SLUSH

SERVES 18 TO 20

This frosty take on the whiskey sour is a fan favorite on balmy game days. Who wouldn't welcome an frozen mix of refreshing lemonade and sparkling citrus when it's 90 degrees with 90% humidity on the stadium lawn? Tuck this away in an ice-packed cooler until kickoff for the perfect consistency.

1 (12-ounce) can frozen lemonade concentrate, thawed

½ (12-ounce) can frozen orange juice concentrate, thawed

6 ounces (¾ cup) lemon juice

20 ounces (2½ cups) bourbon

1 (2-liter) bottle lemon-lime soft drink

Garnish: lemon slices

Stir together the first 5 ingredients. Freeze 8 hours. To serve, stir until the mixture is a uniform slushy consistency. Pour into plastic cups or canning jars to serve. Garnish as desired.

VARIATION

Substitute brandy for the bourbon to make a Brandy Sour Slush.

TAILGATE PUNCH

SERVES ABOUT 45

This is for the mother of all tailgates: the playoffs, the championship game, or when you expect a gathering so big that it's worth mixing a large-scale batch in a (sanitized) trash can. Double or triple the recipe, depending on your crowd.

128 ounces (1 gallon) water

16 black tea bags

32 ounces (4 cups) honey

32 ounces (4 cups) fresh orange juice (from 4 medium-size oranges)

1 (1.75-liter) bottle bourbon

1 (1.75-liter) bottle cognac (such as Hennessy V.S)

1 (1.75-liter) bottle spiced rum (such as Sailor Jerry)

Warm Spiced Rim Sugar (page 19)

1. Bring 1-gallon water to a boil in a large stockpot over high. Remove from heat; add the tea and honey, whisking until the honey dissolves. Cover and steep 5 minutes. Discard the tea bags. Stir in the orange juice, and let cool completely, about 1 hour.

2. Add the bourbon, cognac, and rum; stir to combine. Cover and chill until ready to serve. Transfer to a large punch bowl filled with ice. Serve the punch in glasses rimmed with Warm Spiced Rim Sugar, if desired.

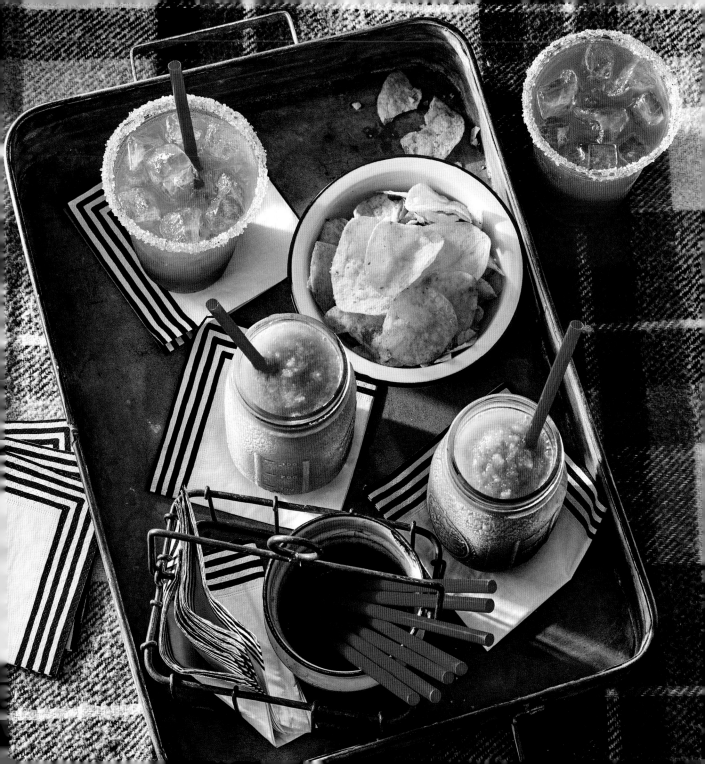

ACROSS-THE-POND HOT TODDY

SERVES 12 TO 14

The word "toddy" comes from South Asia and refers to the fermented nectar of the coconut flower, which was then distilled to make arrack, a liquor similar to whiskey or rum. The resulting alcohol was mixed with hot water, sugar, and spices to make a spirited tea.

6 teaspoons finely grated lemon zest (from about 3 lemons)

1 lemon, thinly sliced

¾ cup packed dark brown sugar

40 ounces (5 cups) boiling water

1 (750-milliliter) bottle Irish whiskey

Garnishes: grated nutmeg and cinnamon sticks

1. Place the lemon zest, lemon slices, and brown sugar in the bottom of a bowl. Muddle in the bottom and against the sides of the bowl to break up the lemons and dissolve the sugar. Set aside 1 hour. Muddle again.

2. Add 8 ounces of the boiling water, and stir until the sugar is completely dissolved. Strain the mixture into a 60-ounce heatproof pitcher. Discard the solids. Add the remaining 4 cups boiling water and the whiskey. Serve in warmed glass mugs or insulated cups. Garnish as desired.

VARIATION

Substitute Scotch whisky for the Irish whiskey to make a Hot Whisky.

SOUTHERN TWIST
Faulkner's Hot Toddy
Mix half a glass of Heaven Hill bourbon with 1 tablespoon granulated sugar and the juice of ½ lemon. Top off with boiling water.

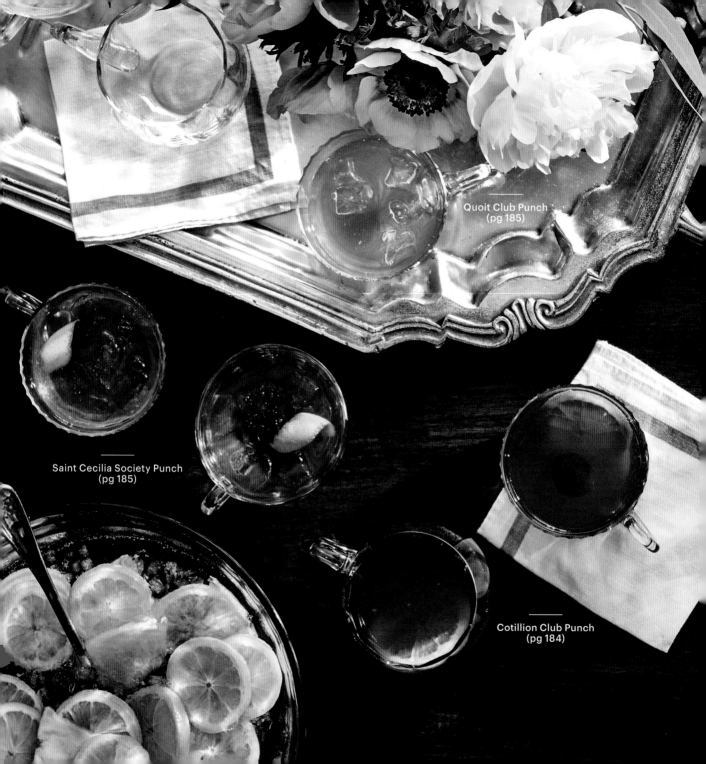

Quoit Club Punch
(pg 185)

Saint Cecilia Society Punch
(pg 185)

Cotillion Club Punch
(pg 184)

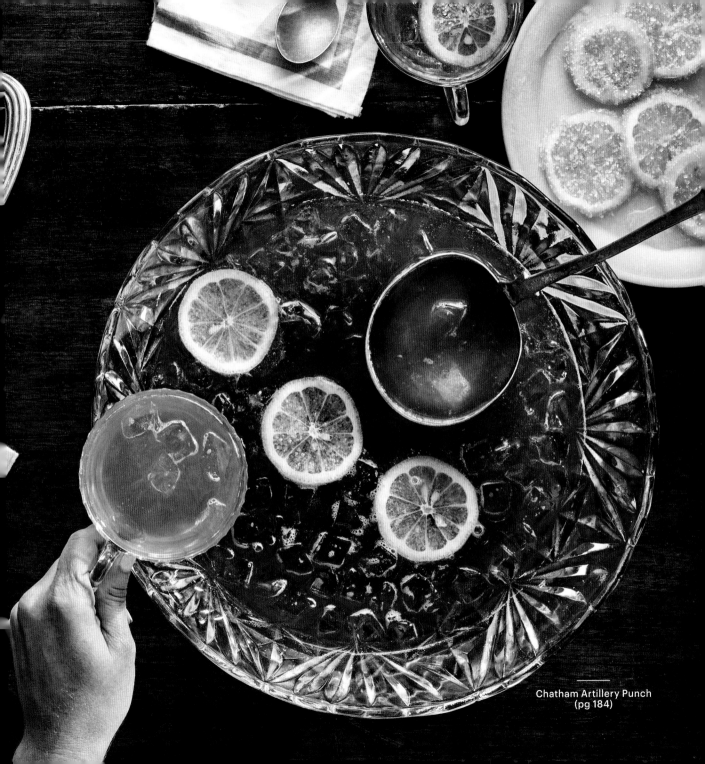

Chatham Artillery Punch
(pg 184)

COTILLION CLUB PUNCH

SERVES 20

From *Charleston Receipts,* this is a classic punch of cotillion dance season. *Photograph on pg 182*

1¼ cups granulated sugar

Peels from 3 oranges, cut into strips

88 ounces (11 cups) water

2 ounces loose gunpowder green tea

2 (15-ounce) cans dark cherries in syrup

8 ounces (1 cup) fresh lemon juice

2 (1.75-liter) bottles (10 cups) rye whiskey

4 ounces (½ cup) light rum

2 (2-liter) bottles seltzer water

1 medium-size orange, thinly sliced

1. Simmer the sugar, orange peels, and 1 cup of the water in a saucepan, whisking often, until the sugar dissolves, 2 minutes. Remove from the heat. Cool 1 hour. Chill until ready to use.

2. Bring remaining 10 cups water to a boil in a saucepan. Remove from the heat and add the tea; stir once. Steep 5 minutes. Pour through a fine -mesh strainer into a bowl; discard solids. Stir in the next 5 ingredients. Chill. Combine ½ cup seltzer for each 1 cup chilled punch base in a punch bowl with orange slices.

CHATHAM ARTILLERY PUNCH

SERVES 24

This is the traditional punch of Chatham Artillery, the oldest military organization in the state of Georgia. It is thought that "gentle ladies" created the light, flavorful punch for visiting dignitaries, but that the Artillery officers tossed in assorted spirits on the sly to give it a welcome punch! *Photograph on pg 183*

Oleo-Saccharum (page 37)

2 cups (16 ounces) fresh lemon juice (from 12 lemons)

1¼ cups (10 ounces) water

1 (750-milliliter) bottle cognac

1 (750-milliliter) bottle Tennessee whiskey or bourbon

1 (750-milliliter) bottle dark rum

3 (750-milliliter) bottles sparkling wine, chilled

Garnish: lemon Candied Citrus Wheel (page 23)

Combine the Oleo-Saccharum, lemon juice, and 1¼ cups water in a punch bowl. Stir in the cognac, whiskey, and rum to combine. Just before serving, stir in the sparkling wine. Serve immediately over crushed ice, and garnish as desired.

QUOIT CLUB PUNCH

SERVES 10 TO 12

A quoit is a ring of iron tossed for sport on a post or peg. Richmond's Quoit Club was a drinking club founded by Chief Justice John Marshall to bring together friends to play the game. This recipe was the club bartender's signature punch.
Photograph on pg 182

1 (750-milliliter) bottle dark rum

1 (750-milliliter) bottle Armagnac

1 (750-milliliter) bottle Madeira

2 cups fresh lemon juice, strained (from 12 lemons)

Oleo-Saccharum (page 37)

6 cups crushed ice

Combine all the ingredients in a large punch bowl, and stir to chill. Serve immediately.

SAINT CECILIA SOCIETY PUNCH

SERVES 12

From the oldest social club in Charleston to punch bowls everywhere, this recipe endures.
Photograph on pg 182

2 small lemons, thinly sliced

8 ounces (1 cup) cognac

½ cup sliced fresh pineapple

8 ounces (1 cup) brewed green tea

6 ounces (¾ cup) honey or Simple Syrup (page 27)

4 ounces (½ cup) dark Jamaican rum

2 ounces (¼ cup) apricot brandy

16 ounces (2 cups) sparkling water, chilled

1 (750-milliliter) bottle brut Champagne, chilled

1. Combine the lemons and cognac in a large bowl. Cover and let stand at room temperature 24 hours.

2. Add the pineapple to the brandy mixture. Let stand 3 hours.

3. Combine the cognac mixture, tea, honey, rum, and apricot brandy, stirring until the honey dissolves. Add the sparkling water and Champagne, stirring gently until blended. Serve immediately.

A combined harvester and a tipper truck make quick work of the sugarcane harvest in Gulf Shores, Alabama.

PLANTER'S PUNCH

SERVES 4

You might think this tipple deserves a spot in the "Storied Southern Sips" chapter, but its origin tale is a tall one. This sweet rum-spiked concoction is often attributed to the original Planters Inn in Charleston, South Carolina, but don't be fooled. As its flavor profile hints, this tiki-esque drink has Jamaican roots. The first mention of this cocktail in print appeared in a London magazine in 1878, which ran a recipe in poetic verse for "Planter's Punch! A West Indies Recipe."

8 ounces (1 cup) lime juice

8 ounces (1 cup) orange juice

8 ounces (1 cup) pineapple juice

½ ounce (1 tablespoon) grenadine syrup

2 tablespoons, plus teaspoons sugar

8 ounces (1 cup) light rum

8 ounces (1 cup) dark Jamaican rum

Garnishes: orange slice and pineapple wedge

Combine the fruit juices, grenadine syrup, and sugar. Stir until the sugar dissolves. Pour into 12-ounce serving glasses filled with the crushed ice. Add the rum. Garnish as desired.

CAJUN LEMONADE

SERVES 8

A veritable swamp of spirits, citrus, sparkle, and spice served over ice, this cocktail beats the heat while curing whatever ails you.

8 ounces (2 cups) light rum

8 ounces (2 cups) citron vodka

1 (12-ounce) can frozen lemonade concentrate, thawed

⅛ ounce (1 teaspoon) hot sauce

1 (1-liter) bottle club soda, chilled

Garnishes: sugarcane sticks, lemon slices

Stir together the first 4 ingredients. Add the club soda just before serving. Serve over the crushed ice. Garnish as desired.

BAR TALK
Club Soda vs. Seltzer

Club soda, seltzer, sparkling water, bubbly water, soda water...whatever you call the fizzy stuff, use them interchangeably. Key differences: Volcanic gas dissolved in spring water creates natural sparkling water. Seltzer is simply carbonated purified water. Club soda is carbonated water to which minerals like potassium citrate, potassium bicarbonate, and sodium have been added to enhance flavor.

Rum

Where there is sugarcane, there is rum. Sugarcane syrup and molasses, both byproducts of sugar production, are distilled to make rum, while fresh-pressed cane juice is fermented to make the spirits cachaça (aka "burning water") and the more refined rhum agricole. Rum varieties are many and they can range in color from rich brown to amber to crystal clear depending on whether they are sweetened with dark molasses or charcoal-filtered to clarify. At most liquor stores, you can find spiced rum, fruit-flavored rum, and high-proof rum like Jamaican or Old Navy which clock in at an eye-opening (or perhaps eye-closing) 58% ABV!

PITCHER BEER MARGARITAS

SERVES 8 TO 10

Mixing beer with a classic margarita recipe tames the latter's tartness. For fast measuring, use the empty can of limeade concentrate to measure the tequila. One 12-oz. can is equivalent to 1½ cups.

1 (12-ounce) can frozen limeade concentrate

12 ounces (1½ cups) cold water

12 ounces (1½ cups) silver tequila

6 ounces (¾ cup) Grand Marnier

1 (12-ounce) bottle Mexican lager (such as Corona), chilled

Garnish: lime wedges

Place the limeade concentrate in the bottom of a large pitcher or drink dispenser; pour the cold water and next 3 ingredients over the concentrate, stirring with a large spoon until frozen concentrate melts and is blended. Serve the margaritas over ice and garnish as desired.

PINK CADILLAC MARGARITAS

SERVES 4

Made with cranberry juice, fresh lime juice, Triple Sec, and tequila, these pretty cocktails are garnished with a sparkling rim.

Citrus Rim Sugar (page 17)

8 ounces (1 cup) tequila

8 ounces (1 cup) fresh lime juice

½ cup powdered sugar

4 ounces (½ cup) orange liqueur

4 ounces (½ cup) cranberry juice

1. Rub the rim of a highball glass with a lime wedge and invert the glass onto a shallow plate covered with a thin layer rim sugar. Twist the glass to coat the rim. Chill the glasses.

2. Stir together the remaining ingredients until the sugar is dissolved. Pour ¼ of the mixture into an ice-filled cocktail shaker. Cover with the lid, and shake vigorously until thoroughly chilled, about 30 seconds. Strain into chilled, rimmed cocktail glasses. Repeat with the remaining mixture. Serve immediately.

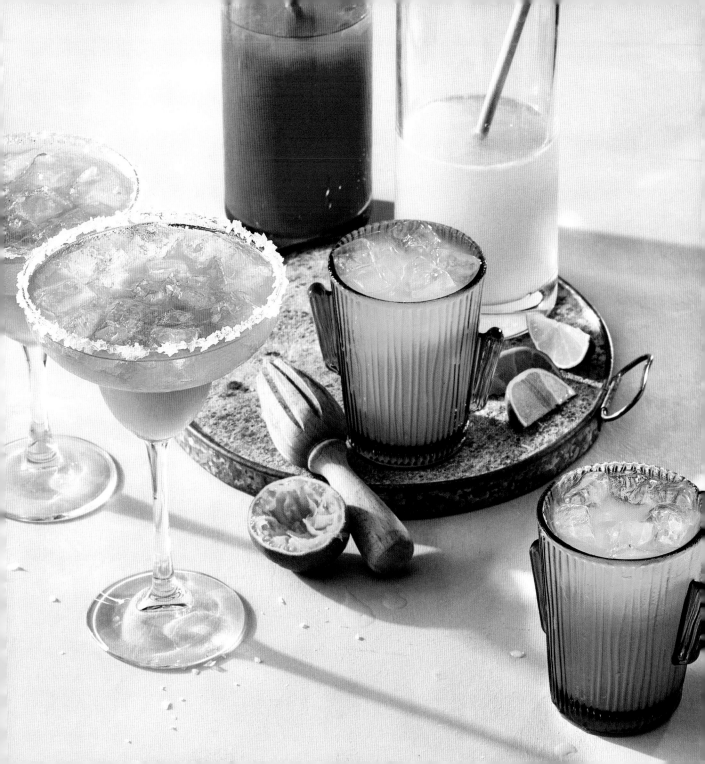

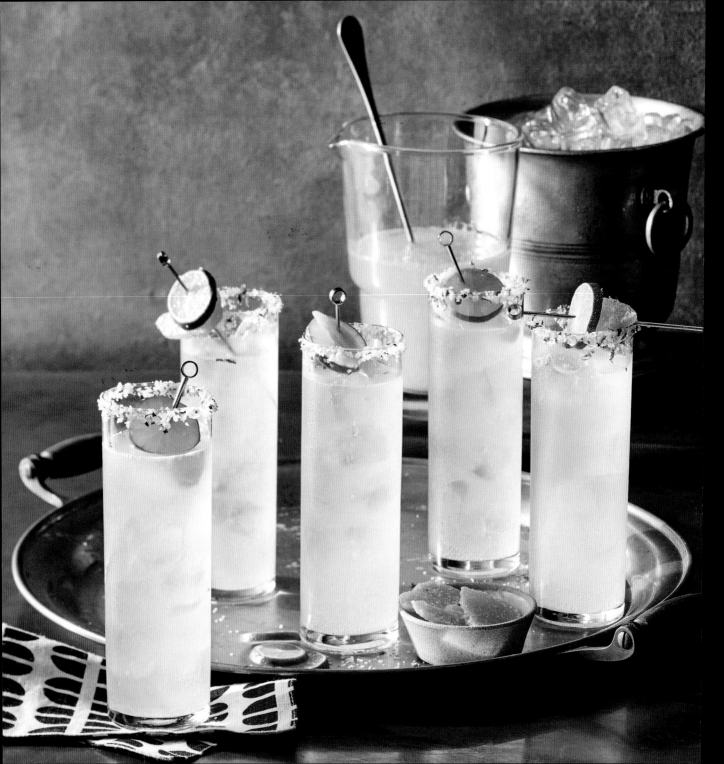

OAXACAN MULE

SERVES 6

This south-of-the-border spin on the popular vodka-ginger beer mashup known as a Moscow Mule trades the vodka for mezcal—a smoky, distilled agave spirit.

Lemon wedge

Citrus Rim Sugar, using Key lime zest (page 17)

3 ounces (6 tablespoons) freshly squeezed lime juice

12 ounces (1½ cups) mezcal (such as Creyente)

3 (12-ounce) bottles ginger beer

Garnish: Candied Ginger (page 25) and lime wedges

1. Rub the rim of each of 6 Collins glasses with a lemon wedge, and invert the glasses onto a shallow plate covered with a thin layer of the Citrus Rim Sugar. Twist the glass to coat the rim. Fill the glasses with ice.

2. Combine the lime juice and mezcal in a pitcher. Add the ginger beer, and stir gently with a mixing spoon.

3. Divide the cocktail among the prepared glasses. Garnish as desired.

THE GOGO-RITA PUNCH

SERVES 24

Grenadine heightens the ruby hue of this tantalizing melon margarita that is go...go... gorgeous! Chill all the ingredients before mixing.

3 cups watermelon juice

1½ cups white tequila

1½ cups lime juice

1½ cups Grand Marnier

1½ cups Simple Syrup (page 27)

½ cup grenadine

1 bottle champagne (3 cups)

Garnish: lime and orange wheels and watermelon wedges

Add the first 7 ingredients to a punch bowl. Stir to combine. Serve chilled or over ice. Garnish as desired.

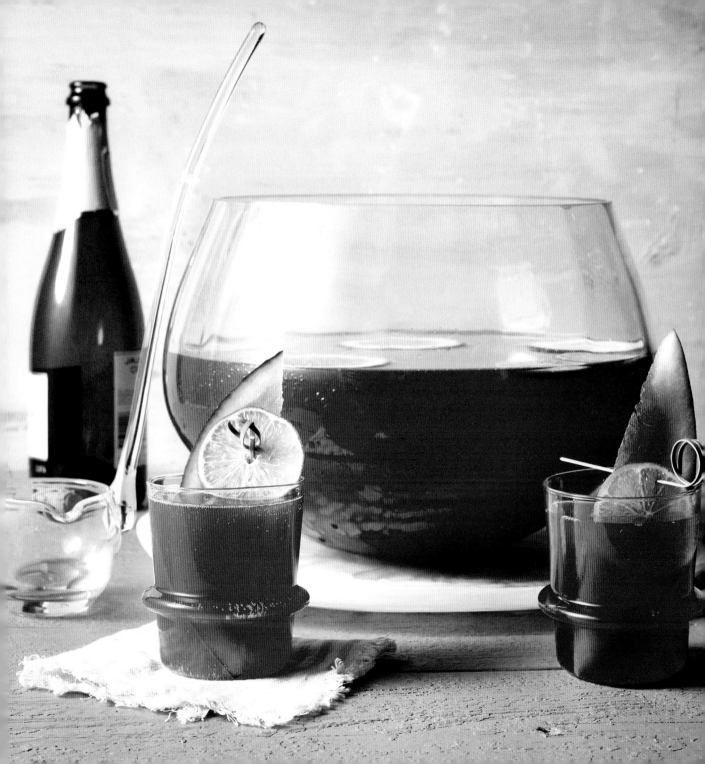

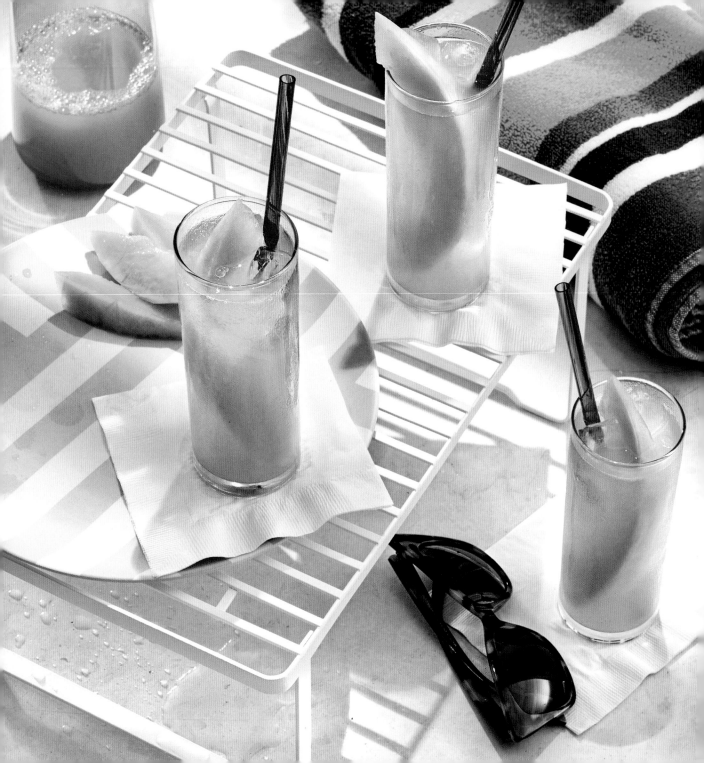

Fragrant, wild honeysuckle, *Lonicera periclymenum*, loves southern heat and sunshine.

199

HONEYDEW-HONEYSUCKLE PUNCH

SERVES 8

Juicy and refreshing, this drink embodies the sweetness of summertime.

8 cups seeded and cubed honeydew melon

8 ounces (1 cup) honeysuckle vodka*

4 ounces (½ cup) fresh lime juice

2 ounces (¼ cup) Simple Syrup (page 27)

4 cups ice cubes

16 ounces (2 cups) lime seltzer

Garnishes: lime slices, melon spear, fresh mint leaves

1. Process the melon in a blender or food processor until smooth. Pour through a fine -mesh strainer into a large pitcher, using back of a spoon to squeeze out the juice; discard the solids.

2. Stir the vodka and next 2 ingredients into the melon juice. Add the ice, and top with the seltzer; gently stir. Serve immediately. Garnish, if desired.

TOMATO MICHELADA

SERVES 8

There are two Michelada camps—the tomato-based diehards and no-tomato-ever purists. This recipe is for the former. See Variation for the tomato-free version.

32 ounces (4 cups) picante-style Clamato juice

3 (12-ounce) bottles Dos Equis beer or other Mexican lager

2 ounces (¼ cup) freshly squeezed lime juice

2 ounces (¼ cup) freshly squeezed lemon juice

¼ ounce (1½ teaspoons) Worcestershire sauce

⅛ ounce (1 teaspoon) Cholula hot sauce

8 lime wedges

Black Pepper-Bacon Rim Salt (page 19)

1. Mix the Clamato juice, beer, lime and lemon juices, Worcestershire sauce, and hot sauce in a large pitcher.

2. Rub a lime wedge around the rim of a pint glass. Invert the glass onto a shallow plate covered with a thin layer of the Black Pepper-Bacon Rim Salt. Twist the glass to coat the rim. Drop the lime wedge into the glass, and fill the glass with ice. Top with the Michelada mixture. Repeat with the remaining mixture and glasses.

VARIATION

Gently stir together 8 ounces (1 cup) freshly squeezed lime, 4 (12-ounce) Mexican lagers, 8 teaspoons Tapatio hot sauce, 6 teaspoons Worcestershire sauce to make a Spicy Lime Chelada to serve 4.

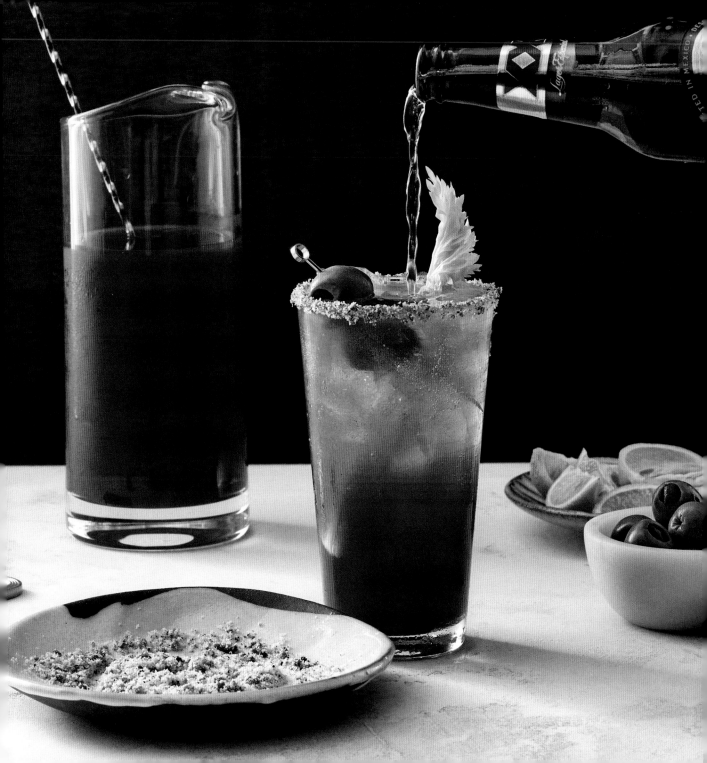

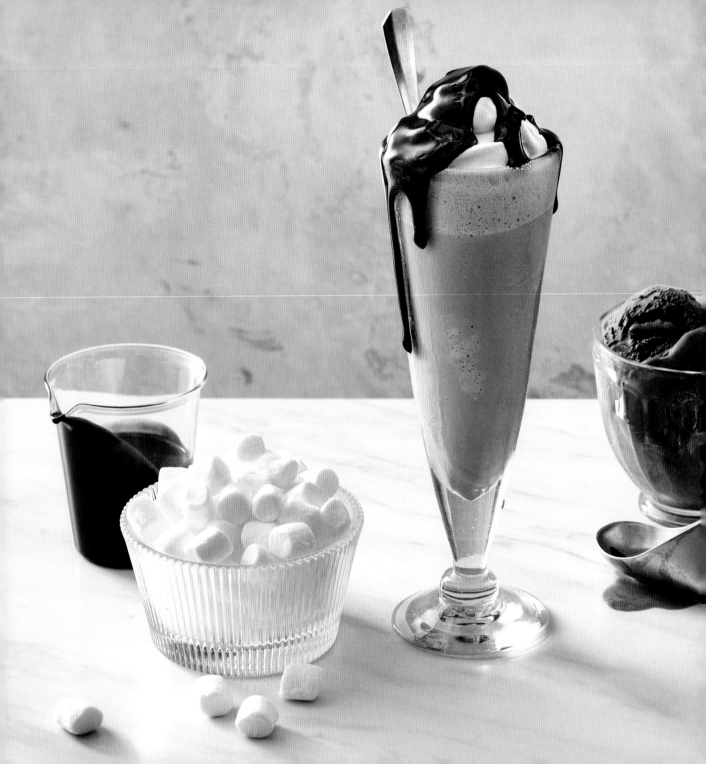

The Natchez River Boat docked on the Mississippi River in the French Quarter of New Orleans.

MISSISSIPPI MUDSLIDES

SERVES 4

Mississippi Mudslides are everything an adult milkshake should be: sweet, creamy, and spiked with just enough bourbon to make sweltering summer heat endurable. This four-ingredient recipe has all the decadence of Mississippi Mud pie or brownies without the work or need to crank up the stove.

1 pint chocolate ice cream

1 pint coffee ice cream

8 ounces (1 cup) milk

4 ounces (½ cup) bourbon

Garnish: whipped cream, chocolate syrup, and marshmallows

Process the first 4 ingredients in a blender until smooth. Garnish as desired.

PITCHERS & PUNCH BOWLS

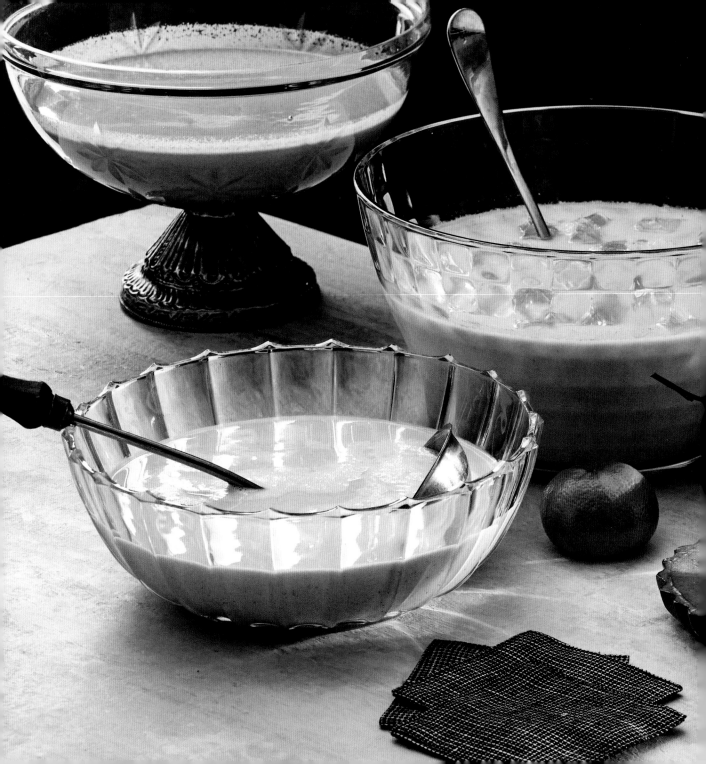

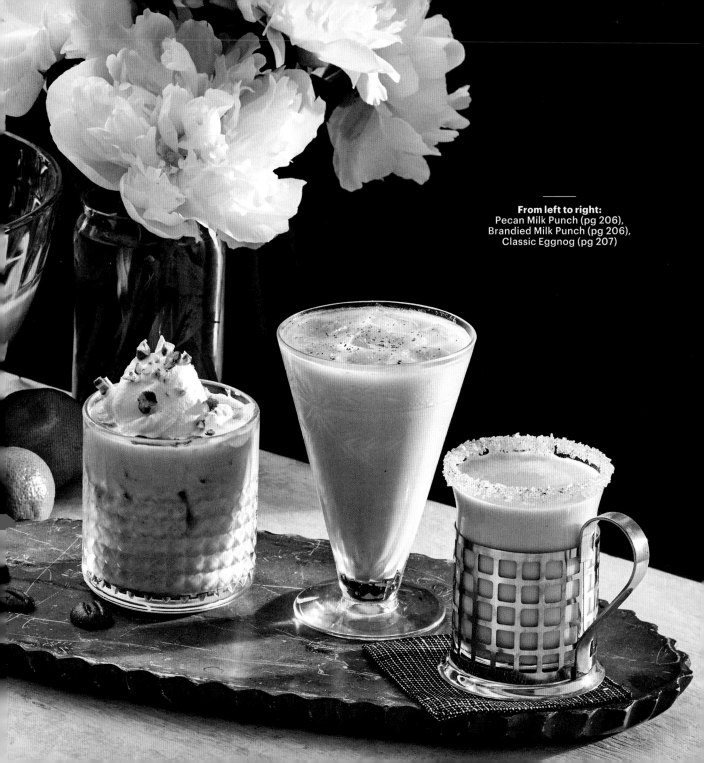

From left to right:
Pecan Milk Punch (pg 206),
Brandied Milk Punch (pg 206),
Classic Eggnog (pg 207)

PECAN MILK PUNCH

SERVES 4

Toasted pecans and coconut cream pack this spiked milk punch with distinctive Southern flavor. *Photograph on pg 204-205*

2 cups chopped toasted pecans

8 ounces (1 cup) cane syrup

1 ounce (2 tablespoons) cream of coconut

2 teaspoons ground cinnamon

2 teaspoons vanilla extract

¼ teaspoon kosher salt

16 ounces (2 cups) water

16 ounces (2 cups) milk

4 ounces (½ cup) bourbon

Garnish: sweetened whipped cream and chopped pecans

1. Process the pecans, syrup, cream of coconut, cinnamon, vanilla, and kosher salt in a food processor 30 to 60 seconds or until smooth. With processor running, pour the water through the food chute. Press the mixture through a fine-mesh strainer into a pitcher, using the back of a spoon. Discard the solids.

2. Cover and chill 3 to 24 hours. Stir in the milk and bourbon just before serving. Serve over ice. Garnish as desired.

BRANDIED MILK PUNCH

SERVES 6

The flavor of classic milk punch is elevated with a heady dose of the pecan-meets-satsuma flavors of homemade orgeat. *Photograph on pg 204-205*

8 ounces (1 cup) milk

8 ounces (1 cup) Satsuma-Pecan Orgeat Syrup (page 35)

16 ounces (2 cups) half-and-half

8 ounces (1 cup) brandy

½ cup sifted powdered sugar

¼ ounce (1½ teaspoons) vanilla extract

Freshly grated nutmeg

Whisk together the milk, orgeat syrup, half-and-half, brandy, powdered sugar, and vanilla in a pitcher. Serve over the crushed ice. Top each serving with freshly grated nutmeg.

CLASSIC EGGNOG

SERVES 8 TO 10

This traditional eggnog recipe, an adapted favorite from the historic Capital Hotel in Little Rock, is rich, sweet, and accented with warm spices thanks to the addition of a spiced rim sugar blend that gets incorporated into the creamy base. *Photograph on pg 204-205*

48 ounces (6 cups) milk

16 ounces (2 cups) heavy cream

⅛ teaspoon ground nutmeg

12 pasteurized egg yolks

1½ cups sugar

½ cup Warm Spiced Rim Sugar (page 19)

Praline or bourbon liqueur

Freshly ground nutmeg

1. Heat the milk, heavy cream, and nutmeg in a saucepan over medium, stirring occasionally, 5 to 7 minutes or until steaming (about 150°F). Reduce the heat to low.

2. Whisk together the egg yolks and the sugar in a large saucepan until smooth. Cook over low, whisking constantly, until the mixture reaches at least 160°F, about 25 minutes.

3. Whisk the milk mixture into the egg mixture, whisking constantly until combined. Let cool 30 minutes; transfer to a pitcher. Cover and chill 3 to 24 hours.

4. Rim a glass with the Warm Spiced Rim Sugar. Pour the desired amount of praline or bourbon liqueur into each glass. Top with the chilled eggnog. Sprinkle with freshly ground nutmeg.

MOCKTAILS

WATERMELON SLUSHIES

SERVES 1

A frozen treat that conjures convenience store icees, only this is naturally red and tantalizingly sippable.

12 ounces (1½) cups fresh watermelon juice

2 ounces (¼ cup) Southern Cherry Grenadine (page 37)

1 ounce (2 tablespoons) fresh lime juice

2 teaspoons Key Lime-Mint Rim Sugar (page 17)

Garnish: small watermelon wedge

1. Pour the watermelon juice into ice-cube trays; freeze 4 hours or overnight.

2. Place the watermelon ice cubes, Southern Cherry Grenadine, and lime juice in a food processor. Pulse until the mixture is slushy, about 15 times.

3. Rim a pint glass with the Key Lime-Mint Rim Sugar. Pour the watermelon mixture into the prepared glass. Garnish as desired.

NOTE

To make the watermelon juice, process 4 cups cubed seedless watermelon in a juicer or blender. Strain before using.

PINEAPPLE MOCK MULE

SERVES 1

A heady cup of flavorful refreshment, this tropical spin on the moscow mule is spiked with white balsamic vinegar to temper the sweetness of the pinepple and ginger beer.

2 teaspoons Herb Rim Sugar made with fresh mint (page 18)

2 ice cubes plus more for glass

2 (¼-inch-thick) fresh ginger slices

2 ounces (¼ cup) pineapple juice

½ ounce (1 tablespoon) white balsamic vinegar

4 ounces (½ cup) nonalcoholic ginger beer

Garnish: pineapple wedge

1. Rim a highball glass with the Herb Rim Sugar using mint. Fill the prepared glass with the ice.

2. Muddle the ginger, pineapple juice, and vinegar in a cocktail shaker. Add 2 ice cubes; cover with the lid, and shake vigorously until thoroughly chilled, about 30 seconds. Strain into the prepared glass. Top with the ginger beer and garnish as desired.

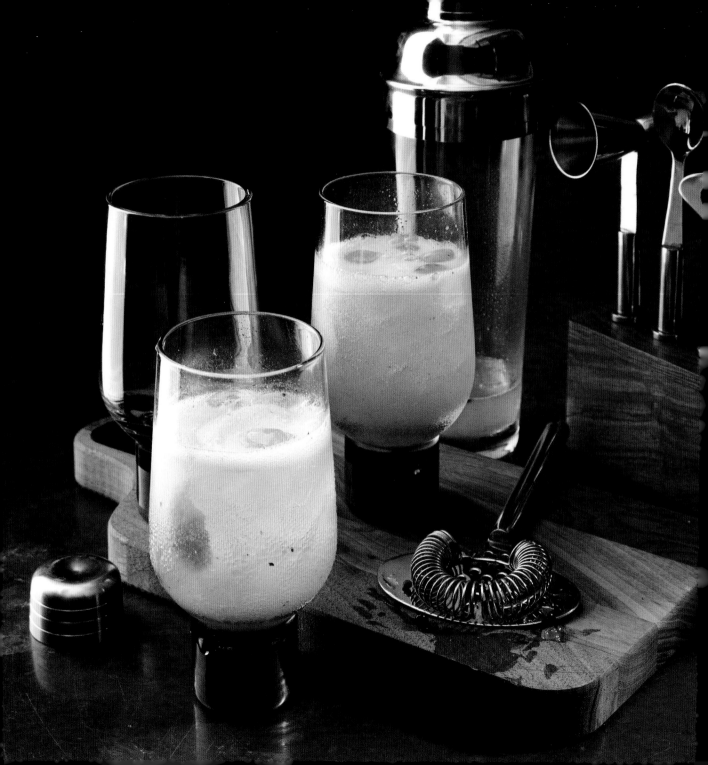

NO-GIN FIZZ

SERVES 1

Sometimes you want a mocktail that tastes like the real thing. Muddling fresh juniper berries (just not ones from a jar that has been in your spice drawer for 3 years) releases their flavor and aroma for a mocktail loaded with the essence of gin minus the alcohol.

1 ounce (2 tablespoons) Simple Syrup (page 27)

1½ tablespoons dried juniper berries

3 green grapes

3 ice cubes plus more for glass

½ ounce (1 tablespoon) fresh lemon juice

6 ounces (¾ cup) seltzer water

Garnish: lemon twist

Muddle the Simple Syrup, juniper berries, and grapes in a cocktail shaker. Add the 3 ice cubes and lemon juice; cover with the lid, and shake vigorously until thoroughly chilled, about 30 seconds. Pour the mixture through a fine-mesh strainer into an ice-filled glass. Add the seltzer water; stir gently, and garnish as desired.

BAR TALK
Botanical flavors
Other delicious flavors to mix or muddle in mocktails or to infuse in Simple Syrup (page 27):

Anise or fennel seeds: Use to give drinks a licorice note similar to liqueurs like Pastis or Anisette.
Barley tea: Steep this tea 3 times longer than directed and use where you would whiskey.
Orange flower water or rose water: Use where floral notes would be welcome.

Bitters: Add to give mocktails a bitter note that hints at a spirited spike.
Sugarcane juice or Mexican piloncillo: Use to add a more complex sweetness than refined white sugar or sugar syrups can provide.

SMOKY APPLE-MAPLE CIDER

SERVES 1

Fermented juices and vinegar have been considered curatives for ages. With the renaissance of the shrub and popularity of kombucha, it's a twangy trend that endures.

32 ounces (4 cups) apple cider

1 Fuji apple, peeled and cubed (8 ounces)

1 bay leaf

1 cinnamon stick plus more for garnish

¼ ounce (1½ teaspoons) pure maple syrup

¼ ounce (1½ teaspoons) Smoked Simple Syrup (page 28)

⅛ ounce (1 teaspoon) apple cider vinegar

1. Bring the cider, apple, bay leaf, and cinnamon stick to a boil in a large saucepan over medium-high. Remove the pan from the heat, and cover the cider mixture; let stand 10 minutes. Remove and discard the apple, bay leaf, and cinnamon stick.

2. To serve, ladle 1 cup of the cider mixture into a mug. Stir in the maple syrup, Smoked Simple Syrup, and vinegar. Garnish as desired. Store the remaining cider mixture in an airtight container in the refrigerator up to 2 weeks.

SPICY CIDER VINEGAR-GINGER TONIC

SERVES 1

Like Autumn in a glass, this chilled drink warms as it refreshes. It's an ideal curative for countless ails.

3 ounces (6 tablespoons) boiling water

3 whole black peppercorns

1 whole clove

1 fresh jalapeño chile slice

1 ginger tea bag

1 ounce (2 tablespoons) Jalapeño-Honey Syrup (page 29)

2 ounces (¼ cup) seltzer water

1 ounce (2 tablespoons) apple cider vinegar

Garnish: Candied Ginger (page 25)

Combine the boiling water, peppercorns, clove, jalapeño slice, and tea bag in a glass measuring cup. Steep 15 minutes. Pour through a fine-mesh strainer into another glass measuring cup, and stir in the Jalapeño-Honey Syrup; cover and chill 15 minutes. Stir in the seltzer water and vinegar. Serve immediately over ice; garnish as desired.

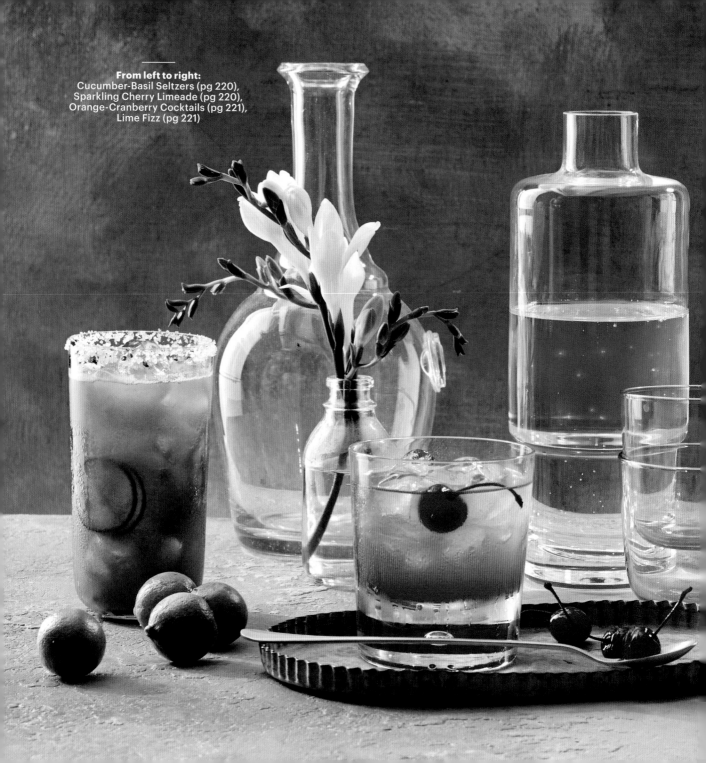

From left to right:
Cucumber-Basil Seltzers (pg 220),
Sparkling Cherry Limeade (pg 220),
Orange-Cranberry Cocktails (pg 221),
Lime Fizz (pg 221)

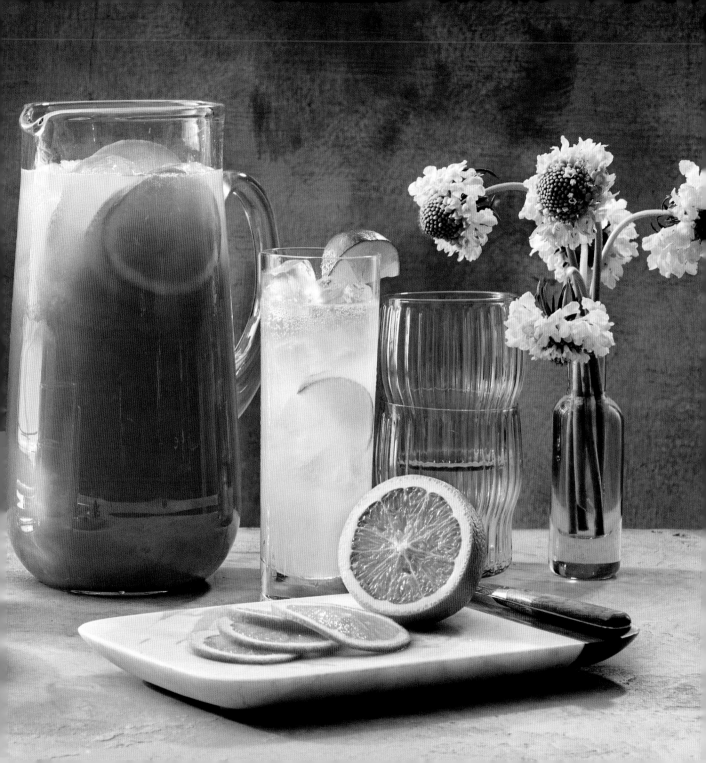

CUCUMBER-BASIL SELTZERS

SERVES 1

Puree a peeled English cucumber and strain it through a fine-mesh strainer for pulp-free juice. A 14-ounce English (seedless) cucumber yields about 1 cup of juice. *Photograph on pg 218*

4 ounces (½ cup) water

½ cup granulated sugar

5 (2-x 1-inch) lemon zest strips

¼ cup packed fresh basil leaves

2 teaspoons Herb Rim Sugar made with basil (page 18)

4 ounces (½ cup) cucumber juice

½ ounce (1 tablespoon) fresh lemon juice

3 ounces (6 tablespoons) club soda

Garnish: cucumber slices

1. Whisk the first 2 ingredients in a saucepan. over medium-high until the sugar dissolves, 4 minutes. Remove and stir in ¼ cup basil; let stand 15 minutes. Strain with a mesh strainer into a measuring cup, discarding solids.

2. Rim a glass with basil rim sugar; add ice. Place 3 tablespoons syrup in a cocktail shaker with the cucumber and lemon juices. Cover. Shake vigorously to blend, 15 seconds. Pour into the glass and top with club soda; stir. Garnish as desired.

SPARKLING CHERRY LIMEADE

SERVES 8

One sip of this sweet-tart sparkler will transport you back to the drive-in and might even make you crave a burger too. *Photograph on pg 218*

1 lime, cut into wedges Key Lime-Mint Rim Salt (page 17)

1 (12-ounce) can frozen limeade concentrate, thawed

28 ounces (3½ cups) cold water

4 ounces (½ cup) liquid from jarred red maraschino cherries

16 ounces (2 cups) sparkling water

Garnish: maraschino cherries

1. Rub the rims of 8 chilled old-fashioned glasses with the lime wedges, and dip the rims in the salt to coat.

2. Stir together the limeade concentrate and 3½ cups cold water; add the liquid from the maraschino cherries.

3. Fill the prepared glasses with the ice. Pour the limeade mixture into the glasses, filling each two-thirds full; add the sparkling water to fill. Garnish as desired.

ORANGE-CRANBERRY COCKTAILS

SERVES 4

The delicious flavors of Thanksgiving's favorite fruit in a glass, a ring of Warm Spiced Rim Sugar (page 19) would give this mocktail autumnal festiveness. *Photograph on pg 219*

¼ cup sugar

8 ounces (1 cup) cranberry juice

1 (6-ounce) can frozen orange juice concentrate, thawed and undiluted

24 ounces (3 cups) club soda, chilled

Garnish: orange slices

Combine the first 3 ingredients in a pitcher, stirring until the sugar dissolves. Cover and chill 1 hour. Stir in the club soda just before serving. Serve over the ice. Garnish as desired.

LIME FIZZ

SERVES 4

This is an ideal quencher during hot, humid Southern summers. Muddle some fresh mint or basil with the Lime Simple Syrup and ice for an herbaceous variation. *Photograph on pg 219*

6 to 8 ounces (¾ to 1 cup) Lime Simple Syrup (recipe follows)

4 ounces (½ cup) fresh lime juice

28 ounces (3½ cups) chilled club soda

Garnish: lime wedges

Fill a large pitcher with crushed ice. Pour the Lime Simple Syrup and lime juice over the ice. Add the club soda; stir to combine. Garnish as desired. Serve immediately.

LIME SIMPLE SYRUP

1 cup sugar

½ cup water

1 tablespoon lime zest

4 ounces (½ cup) fresh lime juice

Combine the sugar and ½ cup water in a small saucepan. Cook over medium , stirring constantly, 3 minutes or until the sugar is dissolved. Remove from heat; stir in the lime zest and lime juice. Cover and chill 1 hour.
MAKES 1½ CUPS

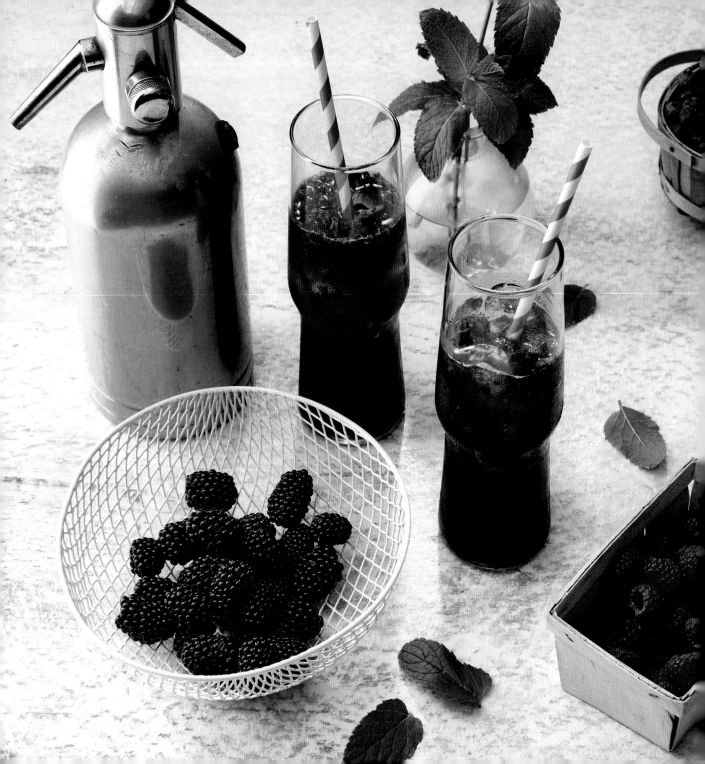

SOUTHERN TWIST
Spicy Spike
Use Alabama's Buffalo Rock Ginger Ale for a more pronounced ginger bite.

Blackberry brambles are abundant in temperate parts of the South where cold snaps help set the fruit. Berries go from white to red to purple-black as they ripen to sweet maturity.

BERRY BASKET SPARKLERS

SERVES 1

Ripe summer berries lend their vibrant hues and distinctive flavors to this effervescent drink sweetened with agave and spiked with ginger's spice.

5 fresh raspberries

4 fresh blueberries

2 fresh blackberries

¾ ounce (1½ tablespoons) light agave nectar

5 fresh mint leaves

1 ounce (2 tablespoons) fresh lime juice

1 cup crushed ice

3 ounces (6 tablespoons) water

1 ounce (2 tablespoons) ginger ale

Garnish: fresh raspberries and blackberries

Muddle the raspberries, blueberries, blackberries, agave nectar, mint leaves, and lime juice in a cocktail shaker. Stir in the crushed ice and water. Cover with the lid, and shake vigorously until thoroughly chilled, about 10 seconds. Pour into a 16-ounce glass, and top with the ginger ale. Garnish as desired.

Southern Sodas

What began as a medicinal drink in Georgia in 1886, Coca-Cola, became the most recognizable soft drink in the world. From colas and lemon-lime sodas to fruity seltzers and ginger-ales, the South loves cold, bubbly, sweet refreshment of all kinds. Here are a few favorites from every state to sip solo or stir into a cocktail or mocktail.

Alabama: Buffalo Rock Ginger Ale, Grapico
Arkansas: Grapette and Orangette
Delaware: Dominion Root Beer
Florida: Mr. Q. Cumber
Georgia: Coca-Cola, NuGrape, and Nehi sodas
Kentucky: Ale-8-One
Louisiana: Abita Root Beer
Maryland: Shasta
Mississippi: Barq's Root Beer
North Carolina: Cheerwine
Oklahoma: Triple AAA Kola
South Carolina: Blenheim Ginger Ale
Tennessee: Sundrop Citrus Cola, Dr. Enuf, Mountain Dew
Texas: Big Red, Dr. Pepper, Dublin Sodas
Virginia: Carver's Original Ginger Ale, Root 66 Black Cherry Soda,
West Virginia: Cryptid Club Sodas

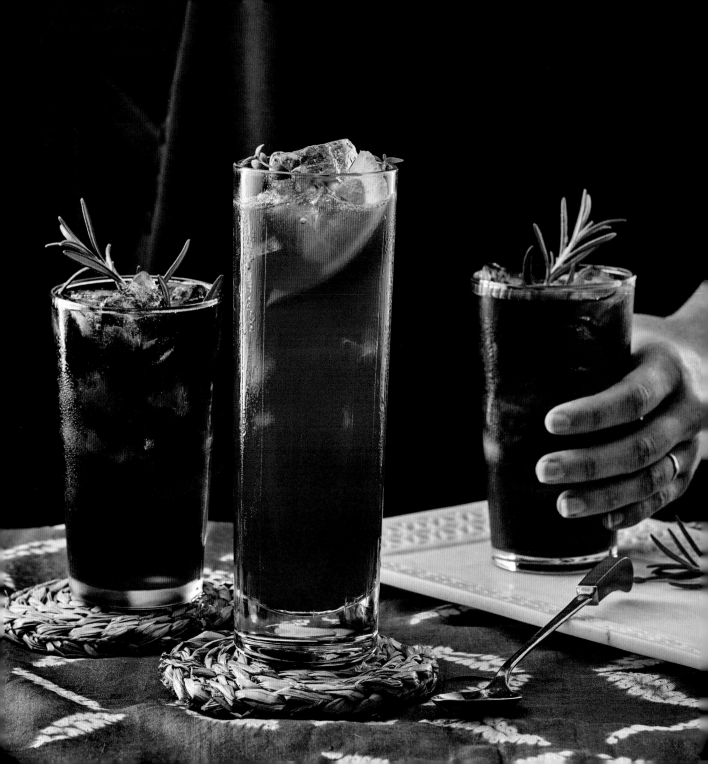

CHICORY TONIC

SERVES 1

Chicory coffee is a blend of ground roasted chicory—the root of the endive plant—and coffee. It gives the coffee at Café du Monde in New Orleans its smooth, crowd-appeal. Here, it rounds out the herbal notes of rosemary and tonic.

48 ounces (6 cups) tap water

16 ounces (2 cups) ground chicory coffee

1 (2-inch) lemon zest strip

4 ounces (½ cup) tonic water

1 rosemary sprig

1. Combine the tap water and coffee. Let stand at room temperature 12 hours or overnight. Line a large, fine-mesh strainer with a coffee filter; set over a pitcher. Pour the coffee mixture into the strainer, and let stand until completely drained, changing the filter if necessary to allow all the liquid to drip into the pitcher. Discard the solids. Cover the coffee mixture, and chill 3 hours.

2. To serve, rub the rim of a highball glass with the lemon zest strip. Fill a glass with ice, and add the lemon zest strip. Pour ½ cup of the coffee mixture into the prepared glass. Add the tonic water, and stir with a rosemary sprig. Store the remaining coffee mixture in an airtight container in the refrigerator up to 4 days.

ORGEAT COOLER

SERVES 1

Traditionally made with almonds, the pecan-infused orgeat gives the syrup in this mocktail a decidedly Southern flavor.

8 ounces (1 cup) bottled cranberry juice

1 ounce (2 tablespoons) Satsuma-Pecan Orgeat Syrup (page 35)

¼ teaspoon orange flower water

Garnishes: thyme sprigs, orange wedge

Combine the juice, Satsuma-Pecan Orgeat Syrup, and orange flower water in a cocktail shaker; cover with the lid, and shake vigorously until blended, about 15 seconds. Pour over ice, and garnish as desired.

TAMARIND FIZZ

SERVES 1

Tamarind paste comes from legumes that grow inside the pods of a subtropical evergreen tree. It is used in Asian, African, Australian, and South American cuisines. It adds a distinctive sweet-and-sour flavor to this bubbly beverage.

1½ ounces (3 tablespoons) agave syrup

¾ ounce (1½ tablespoons) tamarind paste

½ ounce (1 tablespoon) fresh lime juice plus 1 wedge for garnish

½ teaspoon Worcestershire sauce

2 cilantro sprigs

6 ounces (¾ cup) sparkling mineral water (such as Topo Chico)

Garnish: lime wedge

Muddle the agave syrup, tamarind paste, lime juice, Worcestershire sauce, and cilantro sprigs in a cocktail shaker. Strain into an ice-filled glass. Top with the sparkling mineral water, and stir gently. Garnish as desired.

FAUX-JITO

SERVES 1

Omit the tea from this drink if you wish. Simply replace it with an equal amount of additional club soda. *Photograph not shown*

8 fresh mint leaves plus 1 sprig for garnish

½ teaspoon lime zest plus 1 ounce (2 tablespoons) fresh juice (from 1 lime)

2 ounces (¼ cup) brewed white tea

1 ounce (2 tablespoons) Simple Syrup (page 27)

1/2 cup coarsely crushed ice

3 ounces (6 tablespoons) club soda

In a cocktail shaker, muddle the mint leaves and lime zest. Add the tea, lime juice, and syrup. Cover with the lid, and shake vigorously until blended, about 15 seconds. Fill a glass with ½ cup coarsely crushed ice. Pour the lime mixture into the prepared glass. Add the club soda, and stir gently. Garnish as desired.

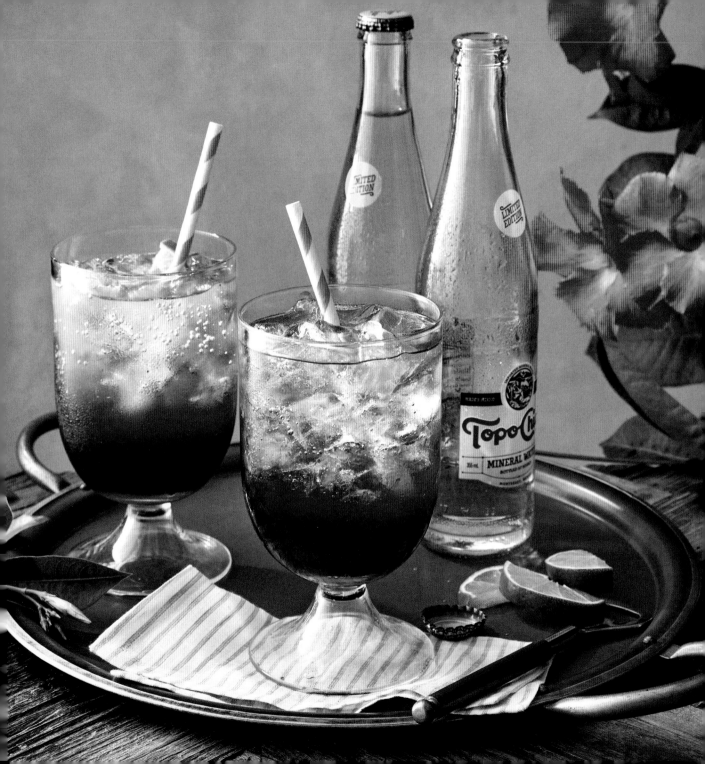

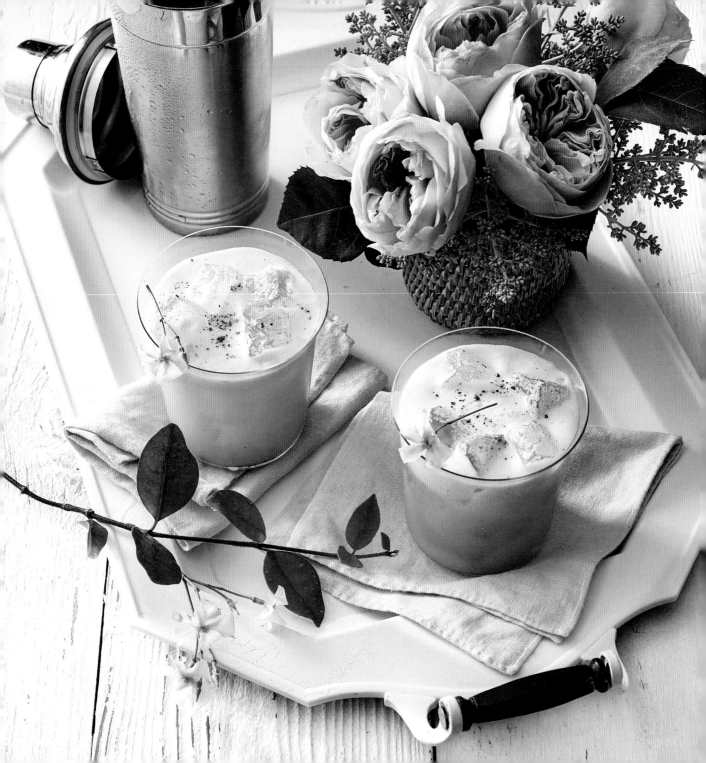

The Monroeville, Alabama courthouse that inspired Harper Lee's *To Kill A Mockingbird*.

231

VANILLA MOCKINGBIRD

SERVES 1

Refined and sublime, the tiki flavors here hint at the tropics, which is not too far off from how it feels in Monroeville, Alabama in the summertime.

¾ cup granulated sugar

6 ounces (¾ cup) water

1 vanilla bean, split lengthwise

6 ounces (¾ cup) pineapple juice

2 ounces (¼ cup) well-shaken and stirred coconut milk

⅛ teaspoon black pepper

1 large pasteurized egg white

1. Combine the sugar and water in a small saucepan; cut the vanilla bean in half crosswise. Split 1 half lengthwise, and scrape the seeds into the sugar mixture. Add the vanilla bean to the mixture. (Reserve the remaining vanilla bean half for another use.) Cook the sugar mixture over medium-high, stirring often, until the sugar dissolves, 4 to 5 minutes. Remove the vanilla syrup from the heat; let stand 15 minutes. Remove and discard the vanilla bean.

2. Place 2 tablespoons of the vanilla syrup in a cocktail shaker. Add the pineapple juice, coconut milk, pepper, and egg white. Cover with the lid, and shake vigorously until frothy, about 45 seconds. Serve over ice. Store the remaining vanilla syrup in an airtight container in the refrigerator up to 3 weeks.

SPICED COLD BREW

SERVES 4 TO 6

Be your own barrista and whip up this cold brew infused with warm spices and rich cream.

1 cup ground coffee

1 teaspoon ground cinnamon

½ teaspoon ground cardamom

½ teaspoon ground allspice

⅛ teaspoon ground nutmeg

40 ounces (5 cups) cold filtered water

Milk, half-and-half, or heavy cream (optional)

Sweetener (optional)

Combine the ground coffee, ground spices, and filtered water in a pitcher, and stir for 30 seconds. Transfer the pitcher to the refrigerator, and let the coffee steep for at least 12 hours and up to 24 hours, depending on the desired strength. Pour the coffee through a strainer lined with cheesecloth or a coffee filter into a clean pitcher. If desired, add the cream and sweetener.

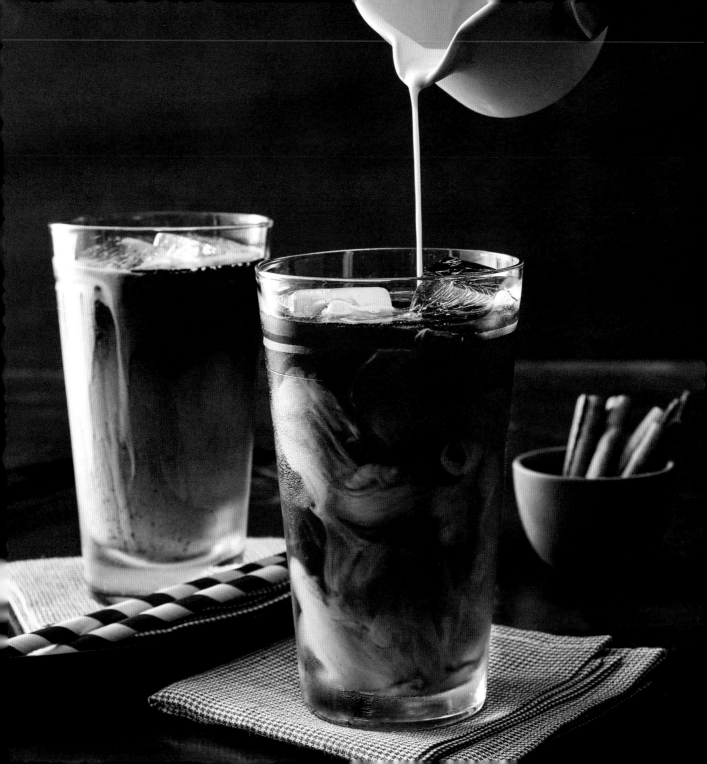

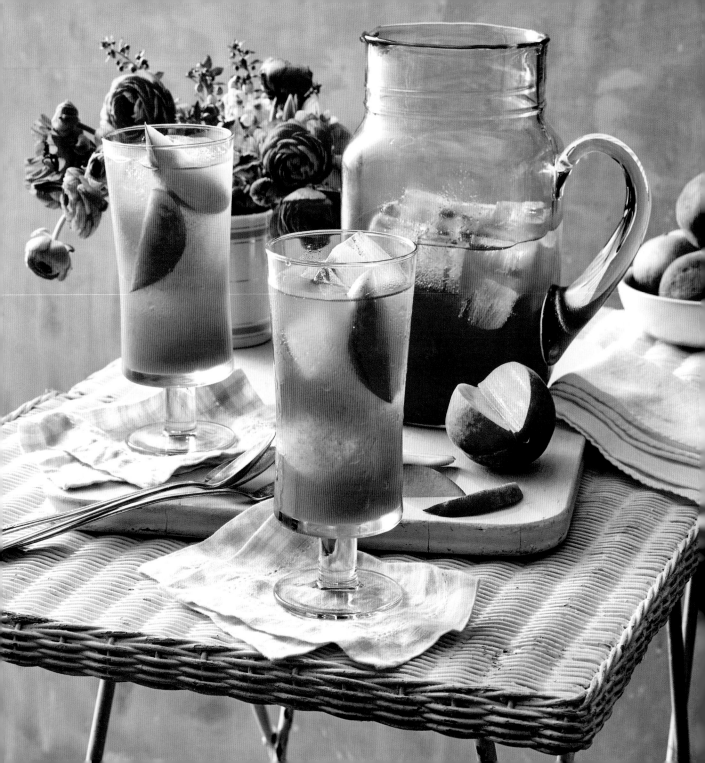

Iced tea and Southern porches go together like butter and a biscuit.

235

FRUITED ICED TEA

SERVES 8 TO 10

Fragrant ripe peaches infuse this spin on what is arguably the South's favorite beverage.

2 cups chopped fresh peaches

1½ cups sugar

32 ounces (4 cups) water

8 regular-size black tea bags

48 ounces (6 cups) cold water

Bring the chopped fresh peaches, sugar, and 1 cup of the water to a boil in a saucepan over medium-high. Reduce the heat to low; simmer, stirring often, 10 minutes. Cool slightly; process in a blender. Pour through a fine-mesh strainer into a 1-gallon container. Bring the remaining 3 cups water to a boil over medium-high in a saucepan. Add the tea bags; boil 1 minute. Remove from the heat; cover and steep 10 minutes. Discard the tea bags, and stir the tea into the peach mixture. Stir in the 6 cups cold water. Serve over ice.

VERBENA-LEMON TEA

SERVES 2

Verbena is an heirloom favorite of the Southern herb garden. It's a woody shrub with aromatic leaves that have a scent reminiscent of ripe lemons.

1 bunch lemon verbena, rinsed

1 (1-inch wide) lemon zest strip

24 ounces (3 cups) boiling water

Lemon wheels

Honey (optional)

Place the lemon verbena sprigs and lemon zest in a teapot. Pour the boiling water into the pot, and let the herbs and zest steep for 5 minutes. Pour through a fine-mesh strainer into 2 warm teacups. Serve with lemon wheels and honey, if desired, for sweetening.

SOUTHERN TWIST
Sweeten the Pot
If you like to sweeten your tea, try verbena-infused sugar for even more citrusy-sweet flavor. Process 1 cup loosely packed dried verbena leaves with 2 cups granulated sugar until blended. Store in an airtight jar for up to 6 months.

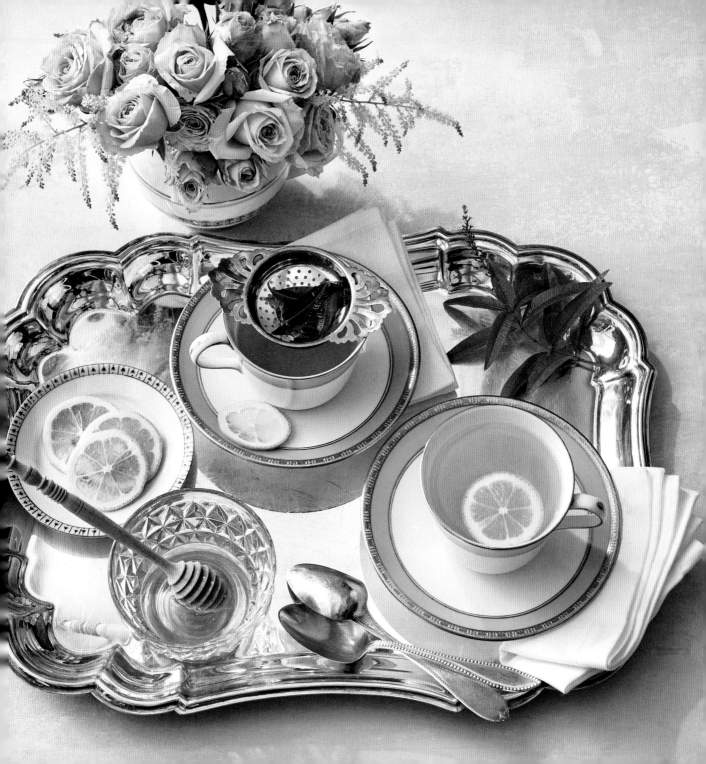

BAR SNACKS

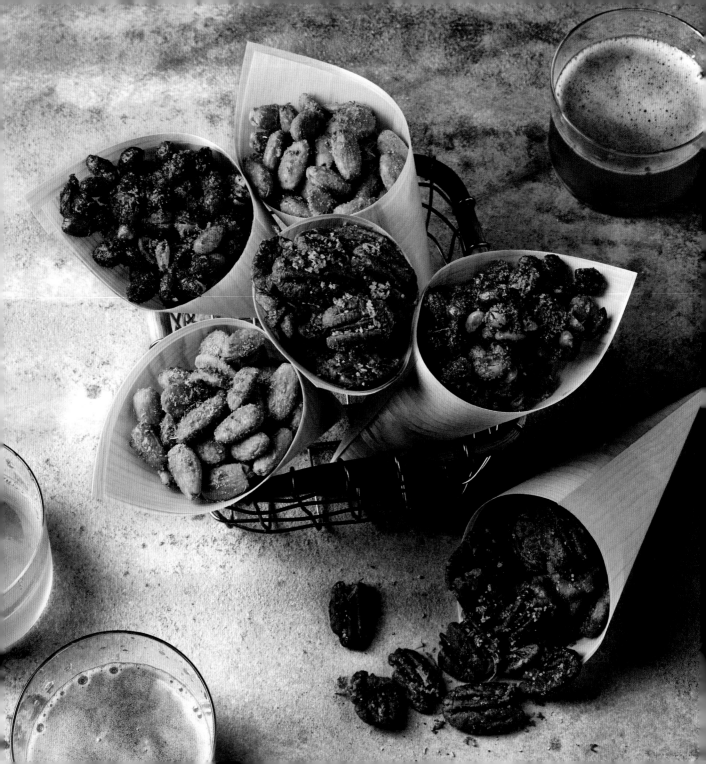

FRIED NUTS, THREE WAYS

SERVES 8

When it comes to bar nibbles, it's hard to beat crunchy, salty, spiced, or candied nuts. This trio of tasty recipes is sure to suit all tastes.

10 cups water

2 tablespoons kosher salt

2 cups nuts of choice

Canola oil

⅓ cup powdered sugar

Spice Mixture of choice (recipes follow)

1. Bring the water and salt to a boil in a large pot over high heat. Add the nuts of choice, and cook until slightly softened, 30 to 45 seconds. Drain. Spread the nuts on paper towels; cool 2 minutes.

2. Meanwhile, pour oil to a depth of 1½ inches into a Dutch oven. Heat over medium-high to 325°F.

3. Toss together the nuts and ⅓ cup powdered sugar in a bowl; stir until the nuts are evenly coated with the sugar and almost all of the excess sugar is dissolved.

4. Carefully add the coated nuts to the hot oil and fry until lightly golden, 3 to 4 minutes. Using a spider skimmer or slotted spoon, transfer the nuts to paper towels to drain briefly, about 10 seconds.

5. Transfer the hot nuts to a medium bowl, and toss with the Spice Mixture of choice below. Cool the seasoned nuts for 30 minutes.

HOT-AND-SWEET PEANUTS

Nuts: 2 cups raw, shelled peanuts or nuts of choice
Spice Mixture: Combine 2 tablespoons light brown sugar, 1 teaspoon cayenne pepper, and ½ teaspoon each chili powder and kosher salt.

FIVE SPICE PECANS

Nuts: 2 cups pecan halves or nuts of choice
Spice Mixture: Combine 2 teaspoons kosher salt, 1 teaspoon orange zest, and ¾ teaspoon Chinese five spice powder.

ROSEMARY ALMONDS

Nuts: 2 cups whole blanched almonds or nuts of choice
Spice Mixture: Combine 2 tablespoons fresh rosemary leaves and 2 teaspoons kosher salt in a spice grinder; pulse until powdery, 15 times.

PROSCIUTTO-AND-MANCHEGO CHEESE STRAWS

SERVES 20

It's not cocktail hour without cheese straws, and we made these extra special for the occasion by including earthy Manchego cheese and salty prosciutto in these twists.

2 (17.3-ounce) packages
frozen puff pastry sheets,
thawed

1 large egg, lightly beaten

6 ounces Manchego
cheese, shredded
(about 1½ cups)

8–10 prosciutto or
Serrano ham slices
(about 5 ounces)

1 tablespoon minced fresh
thyme

1. Preheat the oven to 375°F. Line 2 baking sheets with parchment paper.

2. Unfold 1 sheet of puff pastry on a lightly floured work surface, and roll into a 16- x 10-inch rectangle. Brush the pastry surface edge to edge with a small amount of beaten egg. Sprinkle evenly with ¾ cup of the shredded Manchego cheese. Lay half of the prosciutto slices across lower half of pastry (along the 10-inch side), overlapping slices slightly. Fold the top portion of the pastry over the prosciutto with ends of pastry meeting to form a 10- x 8-inch rectangle. Repeat with the remaining puff pastry sheet.

3. Cut each rectangle into 20 (8- x ½-inch) strips. Working with 1 strip at a time, use both hands to twist and form a spiral stick. Place on the prepared baking sheets, pressing ends onto parchment to adhere. Brush with the remaining egg wash; sprinkle with the thyme.

4. Bake at 375°F until cheese straws are puffed and golden brown, 15 to 17 minutes.

SOUTHERN TWIST
Pimiento Cheese Straws
Use sharp Cheddar for the Manchego and 1 (4-ounce) jar drained diced pimientos that have been patted thoroughly dry in place of the ham. Substitute chives for the thyme.

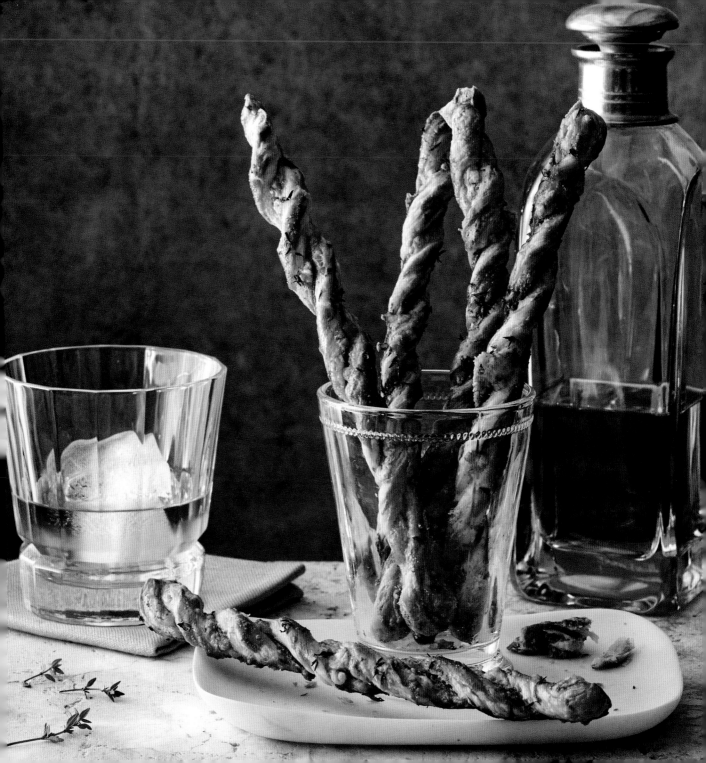

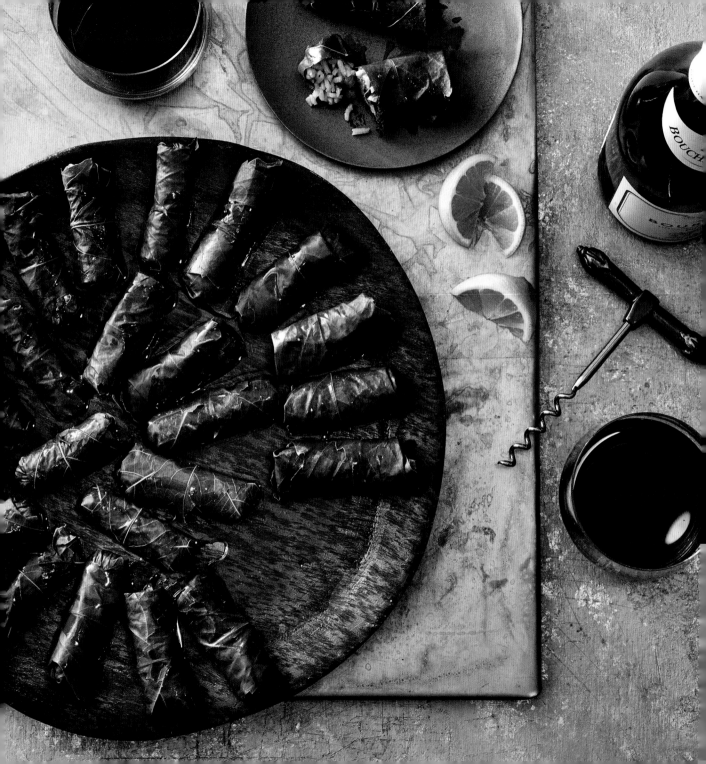

DOWN SOUTH DOLMADES

SERVES 12

Classic Greek dolmades are "southernized" with Vidalias and pecans.

2 tablespoons olive oil

1¾ cups finely chopped Vidalia onion (1 medium onion)

3 garlic cloves, minced (about 1 tablespoon)

1 cup uncooked white rice

½ cup chopped pecans

1½ cups water

1½ teaspoons kosher salt

½ teaspoon Greek seasoning

1 tablespoon chopped fresh parsley

1 tablespoon chopped fresh mint

1 tablespoon chopped fresh dill

1 teaspoon lemon zest plus 3 tablespoons fresh lemon juice (from 1 lemon)

½ (16-ounce) jar grape leaves, rinsed and patted dry (36 leaves)

3 cups chicken stock

¼ cup extra-virgin olive oil

1. Preheat the oven to 325°F.

2. Heat 2 tablespoons olive oil in a large skillet over medium-high. Add the onion and garlic; cook, stirring often, until translucent, 4 to 5 minutes. Add the rice and pecans; cook, stirring often, until coated and slightly toasted, 1 to 2 minutes. Add the water, salt, and Greek seasoning. Cover and bring to a simmer; reduce the heat to low, and simmer 12 minutes. Remove from the heat; let stand, covered, 12 minutes. Stir in the parsley, mint, dill, and lemon zest. Cool slightly, 10 to 15 minutes.

3. Arrange a row of the grape leaves, vein-side up, on a work surface. Place 1½ tablespoons of the rice mixture just below the center of each leaf. Fold bottom of the leaf up and over the filling, and fold sides in toward center; gently roll up. (Do not wrap too tightly.)

4. Transfer the rolls, seam-side down, to a 13- x 9-baking dish. Bring the stock to a simmer in a saucepan over high. Pour over the rolled grape leaves in dish. Drizzle with the lemon juice. Top with another 13- x 9-inch baking dish or an ovenproof heavy plate to weigh down slightly. Cover with aluminum foil, and bake at 325°F for 45 minutes. Let the dolmades cool completely in cooking liquid, about 45 minutes. Remove from the cooking liquid, and pat dry. Drizzle the rolls with ¼ cup extra-virgin olive oil, and serve at room temperature.

AVOCADO FRITTERS WITH LIME CREAM

SERVES 8 TO 10

You'll love these crispy-on-the-outside, creamy-on-the-inside fried avocado wedges. The Lime Cream is a delicious drizzle that also tastes fabulous over fish.

LIME CREAM
1 cup sour cream

3 tablespoons green hot sauce (such as Tabasco Green Jalapeño Pepper Sauce)

¾ teaspoon lime zest

Pinch of kosher salt

FRITTERS
½ cup (2.12 ounces) all-purpose flour

1 tablespoon chili powder

½ teaspoon black pepper

2¼ teaspoons kosher salt

3 large eggs, beaten

1½ cups panko (Japanese-style breadcrumbs)

3 medium-size firm-ripe Hass avocados, peeled and cut into ½-inch-thick slices

Vegetable oil

1. Prepare the Lime Cream: Whisk together all the ingredients. Chill until ready to serve.

2. Prepare the Fritters: Stir together the flour, chili powder, pepper, and 2 teaspoons of the salt in a shallow dish. Place the beaten eggs in a second shallow dish. Place the panko in a third shallow dish. Dredge the avocado slices, in batches, in the flour mixture; dip in the beaten eggs, shaking off excess. Dredge in the panko, pressing to adhere.

3. Pour the oil to a depth of ¼ inch in a large nonstick skillet. Heat over medium-high. Test the oil by sprinkling in a pinch of panko; it should begin to sizzle immediately without the oil popping. Fry the coated avocado slices, in batches, in the hot oil until crisp and deep golden, about 1 minute on each side. Transfer the Fritters to a wire rack, and sprinkle evenly with the remaining ¼ teaspoon salt. Skim any loose panko crumbs from the oil, and let the oil return to temperature between batches. Serve immediately with the Lime Cream.

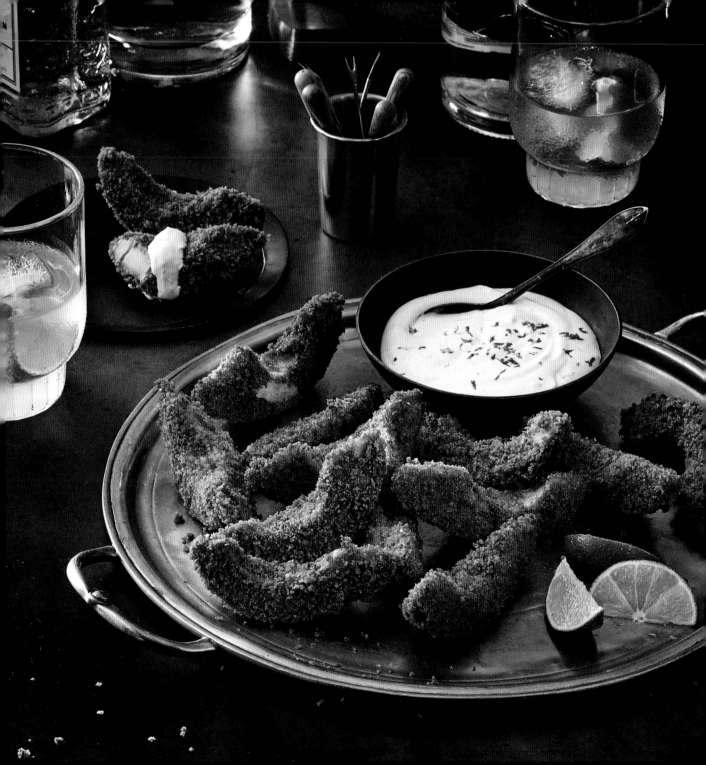

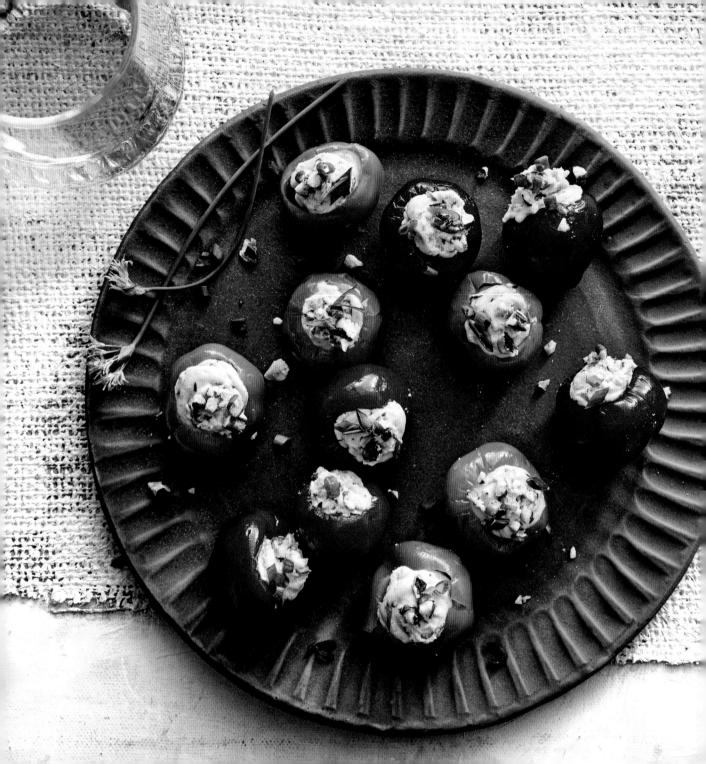

From pralines to pie, the South loves its pecans. The nut grows all over the region. Here, processing equipment awaits a new crop at the Nilo Plantation in Auburn, Georgia.

BLUE CHEESE-AND-PECAN STUFFED CHERRY PEPPERS

SERVES 20

Pickled cherry peppers (or Peppadews) are sold in jars and from self-serve olive bars in specialty grocery stores. Look for them with stems and seeds removed.

4 ounces cream cheese, softened

2⅓ ounces crumbled blue cheese (about 6 tablespoons)

6 tablespoons heavy cream

½ cup plus 2 tablespoons finely chopped toasted pecans

3 (16-ounce) jars cherry peppers, drained (50 to 60 cherry peppers)

2 tablespoons thinly sliced fresh chives

Place the cream cheese, blue cheese, and heavy cream in a medium bowl. Beat with an electric mixer on medium-high speed until well blended and light and fluffy. Stir in ½ cup finely chopped pecans. Spoon the mixture into a piping bag fitted with a ¾-inch-wide tip, and pipe about 1 tablespoon of the mixture into the open end of each pepper. Place the peppers on a platter, and sprinkle with the remaining 2 tablespoons pecans. Sprinkle the chives evenly over the stuffed peppers. Serve immediately, or chill until ready to serve.

CREAMY FETA DIP

SERVES 12

Serve with an array of raw veggies and pita chips.

1 (1-pound) block feta cheese, drained

½ (8-ounce) package cream cheese, softened

½ cup sour cream

½ cup mayonnaise

1 tablespoon fresh lemon juice

1 garlic clove, minced (about 1 teaspoon)

¼ teaspoon black pepper

1½ tablespoons chopped fresh parsley

1½ tablespoons chopped fresh dill

2½ teaspoons chopped fresh thyme

½ teaspoon paprika

1 tablespoon extra-virgin olive oil

Crudités and pita chips, for serving

1. Place 12 ounces of the feta in a food processor. Crumble the remaining 4 ounces; set aside. Add the cream cheese and the next 5 ingredients to the processor; process until combined and creamy, about 1 minute and 30 seconds. Transfer to a medium bowl, and gently stir in the parsley, dill, thyme, and crumbled feta. Chill until ready to serve.

2. Just before serving, sprinkle with the paprika and drizzle with the olive oil. Serve with crudités and pita chips.

JALAPEÑO-PIMIENTO CHEESE

MAKES ABOUT 3 CUPS

What's better than pimiento cheese? The classic is always delicious, but this spicy spin, lightened with Greek yogurt and accented with piquant pickled jalapeños may become your new favorite.

1¼ cups Greek yogurt

1 (4-ounce) jar diced pimientos, drained

2 tablespoons finely chopped fresh cilantro

1 tablespoon chopped jarred pickled jalapeño chiles, undrained

1 (8-ounce) block extra-sharp Cheddar cheese, shredded

½ (8-ounce) block Monterey Jack cheese, shredded

Stir together the yogurt, pimientos, cilantro, pickled jalapeños, and 1 tablespoon of the liquid from the pickled jalapeños. Fold in the cheeses, and stir well to combine.

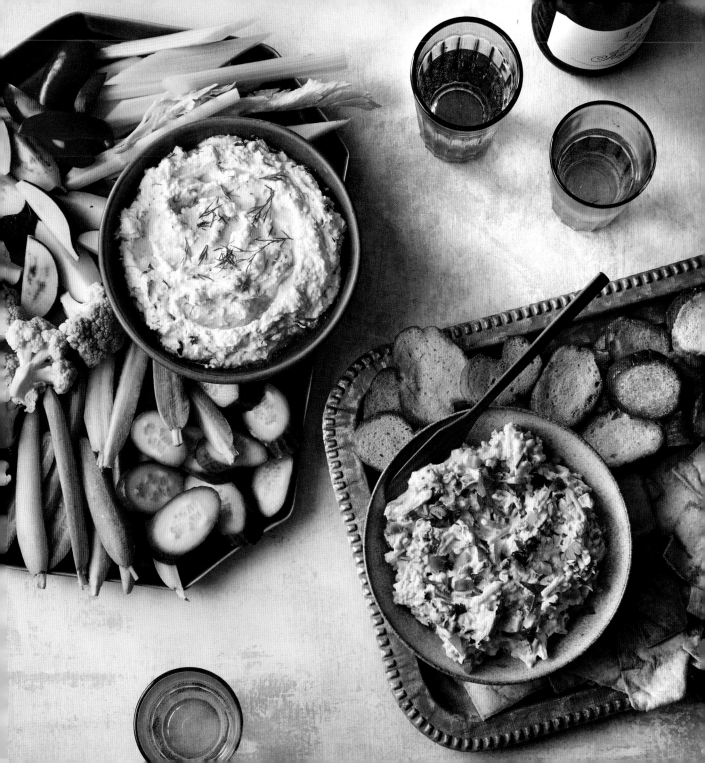

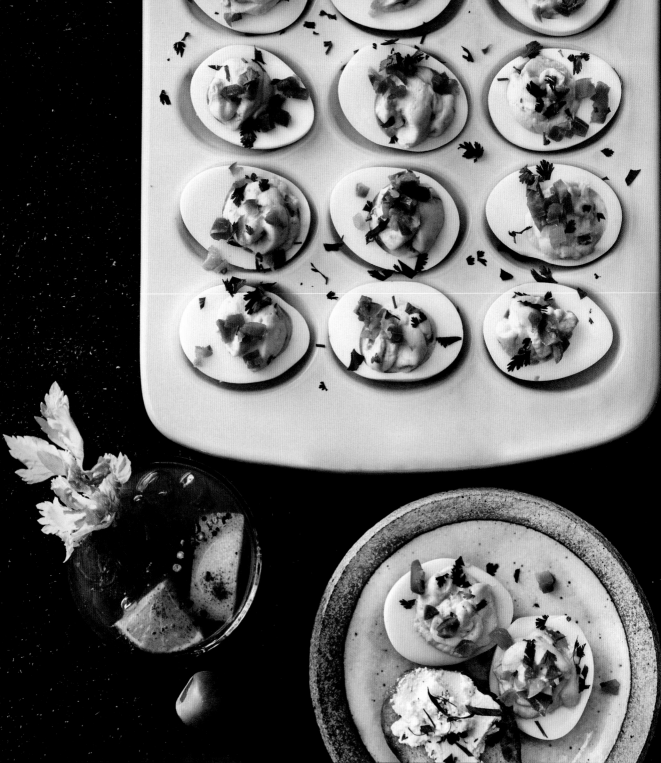

SPICY SOUTHWESTERN DEVILED EGGS

MAKES 2 DOZEN

Boiled eggs may seem as Southern as succotash, but even the ancient Romans served boiled eggs often seasoned with wine and pepper at the start of a meal. The "deviled" in deviled eggs is a 16th century English reference to zesty or highly-seasoned dishes.

1 dozen large eggs, hard-cooked and peeled

6 tablespoons mayonnaise

2 to 4 tablespoons pickled sliced jalapeño chiles, minced

1 tablespoon yellow mustard

½ teaspoon ground cumin

⅛ teaspoon table salt

Garnish: chopped fresh cilantro

Cut the eggs in half lengthwise, and carefully remove the yolks. Mash the yolks; stir in the mayonnaise and next 4 ingredients. Spoon or pipe the egg yolk mixture into the egg halves. Cover and chill at least 1 hour or until ready to serve. Garnish, if desired.

BAR TALK
Devilish Ways

Enjoy these other delicious additions to the South's favorite finger food.

The Basic: Mash egg yolks with mayonnaise, mustard, and sweet pickle relish. Dust eggs with paprika.
Pesto Deviled Eggs: Make The Basic above, but substitute pesto for the relish.

Creole Deviled Eggs: Make The Basic filling with softened cream cheese instead of mayo and season it with Creole seasoning. Top each egg with minced parsley and a cooked bay shrimp.

Barbecue Deviled Eggs: Fold chopped pork barbecue into The Basic filling made with dill pickle relish instead of sweet relish. Garnish each egg with a dollop of prepared Chow Chow.

CHORIZO-STUFFED MUSHROOMS

SERVES 12

These meaty bites hit on all flavor cylinders. Print the recipe on cards because you're sure to be asked for it.

24 large fresh button mushrooms

¾ pound fresh Mexican chorizo

¾ cup finely chopped yellow onion (from 1 large onion)

5 ounces Monterey Jack cheese, shredded (about 1¼ cups)

¾ cup panko (Japanese-style breadcrumbs)

Chopped fresh cilantro

1. Remove the stems from the mushrooms, reserving the stems. Wipe the caps with paper towels to remove any dirt; set the caps aside. Finely chop the stems.

2. Cook the chorizo in a large skillet over medium-high, stirring to crumble, until lightly browned, 6 to 7 minutes. Add the chopped mushroom stems and onion. Cook, stirring often, until tender, 5 to 6 minutes. Transfer to a bowl; cool slightly, about 5 minutes.

3. Preheat the oven to 425°F. Arrange the mushroom caps on a rimmed baking sheet with cavity facing up.

4. Stir the cheese and panko into the chorizo mixture. Press 2 tablespoons of the chorizo mixture into each mushroom cavity. Bake at 425°F until the caps are just tender and the tops are browned, 15 to 17 minutes. Top with the chopped cilantro.

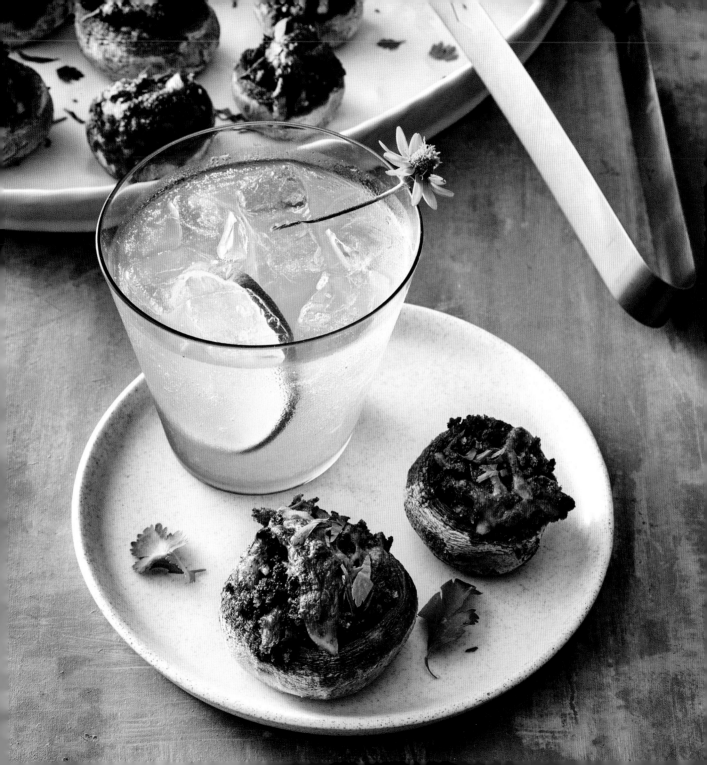

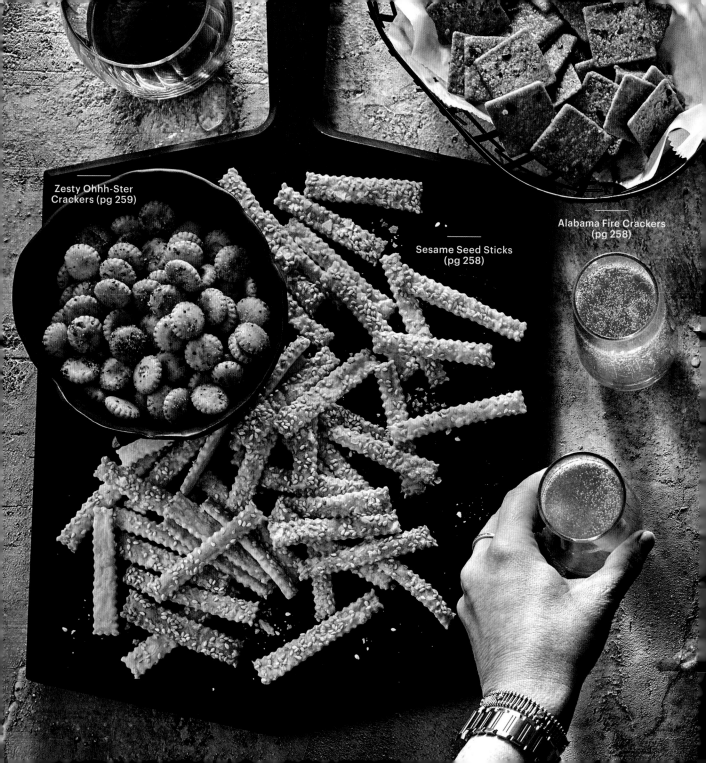

Zesty Ohhh-Ster
Crackers (pg 259)

Sesame Seed Sticks
(pg 258)

Alabama Fire Crackers
(pg 258)

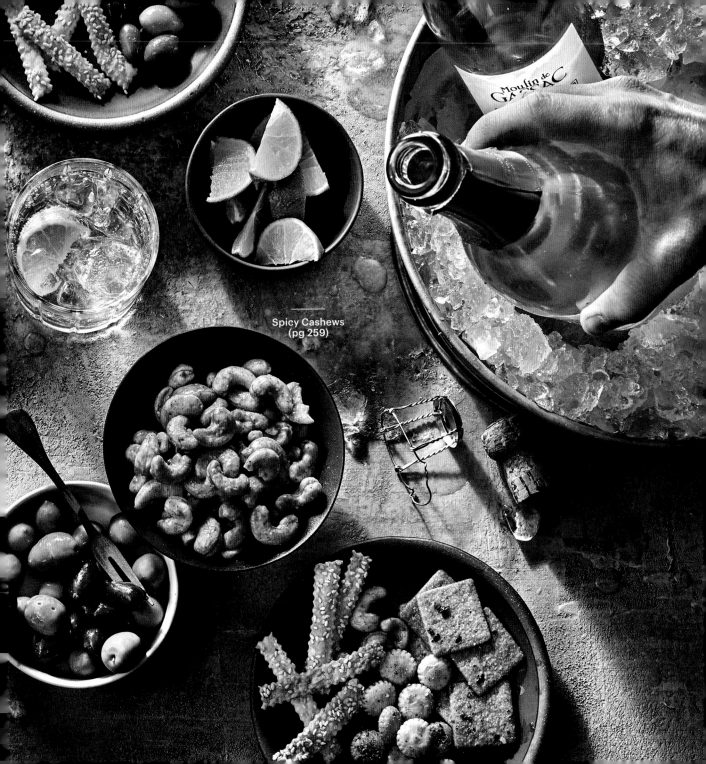

Spicy Cashews
(pg 259)

SESAME STICKS

SERVES 6

Crunchy and nutty, these are great for nibbling and giving. *Photograph on pg 256*

2 cups (about 8½ ounces) all-purpose flour plus more for rolling dough

1 teaspoon kosher salt

⅛ teaspoon cayenne pepper

¾ cup (6 ounces) cold unsalted butter, cubed

8 tablespoons ice water

1 large egg white, lightly beaten

⅓ cup sesame seeds

½ teaspoon flaked sea salt

1. Preheat the oven to 350°F. Stir together the first 4 ingredients in a bowl. Cut in the butter with a pastry blender until it resembles coarse crumbs. Sprinkle 1 tablespoon ice water at a time over the dough until it just holds together. Turn it out onto a floured surface; knead 2 or 3 times until it comes together. Roll into ⅛-inch thickness (14- x 12-inch rectangle). Brush the dough with the egg white and sprinkle with sesame seeds and sea salt. Cut into ½-inch strips. Cut the strips into 3-inch pieces and arrange on 2 ungreased baking sheets.

2. Bake at 350°F until light golden brown, 15 to 20 minutes. Cool completely on the baking sheets, 10 to 15 minutes.

ALABAMA FIRE CRACKERS

SERVES 16

These "marinated" crackers are downright addictive but so simple to make that you might want to keep the recipe top secret. *Photograph on pg 256*

2 cups olive oil

1 teaspoon garlic powder

1 teaspoon onion powder

½ teaspoon black pepper

4 tablespoons (about 2 packages) Ranch dressing mix

3 tablespoons crushed red pepper

2 (16-ounce) packages thin wheat crackers

1. Pour the olive oil, seasonings, and spices in a 2-gallon ziplock bag. Seal the bag and knead to thoroughly mix the ingredients together.

2. Place the crackers in the bag, seal, and gently turn the bag over several times to coat the crackers with the mixture. (The more times you do this, the better the coating.)

3. Let the bag stand overnight.

4. Preheat the oven to 250°F. Arrange the crackers on a baking sheet in an even layer. Bake at 250°F until lightly toasted, about 15 minutes.

ZESTY OHHH-STER CRACKERS

SERVES 12

This new spin on the gussied up-and-baked savory cracker is a winner. *Photograph on pg 256*

⅓ cup olive oil

1 (0.75-ounce) envelope garlic-and-herb salad dressing mix

1 tablespoon lemon pepper

1 tablespoon garlic powder

1 (14-ounce) package oyster crackers

1. Preheat the oven to 300°F. Whisk together the olive oil, dressing mix, lemon pepper, and garlic powder in a large bowl. Add the oyster crackers; toss to coat.

2. Divide the crackers between 2 large rimmed baking sheets, and spread in an even layer. Bake at 300°F until lightly toasted, about 30 minutes, stirring every 10 minutes. Cool on the baking sheets 30 minutes. Store in a large ziplock plastic bag or airtight container.

SPICY CASHEWS

MAKES 3 CUPS

Interesting fact: Cashews are not a nut in the true sense of the word, but rather the seed inside a cashew apple, a pod that matures beneath the fruit. *Photograph on pg 257*

¼ cup butter

¼ cup vegetable oil

2 (7-ounce) jars dry-roasted cashews

½ teaspoon salt

¼ to ½ teaspoon cayenne pepper

½ teaspoon chili powder

1. Melt the butter with the oil in a large skillet over medium; add the cashews, and cook 3 to 5 minutes or until browned. Remove the cashews, and drain on paper towels; place in a bowl.

2. Combine the salt, cayenne, and chili powder in a small bowl. Sprinkle over the warm cashews, tossing to coat.

BACON BOW-TIE CRACKERS

SERVES 8

If the humble rasher of bacon and cellophane-wrapped Club cracker seem too
low-brow to serve at a cocktail party, try the former lassoed around the latter for
an epicurean epiphany.

**8 thin bacon slices
(about 6 ounces)**

**24 rectangle-shaped
buttery crackers (such as
Club or Captain's Wafers)**

1. Preheat the oven to 250°F. Cut each bacon slice crosswise into
thirds (to make a total of 24 pieces). Wrap 1 bacon piece around
the narrow center of each cracker without overlapping the ends.
Arrange the wrapped crackers in a single layer, seam side down,
on a lightly greased wire rack set in a rimmed baking sheet.

2. Bake at 250°F until the bacon "belts" have crisped and
contracted a bit so that the crackers resemble bow ties, about
1 hour and 30 minutes. Cool on a wire rack 5 minutes before
serving.

BEER-BATTERED CHEESE CURDS

SERVES 10 TO 12

The curd is the word these days and these gooey deep-fried morsels are super simple to make. Get ready win friends and influence waistlines.

1½ pounds white Cheddar cheese curds (about 6 cups)

2 quarts vegetable oil

2¾ cups (about 11¾ ounces) all-purpose flour

2 teaspoons kosher salt

¼ teaspoon cayenne pepper

1¾ cups whole buttermilk

12 ounces amber lager beer (such as Yuengling)

2 large eggs, beaten

1. Place the curds in the freezer for 1 hour.

2. Heat the oil in a Dutch oven over medium-high to 375°F.

3. Whisk together the flour, salt, and cayenne in a large bowl. Add the buttermilk, beer, and eggs and whisk until just blended. (Batter may be slightly lumpy.) Add the cheese curds and gently stir to coat with the batter. Using a wire strainer, transfer the coated cheese curds to the hot oil in batches of 10 to 12, and fry until lightly browned and crispy, 1 to 2 minutes. Drain on paper towels. Serve warm.

SUCCOTASH SALSA

SERVES 8

Succotash isn't sufferin' anymore. Consider this a Deep South version of Texas caviar.

1 pint grape tomatoes, diced

1 (15.25-ounce) can baby lima beans, drained

1 (15.25-ounce) can whole-kernel yellow corn, drained

½ cup finely chopped sweet onion

¼ cup extra-virgin olive oil

3 tablespoons chopped fresh flat-leaf parsley

3 tablespoons white wine vinegar

1 teaspoon kosher salt

¾ teaspoon black pepper

Scoop-style corn chips

Combine the tomatoes, lima beans, corn, onion, olive oil, parsley, vinegar, salt, and pepper in a medium bowl; stir to mix well. Serve with the chips.

HOT COLLARD DIP

SERVES 8

If you're a spinach-artichoke dip fan, then you'll appreciate how sturdy collard greens can stand alone in this rendition of the bubbling cheese dip.

1 (8-ounce) package cream cheese

4 ounces shredded Swiss cheese (about 1 cup)

½ cup mayonnaise

½ cup grated Parmesan cheese (about 2 ounces)

2 tablespoons minced shallot

¾ teaspoon black pepper

½ teaspoon kosher salt

1 (15-ounce) package frozen chopped collard greens

Toasted baguette slices

1. Preheat the oven to 375°F.

2. Stir together the cream cheese, ¾ cup of the Swiss cheese, mayonnaise, ¼ cup of the Parmesan cheese, shallot, black pepper, and salt. Fold in the collard greens.

3. Spread in a 3- to 4-cup baking dish and top with the remaining ¼ cup each Swiss and Parmesan cheeses. Bake at 375°F until bubbly, 30 to 35 minutes. Serve with the toasted baguette slices.

SMOKY BLACK-EYED PEA HUMMUS

SERVES 8

Black-eyed peas are a barbecue joint staple. Pureed into a creamy dip, they get a welcome wisp of smokehouse flavor thanks to a few dashes of smoked paprika.

2 garlic cloves, peeled

2 (16-ounce) cans black-eyed peas, drained and rinsed

6 tablespoons extra-virgin olive oil

3 tablespoons tahini

2 tablespoons fresh lemon juice

1 teaspoon smoked paprika

¾ teaspoon kosher salt

½ teaspoon black pepper

Pita chips

Lemon zest (optional)

Process the garlic in a food processor until finely chopped. Add the black-eyed peas, ¼ cup of the olive oil, tahini, lemon juice, ¾ teaspoon of the smoked paprika, salt, and pepper. Process until smooth. Spoon into a bowl; top with the remaining 2 tablespoons olive oil and ¼ teaspoon smoked paprika. Serve with pita chips. Top with lemon zest, if desired.

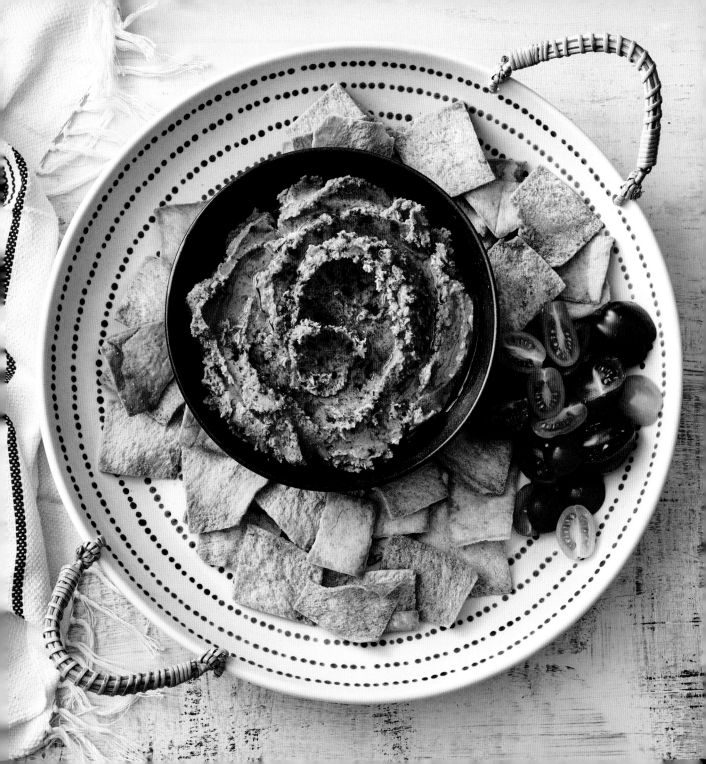

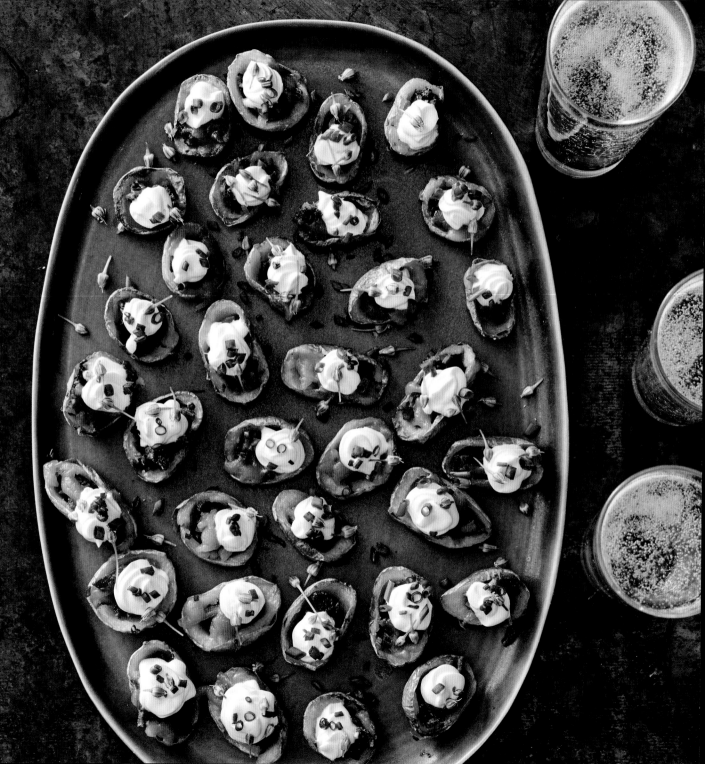

MINI POTATO SKINS

SERVES 20

These appetizers were made to travel. To take them to a party, prepare the recipe through Step 3, and place the potato skins in a container. Complete Step 4 just before serving.

1–1½ pounds Baby Dutch Yellow potatoes (about 20 [2-inch] potatoes)

1 tablespoon olive oil

4 ounces sharp Cheddar cheese, shredded (about 1 cup)

6 bacon slices, cooked and crumbled

½ cup sour cream

2 tablespoons chopped fresh chives

1. Preheat the oven to 425°F. Scrub the potatoes, and pat dry thoroughly. Place the potatoes in a large bowl, and drizzle with the olive oil; toss to coat. Arrange the potatoes in a single layer on a baking sheet lined with parchment paper. Bake at 425°F until tender, 17 to 20 minutes. Cool the potatoes completely on the prepared baking sheet, about 30 minutes.

2. Slice the potatoes in half lengthwise, and scoop out the potato flesh, leaving a ⅛-inch-thick shell. Reserve the potato flesh for another use.

3. Increase the oven temperature to 450°F. Place the potato skins, hollowed sides down, on the baking sheet lined with parchment paper. Bake at 450°F for 10 minutes; flip the potatoes over, and bake until crispy, 8 to 10 more minutes.

4. Fill the potato skins evenly with the Cheddar cheese, and top with the bacon crumbles. Bake at 450°F until the cheese melts, 1 to 2 minutes. Top each potato skin with a dollop of the sour cream, and sprinkle evenly with the chopped fresh chives.

TIP

For topping potato skins with neat dollops of sour cream, pipe it through a ziplock plastic bag with a corner snipped off.

'CUE JOINT NACHOS

SERVES 6 TO 8

Potato chips and pork and beans take the place of tortilla chips, beef, and refried beans in this Southern spin on nachos.

10 cups salt-and-ground pepper kettle-cooked potato chips (such as Kettle Brand Krinkle Cut Salt & Fresh Ground Pepper Potato Chips) (from 2 [8.5-ounce] packages)

1 (16-ounce) can baked beans, drained

2½ cups shredded smoked pork

10 ounces colby-Jack cheese, shredded (about 2½ cups)

1 cup shredded angel hair cabbage (from 1 [10-ounce] package)

½ cup jarred chow chow

⅔ cup bottled red barbecue sauce

⅓ cup bottled white barbecue sauce (optional)

1. Preheat the broiler to high with the oven rack in the top position.

2. Arrange the kettle chips in a single layer on a rimmed baking sheet. Top evenly with the beans, pork, and cheese. Broil until the cheese melts, 5 minutes. Top evenly with the cabbage, chow chow, red barbecue sauce, and white barbecue sauce, if desired. Serve immediately.

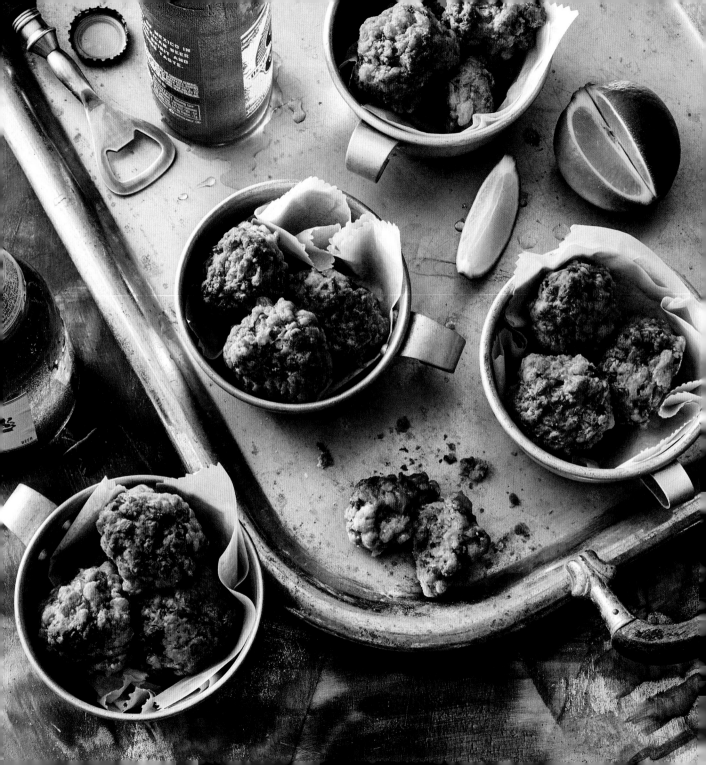

Sweet potatoes come in an array of colors and varieties, and the South's favorite tuber finds its way into everything from appetizers and sides to main dishes and pies.

SWEET POTATO AND SPICY SAUSAGE BITES

SERVES 12

This tasty twist on the ubiquitous party nibble has sweet potato folded into the mix.

1 pound bulk hot Italian sausage

2¼ cups all-purpose baking mix (such as Bisquick)

8 ounces sharp Cheddar cheese, shredded

½ cup chilled mashed roasted sweet potato

⅛ teaspoon ground cinnamon

⅛ teaspoon kosher salt

6 tablespoons plum jam

2 tablespoons Dijon mustard

1. Preheat the oven to 350°F. Lightly grease a baking sheet.

2. Stir together the sausage, baking mix, cheese, mashed sweet potato, cinnamon, and salt in a large bowl. Roll into 48 (1½-inch) balls, and place about 1 inch apart on the prepared baking sheet. Bake at 350°F until the sausage balls are cooked through and deep golden brown, about 20 minutes.

3. Stir together the jelly and mustard in a small bowl until well blended. (If the jelly is too stiff to blend, microwave the mixture at HIGH in 15-second increments until soft enough to stir.) Serve with the sausage balls.

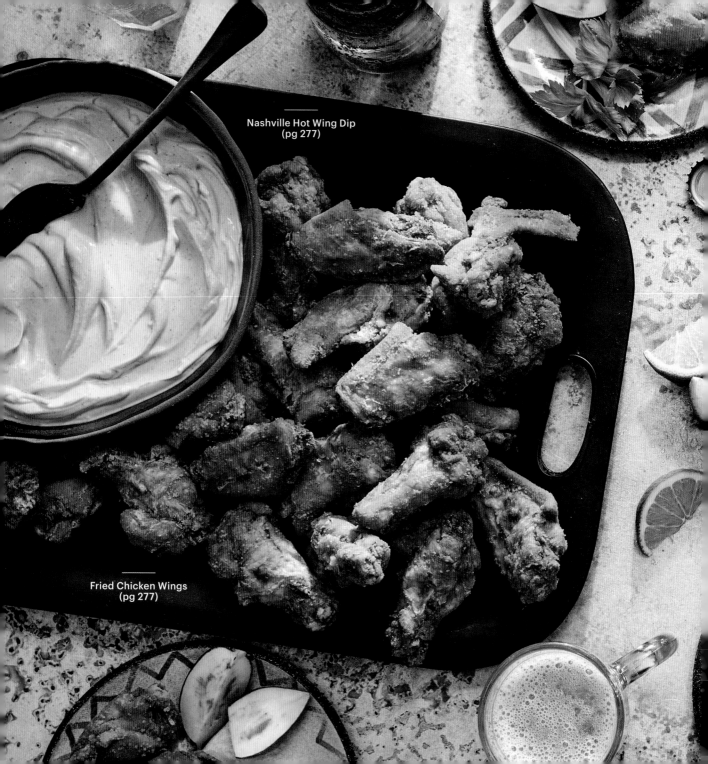

Nashville Hot Wing Dip
(pg 277)

Fried Chicken Wings
(pg 277)

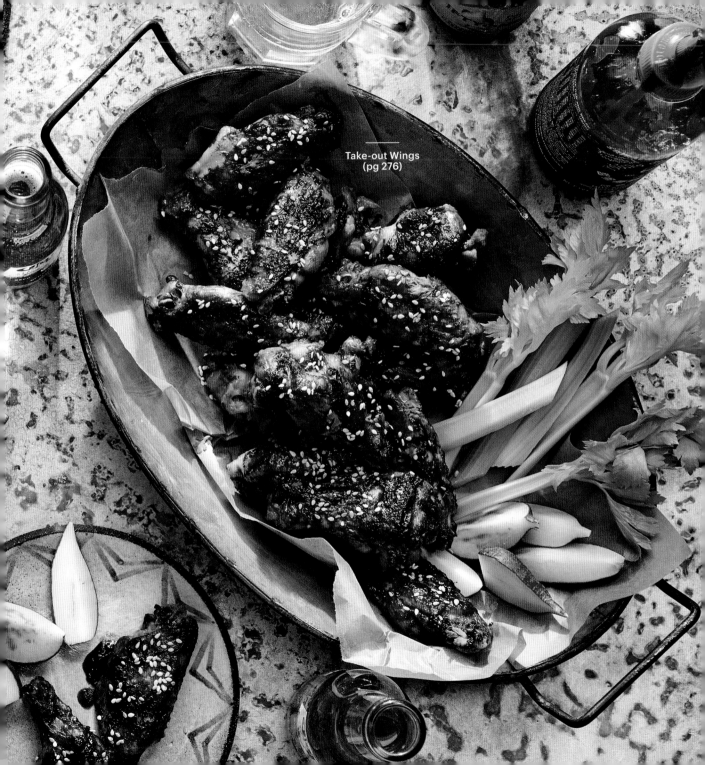

Take-out Wings
(pg 276)

TAKE-OUT WINGS

SERVES 4

These Asian-style sticky wings are slathered in Far East flavor, which is a nice change of pace from the traditional game day recipe. *Photograph on pg 275*

10 chicken drumettes

10 chicken wings

2 tablespoons toasted sesame oil

⅓ cup soy sauce

¼ cup packed dark brown sugar

1 tablespoon minced fresh ginger

½ teaspoon Chinese five spice powder

1 tablespoon balsamic vinegar

1 tablespoon dry sherry

1 tablespoon Sriracha chili sauce

½ teaspoon toasted sesame seeds (optional)

¼ cup chopped fresh cilantro (optional)

1. Preheat the broiler with the oven rack in the top position.

2. Coat a rimmed baking sheet with cooking spray. Brush the chicken drumettes and wings with sesame oil, and arrange in a single layer on the prepared baking sheet. Broil the chicken until golden brown and crispy, about 15 minutes. Turn the chicken pieces over, and broil until golden brown, about 10 minutes.

3. Meanwhile, combine the soy sauce, brown sugar, ginger, Chinese five spice powder, balsamic vinegar, sherry, and Sriracha in a small saucepan. Bring to a boil over medium-high, stirring occasionally; boil, stirring occasionally, until syrupy, 6 to 8 minutes.

4. Brush the chicken with the soy sauce mixture, and broil until the chicken is lightly charred on top, about 2 minutes. Turn the chicken over, brush with the soy sauce mixture, and broil 4 more minutes.

5. Arrange the chicken on a platter, and sprinkle with the sesame seeds and cilantro, if desired. Drizzle with the remaining soy sauce mixture.

FRIED CHICKEN WINGS

SERVES 4

It's hard to resist the miniature version of what is arguably one of the South's favorite foods. For those who like it hot, the accompanying wing dip is a mouthwatering must. *Photograph on pg 274*

2 cups (8.5 ounces) all-purpose flour

1½ teaspoons table salt

¾ teaspoon paprika

⅛ teaspoon cayenne pepper

4 pounds chicken wings

Vegetable oil

Nashville Hot Wing Dip (recipe follows)

1. Combine the flour, salt, paprika and cayenne pepper in a large bowl.

2. Cut off the chicken wing tips, and discard; cut the wings in half at the joint. Add the wings to the flour mixture; toss to coat. Cover and chill the wings in the flour mixture 1½ hours.

3. Pour oil to a depth of 2 inches into a Dutch oven; heat to 375°F. Remove the wings from the flour mixture, shaking off excess. Fry the wings, in batches, 10 to 12 minutes or until golden brown. Drain on a wire rack over paper towels. Transfer the wings to a wire rack in a jelly-roll pan, and keep warm in a 225°F oven. Serve the hot wings with Nashville Hot Wing Dip.

NASHVILLE HOT WING DIP

MAKES 4 CUPS

This creamy spin on the Nashville Hot chicken sauce is perfect for dipping wings and other things: French fries, chicken nuggets, fried shrimp, raw veggies, chips... *Photograph on pg 274*

3 (8-ounce) packages cream cheese, softened

¾ cup buttermilk

6 tablespoons hot sauce

1 tablespoon honey

1½ teaspoons cayenne pepper

¾ teaspoon garlic powder

1 tablespoon sliced scallions

Microwave the cream cheese at HIGH until melted, 1 to 2 minutes, stirring after 1 minute. Stir in the buttermilk, hot sauce, honey, cayenne, and garlic powder. Microwave at HIGH until hot, 2 to 3 minutes. Top with 1 tablespoon sliced scallions.

A trip to the beach is never complete without a stop at the seafood shack.

CREAMY CRAB DIP

SERVES 6

Sweet, fresh crabmeat elevates humble herb dip to elegant appetizer. Use crab clawmeat for an economical and equally delicious substitute for pricier lump crabmeat.

12 ounces fresh lump crabmeat, drained and picked clean of shells

½ cup sour cream

½ cup mayonnaise

⅓ cup chopped scallions

2 tablespoons fresh lemon juice

1 tablespoon chopped fresh flat-leaf parsley

1 tablespoon Old Bay seasoning

Chopped fresh chives

Celery sticks

Buttery crackers

Stir together the crabmeat, sour cream, mayonnaise, scallions, lemon juice, parsley, and Old Bay seasoning in a bowl. Top with fresh chives. Serve with the celery sticks and crackers.

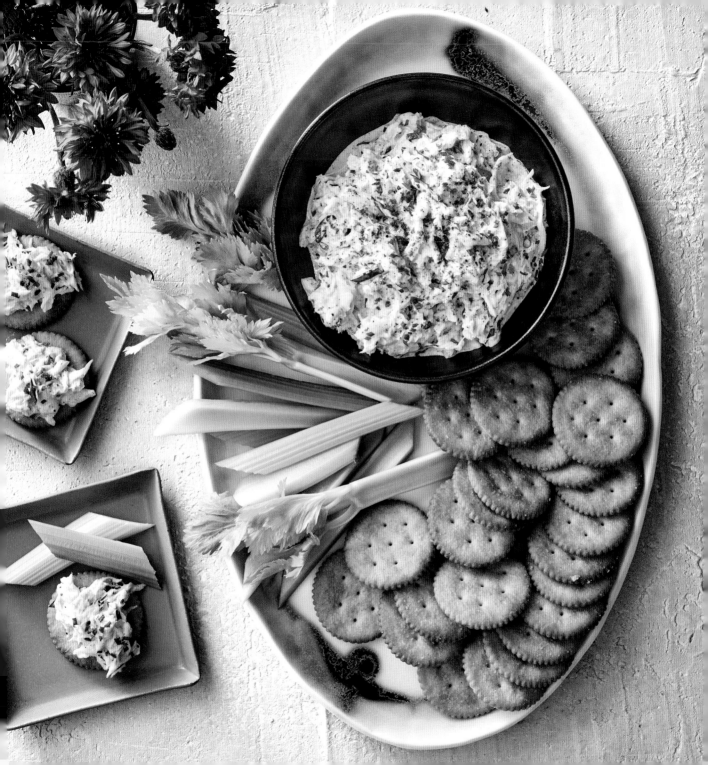

INDEX